AGE OF SURREALISM

BLOOMINGTON & LONDON

INDIANA UNIVERSITY PRESS

AGE OF

WALLACE
FOWLIE

Surrealism

TO HENRI PEYRE

TABLE OF CONTENTS

ILLUSTRATIONS

I · ORIGINS

I

The word *surrealism*, although it has only very recently entered the language of dictionaries, already designates an historical period. It has one closed and confining use to describe the artistic movement centering in Paris in the years between the two World Wars, 1919-1939. In the 20's and the 30's, surrealism was an organized movement, iconoclastic and revolutionary in nature, with its leaders and disciples, its manifestoes and publications, its exhibitions and even its street brawls. It became international during those years to such an extent that fourteen countries were represented in its 1938 exhibition.

But surrealism has another meaning, perhaps even an eternal meaning, and a context far wider than that of the André Breton group which chronologically succeeded dadaism about 1924. This book has been so devised as to maintain some manner of just proportion between the historical achievement of the literal 20th century surrealism and its profounder and more philosophical meaning. Some of the chapters, then, will deal with the self-appointed exponents of the school, such as Breton and Eluard. Other chapters will be concerned with artists who were close to surrealism and yet never actively participated

in it, such as Apollinaire and Cocteau. Still other artists were close to it and yet by the magnitude and universality of their work, surpassed it: Picasso, for example, who is the subject of the next to the last chapter. The opening studies are on the immediate often-acknowledged ancestors of surrealism: on Lautréamont, first, whose importance and influence have been stressed more steadfastly than those of any other writer; and then, on Rimbaud and Mallarmé, who have enjoyed much more intermittent favor with the surrealists than Lautréamont. Of course, many other names will be evoked and accredited. The surrealists were always concerned with discovering in the past, both near and distant, confirmation for their beliefs and practices. They demolish their adversaries as vigorously as they extol spirits kindred to their own. Thus Breton claims Heraclitus as a surrealist dialectician, and Baudelaire as a surrealist moralist. Not only do the surrealists traffic familiarly with such obvious names as Sade, Hegel, Marx, Freud, Saint-Just, but they also permit entrance into their chapel, through a side-door perhaps and a bit grudgingly, to Dante, Shakespeare, Gide.

The term itself of surrealism has already passed through the period when it was considered a joke, especially by academic circles and even serious critics who refused to pay any attention to it. There is still some scoffing at its expense, but I believe it comes now from those who are totally uninitiated to art. I spent several days at the International Exposition in Paris of 1938, which has been the biggest show put on by the surrealists to date, and still remember the tittering and even jeering on the part of some of the by-standers. And today in the Museum of Modern Art in New York and in the Art Institute in Chicago one can witness the same attitude of scepticism and marked distaste in some of the tourists who turn up there. The importance and the seriousness of surrealism equal now the seriousness granted the other two contemporary move-

ments of communism and neo-thomism. These three "revolutions" seem to be the most important for an understanding of our modern world, and although they appear to us now of almost equal importance, I shouldn't be surprised that in time surrealism, because of its subtle alliances with communism and the problem of spirituality, will grow into its real stature of the most vital and renovating movement of modern thought and art.

If, then, in a contemporary sense, surrealism takes its place mightily and pervasively beside communism and neo-thomism, in an historical sense the word seems more and more to justify a place beside the two words classicism and romanticism which for so long have been the cause of controversy and definition in Western art. As in the case of surrealism, there is a limited meaning of these terms applicable to an historical movement of twenty years, when manifestoes were published and aesthetic programs enunciated: classicism, in France, between 1660 and 1680; and romanticism, between 1820 and 1840. But it is futile to limit these three terms to any specific period of twenty years. An organized school of art, like an academy or a university, tends to disintegrate into pedantry and sterile rules. The great exponent of these modes of art usually stands outside the officially titular school, as Lautréamont does for surrealism. In fact, the greatest artists have been claimed by both the romantics and the classicists, and now, since the advent of surrealism, are claimed by the surrealists. Shakespeare, for example, might be named a classical writer because he wrote his tragedies in five acts, but an excellent case might be made out for the romanticism of his temperament, and I am confident that one day an important and much needed work will be written on Hamlet as surrealist hero. (When Hamlet's irrationality in the surrealist sense is finally acknowledged, much of the useless and tiresome theorizing about his motivations and problems will be discarded.)

I do not intend to review the many definitions of classicism and romanticism in order to set forth more adequately a definition of surrealism. All I shall attempt at this point is a statement about what seems to be the most basic difference between these two seeming adversaries in art form and then indicate the relationship of surrealism to one of them.

The immediate words which come to mind when we think of classicism are *order, control, condensation, choice, synthesis, rules.* The classical moment is that one when the artist is faithful not only to the rules of his art, established by such an authority as Aristotle, but faithful also to the government of his political state. As an artist, he is in accord with the moral, political and aesthetic beliefs of his society. His personal sentiments are so universally shared by his contemporaries that they have ceased being personal and have become classical. Classicism then seems to be the aesthetic counterpart of political absolutism. This fundamental interpretation of the classical spirit is offered by such diverse critics, but all equally pontifical in tone, as Grierson, Brunetière and Herbert Read.

In this light, romanticism, as the opposite of classicism, is always in some form or other associated with revolution and liberation. The classicist is closely bound up with society and the romanticist is the artist quite alone and apart, the individual who is opposed to society and who finds the rules for his art in himself. In its highest sense, romantic art is created by a single artist, as opposed to classical art which is created by a society. The early romantics of the 19th century were justified to some degree in identifying art with romanticism. The way is not very far from a belief in the autonomy of the artist, in his isolation and uniqueness, and a belief in automatism or automatic writing which the surrealists extolled as being the legitimate method of the creative artist. To seek in oneself, on all the various levels of consciousness of oneself, the rules and the

form of one's art is the romantic method, but it is also the surrealist method. And that is why surrealism appears as a reaffirmation of romantic principles. It would not be difficult to prove that the romantic or surrealist conception of the artist is not limited to the 19th and 20th centuries, but is on the contrary an ancient belief, firmly established in the cultures which have formed our world. In Plato's *Ion,* Socrates says: "The poet is a light and winged and holy thing, and there is no invention in him until he has been inspired and is out of his senses, and the mind is no longer in him." I don't remember the surrealists ever having used this text, but it is one which they might well have exploited. From the Old Testament, the words of Samuel might also be evoked, especially those he addressed to Saul when he said: "I am the seer: go up before me unto the high place; for ye shall eat with me today, and tomorrow I will let thee go, and *will tell thee all that is in thine heart.*" Both the Greek and Hebraic worlds, as well as providing our world with almost every idea and belief it functions by, formulated surrealist definitions of the artist.

II

Surrealism, during the years which separate the two world wars, seemed particularly concerned with negation, with revolution and the demolishing of ideals and standards. The surrealists were "anti" everything, but especially anti-literature and anti-poetry. They were asking for not much less than a total transformation of life. The formula which they combatted the most relentlessly was that which called literature an expression of society. This they considered the goal of bourgeois self-satisfied literature, and in denouncing it they were attacking what we have already defined as a basic aspect of classicism.

However, long before the period of surrealist invective, there had been in France a marked shift of preferences, a

shift away from the kind of literature which was a social expression and a sociological document to forms of writing in which the artist tries to be sincere with himself, to express his thoughts and experiences with maximum degree of candor and honesty. It was obvious from the beginning of the century on, that preference of younger writers and critics, only some of whom were to become literally surrealists, was moving toward a literature of absolute sincerity. The word *realism* had taken on offensive connotations. The realistic creed had worn itself out tiresomely and monotonously. The two leading examples in this shift of preference are, first, in poetry, the ascendancy of Baudelaire, whose art is preferred to the cold impeccably formed Parnassian documents and the worn-out exercises of second-rate symbolists; and secondly, in prose, the preference accorded to Stendhal over Balzac. Younger readers in France had become irritated with the clearly defined motivations and the over-simplified psychological formulas of Balzac and other realists. François Mauriac was able to record early in the century, that young men were protesting against the real: "les jeunes êtres se défendent contre le réel." The success in 1913, when it was first published, of such a novel as *Le Grand Meaulnes* by Alain-Fournier was proof of the eagerness with which the French public accepted a work dealing with the world of dreams and the strange attraction of irrationality. The first part of Proust's novel *Du Côté de chez Swann* was published in 1913, but it wasn't read until after the war.

The need for sincerity in literary expression, felt strongly in France during the first twenty years of the century, is really the belief that the conscious states of man's being are not sufficient to explain him to himself and to others. His subconscious contains a larger and especially a more authentic or accurate part of his being. It was found that our conscious speech and our daily actions are usually in contradiction with our true selves and our deeper de-

sires. The neat patterns of human behavior, set forth by the realists, and which our lives seem to follow, were found to be patterns formed by social forces rather than by our desires or temperaments or inner psychological selves. This discovery or conviction that we are more sincerely revealed in our dreams and in our purely instinctive actions than in our daily exterior habits of behavior (tea-drinking or cocktailing, etc.) is of course basic to surrealism. It is admirably summarized in a sentence of André Gide's autobiography, *Si le grain ne meurt,* when he speaks of the difficulty of our knowing the real motivation of any of our actions: "le motif secret de nos actes nous échappe."

Reality, then, as demonstrated by the realists and as seen by man's own limited conscious self, entered upon a period of disfavor when it was considered imperfect, transitory, impure. And many of the new writers are characterized by their refusal of reality. Refusal and denial, in terms of reality, become currently used words. This is negative, a movement of anti-realism, but contains, as most negations do, an overwhelming positive aspiration. A new kind of absolute is in sight, which, although it contains a refusal of what we usually call logical intelligence, is an elevation of the subconscious of man into a position of power and magnitude and (the word now forces itself on us) surreality.

Behind this discovery or elevation of surreality lies the denial or refusal of reality, and still farther behind that, lies a more permanent state of mind of modern man for which the French have an excellent word: *inquiétude,* which in its English translation of "restlessness" seems inadequate. The current explanation of this *inquiétude* is the fact that man in the 20th century is forced to live in a period of threatened warfare or literal wars of such increasing cosmic magnitude that his state of mind is anything but peaceful. War is the most obvious human experience which accentuates the instability of the world.

It certainly explains to a large degree the urgency felt by artists of the 20th century to discover a philosophy and art forms which will express their permanent sentiments of instability and restlessness.

If what is usually called real life or realistic life, ceases to have meaning, or represents a trap or false ambiency for the human spirit, reaction against reality is to be expected. An entire literature has come into being whose avowed goal was to escape from the real, to create an antidote for the insufficiency of realism. It might be called a literature of evasion and escape, in which the hero undertakes, not an exploration of the world with which he is most familiar, but an adventure in a totally exotic land or an investigation of his dream world. The example of Rimbaud in Ethiopia served as a model for the creative artist who was able to cut loose from all the stultifying bourgeois habits of living. And Lafcadio, the hero of André Gide's *Caves du Vatican,* whose goal is to commit a gratuitous act, an act having no motivation and no reason, also epitomized much of the new literature. Rimbaud always remained one of the gods of the surrealists, and *Les Caves du Vatican* was the book they preferred to all others of Gide, the only one of his which they wholeheartedly accepted.

The new hero is the unadaptable man, the wanderer or the dreamer or the perpetrator of illogical action. He represents what psychologists would define as the schizoid temperament. His method, and even his way of life, is introspection. For any man to understand himself, he must analyze all the varying and contradictory elements which go to form his personality. The great prose masters of this method of introspection—Dostoievski, Proust, and Gide— were heeded and studied by the surrealists who continued their method and pushed it so far that what is simply introspection in a Proust became in surrealist art the dissociation of personality, the splitting apart of the forces of a human character.

In whatever century we study him, man seems to remain strangely the same and recognizable. We can discover in each period the same human problems. What does change is the emphasis and the importance of these problems. But no matter what particular problem emerges as central and characteristic of an age, whether it be political or religious, philosophical or psychological, the artist goes about his work in much the same way. Whatever the problem of his particular age is, the artist, by his very vocation, has to make himself into the articulate conscience of the problem. The artist does not create the problem of his age, but he does create the myth of the problem. That is, the form by means of which the problem may in some sense be understood and felt by his own age and by subsequent ages. The form given to a problem by an artist, which is a myth, is precisely that form which will permit the problem to be understood in the general hierarchy of all human problems. The myth of surrealist art—although it is perhaps too early to be certain of it—may well turn out to be the myth of the subconscious. That is, the myth of knowledge derived from data of man's subconscious activity.

Three writers especially, one of whom was venerated by the surrealists, presided over the emergence of this myth. First, the philosopher Henri Bergson demonstrated by his lessons of intuition the need to exceed the bounds of logical intelligence. Then, André Gide promulgated his lyrical lessons on self-affirmation. One of his early books, his most persuasive statement of doctrine, *Les Nourritures Terrestres*, is a paean of liberation from the traditional standards of society. It is a program of search for self-realization, self-integration, for morality of self, and especially a sensuous rejuvenation and understanding of self. The third among these major thinkers of modernism is, of course, Freud, whose illuminations on the subconscious form the leading principle of the surrealist creed.

It would be inaccurate to consider Bergson, Gide, and

Freud as forerunners of the specific school of surrealism. They have influenced, in France, especially, and in those countries which follow France as a civilizing force, almost every aspect of modern thought. But the surrealists have derived from them a kind of subterranean impetus and confirmation. They have contributed help to the tremendous problem of sincerity for the modern artist: Bergson, in his lessons on the sincerity of intuition; Gide, on the sincerity of individual morality; Freud, on the revelations of the subconscious mind. The intellect alone, or a life regulated by the fixed standards of society, or our conscious states of being considered the sole source of self-knowledge, became for such thinkers as Bergson, Gide, and Freud, three barriers to sincerity, three ways of leading man into contradictory and deceitful life where actions, sentiments, and thoughts would be uncoordinated and unfruitful. If the principal problem for a Stendhal around 1830 seemed to be: how should I act? what should I do?, the problem one hundred years later appears to be: what am I? how can I attain to the center and the reality of my being? The problem of action for the hero of 1830 became for the hero of 1930 the problem of personality. The surrealists riveted themselves to this problem and in order to attain to some approximation of it have not ceased interrogating subconscious states of man, hypnotic states, and echolalia.

The surrealist found himself preoccupied with a contemporary hamletism. If he found himself unadaptable to society, it was because the secret of his being had to be revealed before he could actively engage in life, before he could follow any familiar course of action. This hamletism, which is an excessive analysis and study of self, an effort to probe into the deep restlessness or *inquiétude* of modern man which results in immobility and inactivity, seems to be a new form of the *mal du siècle*, the romantic malady of the early 19th century. Proust has been the full-

est recorder of this *inquiétude*. He has played the rôle of analyst for our world which Rousseau and Chateaubriand played for the 19th century.

III

This new *mal du siècle* or hamletism came into great prominence after the first World War. In fact dadaism, which is a violent expression of it, originated in 1916, in Zurich, before the end of the war. The movement of Dada was soon replaced in the early 20's by surrealism, but not before it had expressed its strongly negative emphasis on many respectable notions and activities. It rebelled against society, language, religion, intelligence, and especially literature. The shattering effect of the war —that is, the defeatism of the war, felt even after the Armistice of 1918—explains to some degree and perhaps very considerably, the *inquiétude* of the young men in the post-war world, their sense of futility, and their attacks of open remonstrance which find their expression in early surrealism.

The direct experience with war accounts ·therefore somewhat for the sense of futility and the philosophy of nihilism apparent in much of the surrealist art and literature. André Malraux, not a surrealist, but one of the best prose writers of contemporary France, who in 1947 announced unexpectedly his affiliation with De Gaulle and right-wing politics, wrote in his early book, *Les Conquérants:* "Nous avons été formés dans l'absurde de la guerre." In this sentence, "We were formed in the absurdity of war," he expresses an underlying thought of his generation, which is that of the surrealists. The first surrealists were also the first dadaists, and they had all been affected and marked in some personal way by the war: Breton, Eluard, Aragon, Péret. It is significant that the genesis of surrealism, between 1916 and 1922, developed under the influence of the war and that the literary works most ad-

mired by the surrealists, the writings of Lautréamont and Rimbaud, came into being at the time of the other war, that of 1870, in a comparable spirit of defeatism, in a comparable urgency to destroy traditional values.

The new movement was named before the end of the war by Guillaume Apollinaire. In a letter to Paul Dermée, of March, 1917, Apollinaire stated that he preferred to adopt the word *surrealism* rather than *surnaturalism,* and added that *surrealism* wasn't yet in the dictionary. Apollinaire at this time was the main god among the living for the first surrealists: Breton, Eluard, Aragon, Péret, Soupault. They also admired Max Jacob and especially the painters: Picasso, Matisse, Laurencin, le douanier Rousseau, Derain, Braque, Fernand Léger. The four earlier writers whom they all read and studied and claimed as the first gods of surrealism, the real ancestors, were Nerval, Baudelaire, Lautréamont, and Rimbaud.

The initial destructive element of surrealism might be illustrated by the character and the tragic end of Jacques Vaché. Before the war Vaché had been an art student in Paris, of not too great promise. He was sent to war and at the front was wounded in early 1916. He was treated, for his leg wound, at the neurological center at Nantes where André Breton, who had begun his career as a medical student, was an interne. The meeting in 1916 at Nantes of Breton and Jacques Vaché was of capital importance for the history of surrealism. In applying the principles of his personal philosophy, Vaché was to become for Breton and for most of the young surrealists, the dramatic symbol of their revolt, the man who dared to live his principles, who dared to surpass the mere eccentricities of behavior with which most of them stopped.

When Vaché was released from the hospital, he spent his time unloading coal on the wharves of the harbor at Nantes, or, dressed in impeccable elegance, frequenting the lowest dives of the city. He used to wear alternately a Brit-

ish uniform or a French aviation uniform, and give him-
self invented titles or tell about himself totally imagined
adventures. The word he was the most serious about de-
fining was *humor*, which he called "un sens de l'inutilité
théâtrale et sans joie de tout, quand on sait." Humor, thus
defined as the "theatric uselessness of everything," is an
admirable clue to the meaning of dadaism, over which
Jacques Vaché seemed to preside as a kind of prophet. The
seemingly senseless actions of Vaché were really perpe-
trated in order to create about himself a world of unreal-
ity. He tried quite literally to live within the realm of his
imagination.

He left no work of importance, save a volume of letters,
Lettres de Guerre (Au sans Pareil, 1919), published after
his death. His importance was his effect on, first, André
Breton, who said he owed the most to Vaché ("C'est à
Jacques Vaché que je dois le plus"), and then on his many
admirers for whom he was a lucid and brilliant exponent
of a way of life, or rather a way of looking at art. There
are passages in his letters of literary nihilism, which be-
came the manifesto of dadaism: "We have no liking for
art or for artists—down with Apollinaire!" ("Nous n'ai-
mons ni l'art ni les artistes—à bas Apollinaire!") Such sen-
tences as "Nous ignorons Mallarmé" ("We don't know
who Mallarmé is") were said in a tone both of scorn and
high seriousness. They came from his fundamental belief
in the ludicrous or useless display of art, or at least what
was traditionally admired as art.

Vaché pushed his philosophy to its logical conclusion by
taking his own life, at the end of 1918 in Nantes. He was
a tall red-headed fellow who easily attracted people by his
physical appearance. His personality and personal convic-
tions were so strongly felt by his friends and admirers that
they not only accepted the idea of his suicide but also the
fact that he took a friend's life at the same time. The
means of his suicide was an overdose of opium and he gave

the same amount of opium to a friend who had asked to be initiated to the drug. It is more than probable that Vaché knew what the result of the two doses would be. I mention this tragic story first to illustrate the sense of defeatism which was felt at the end of the war, and secondly to illustrate the attraction toward death and self-destruction which is apparent in much of surrealist art. Prophecy, doom, destiny, occultism, and suicide are all manifestations of the pessimistic or nihilistic aspects of surrealism, and they will be studied at suitable points throughout this book. Vaché's suicide was immediately interpreted as a kind of martyrdom. He was a martyr to the futility and the doom of life, and his action was celebrated as a poetic or surrealistic justification of selfhood.

IV

Surrealism at all times seemed to offer suicide as one alternative. But its other alternative has fortunately been believed in and practiced more assiduously than the suicidal interpretation. Belief in suicide has been strongly counteracted by belief in the miracle of art, in the magical qualities and properties of the artist. Surrealism receives this belief as a heritage from the early romantics of the 19th century, from a conviction about the artist and his work which had steadily grown in force and clarity throughout the century. The rôle of the writer was seen as usurping more and more the prerogatives of the priest, of the miracle-worker, of the man endowed with supernatural vision. The work itself of the writer, and particularly of the poet, was seen more and more to be a magical incantation, an evocative magic or witchcraft whose creation and whose effect were both miraculous. The artistic work might be compared to the "host" of sacramental Christianity which contains the "real presence." The poet then is the priest who causes the miracle by a magical use of words, by an incantation which he himself does not fully

understand. And the work, thus brought into being, is a mystery which can be felt and experienced without necessarily being comprehended.

For the most part, the surrealists were poets and hence specialists in language. Poetry was for them, as legitimately as science and philosophy were for others, the way of knowledge. In the deepest sense, surrealism is a way of life, a method by means of which we may accept the enigmas of existence and in daily living learn to transcend impotencies, defeats, contradictions, wars.

In this way of knowledge, by which we are defining surrealism, there is one primary precaution always stressed, and this precaution helps to distinguish surrealism from other ways of knowledge: in the poetic or artistic creation, the poet must not intervene too consciously. He must learn the method of making himself into an echo, the method of echolalia. To become the magician, or the seer (the *voyant,* as Rimbaud calls him), he must learn to follow his inner life, or his imagination, as if he were an observer. He must learn to follow his conscious states, as when asleep he observes his dreams. Freud taught the surrealists that man is primarily a sleeper. The surrealist must therefore learn how to go down into his dreams, as Orpheus descended into the underworld, in order to discover his treasure there.

One poet, more profoundly than all others, is the ancestor of the surrealists. The position occupied by Charles Baudelaire in the history of modern poetry is remarkably equidistant between the two extremes or two heresies of modern poetry: first, the theory usually referred to as the art for art's sake theory (*L'art pour l'art*) and stressing the independence of art from any other occupation or preoccupation of man; and second, the utilitarian theory of art which stresses its use and application. Baudelaire's life-long avoidance of falling into either one or the other heresy of art, is so important and so remarkable that I

think his position in art might be compared to that of St.
Thomas Aquinas in theology, who especially in his articles
on grace, always avoided falling into one of the two possible
heresies: of determinism or predestination on the one side,
and of total liberty and independence of man from God's
help on the other side.

Baudelaire's lesson on the autonomy of the imagination
was to become a principal article of surrealist faith. For
Baudelaire, the work of art is essentially a work of the
imagination and yet it is true and real at the same time.
This is perhaps the best way of defining what is meant by
the sincerity of a work of art: the fidelity with which it
adheres to the imagination of the artist. Additionally, for
Baudelaire, a work of the imagination comes from a very
real kind of anguish. Not so much the impermanent and
transitory anguish of daily living, of insecurity, of war
and love, as the inner and deeply permanent anguish of
man which is usually repressed and covered over with will-
ful forgetfulness. As in the treatment of psychoanalysis, the
poet has to go very far down into his past, into the signifi-
cance of his childhood. Considerable heroism is demanded
for this facing of oneself in one's past.

The supernatural heroism of Baudelaire, which is the
outstanding mark of his genius, was never matched by any
surrealist writer. But the method and the ritual of his hero-
ism were used and imitated by the surrealists. Baudelaire's
self-discovery in his anguish and his self-revelation in his
writing were archetypal. The artists who followed him, and
especially the surrealists, have reenacted his method almost
as a religious mystery, with the conviction that if all as-
pects of the ritual be observed, the mystery will again be
achieved. All literature is to some degree psychoanalytic.
Baudelaire went so deeply into psychoanalytic exploration
that he passed beyond the personal reminiscence into the
universal. That moment when the poet arrives at the cen-
ter of himself and therefore at the center of human destiny,

when he participates in the consciousness of the world and there establishes a point of contact between himself and the world, would be claimed by the men whom we are going to study, as the supremely surrealistic moment.

Baudelaire, and the man he claimed as spiritual brother, Edgar Allan Poe, whose life paralleled in so many ways Baudelaire's, would offer in their literary works sufficient material to establish the origins of surrealism. The particular kind of heroic anguish which they had to go through before they could attain to what we have called their surrealistic moment, appears to us, as time goes on and we see more clearly, propitiatory. An artist like Baudelaire assumes in himself much of the evil of humanity and by projecting it in his work relieves humanity of its evil. When we read the flowers of evil of Baudelaire, poems whose subject is known to us in varying degrees, we are thereby purged of the very evil which was in us. One of the most precious concepts of our world is the cathartic principle of art, which we owe to the *Poetics* of Aristotle. The surrealists, with the example especially of Baudelaire, have given to the doctrine of catharsis a renewed and vigorous interpretation. The myth of psychoanalysis, or rather the myth of the subconscious, which would be one facile way of describing the myth created and recreated by the surrealists, was formed in the wake of invasions, wars, and revolutions, in company with neo-thomism and communism, as a way of integrating and uniting scientific determinism and poetic sublimation. When one knows oneself (science means knowledge), at the end, say, of the performance of a tragedy, or after the reading of a poem, or after contemplating the spectacle of a painting, one has lived through both a human experience and its absolution. Infinitely more than practices which might be called classical, or romantic, surrealism has emphasized the closeness of art to a certain kind of psychic human experience and the remedial effect which such an art has on the human spirit.

II · LAUTRÉAMONT: *the temperament*

I

The word most often used to describe the romantic temperament is *individualism*. The romantic is generally considered the type of artist who has broken the rules and constraining bonds of an established order. By individualism is meant the prestige of liberty with which the artist has covered himself, the intoxication of freedom and rebellion. But before attaining to this experience of himself, the romantic has had to go through a longer and, I believe, a far more significant experience which is that of solitude—a very particular kind of solitude which results in forming the prevailing temperament of the great modern artists.

The destiny of a classical artist, like Racine, is implicit in the work which he is called upon to write, which lies ahead of him in the rules of composition, in the ideals of art, in the beliefs and needs of a society, in all the pedagogical and sociological privileges which he inherits. In this sense, the classical artist writes in the midst of a vast company, both past and present. He is never without models, and never without teachers and critics and a public.

The romantic, or his successor, the surrealist, has no such inheritance and no such guidance. He finds himself in the midst, not of a vast company, but of a vast solitariness. The world he discovers is in ruins. The early romantics very literally used a décor of ruins as the familiar setting for their thoughts and their experiences. Such a man has no model but himself; he has no destiny to accomplish, but a destiny to discover and invent.

It is true that the modern schools of poetry—the romantics, the parnassians, the symbolists, and the surrealists—all have their various meetings and gatherings, their *cénacles*, their cafés and even their *salons*, such as Mallarmé's apartment on the rue de Rome; but the artists remained solitary, always uncertain of their artistic enterprises for which there seemed to be no precedent and no public. They no longer wrote about celebrated heroes, whose adventures were known, because each one had to become a new and unique solitary hero, discovering in his own conscience and his own memory the subject matter of his works.

The experience of solitude probably explains more about modern literature and art than any other single experience. And I am thinking of the solitude of such different geniuses as Vigny in his ivory tower, Hugo on his islands, Rimbaud in his voyages and escapes, Claudel in his religious meditations, Joyce in his exile from Dublin. In his solitude, which is his inheritance, the modern artist has had to learn that the universe which he is going to write or paint is in himself. He has learned that this universe which he carries about in himself is singularly personal and unique as well as universal. To find in oneself what is original and at the same time what can be translated into universal terms and transmitted, became the anxiety and the occupation of the modern artist. The romantics held this belief partially and intuitively. The surrealists made it into a creed and a method. Surrealism was actually founded on the doctrine that the artist does not belong to

any one period and that he must discover solely in himself his universe.

The man who did more than any other to bridge the gap between the romantic perception, only faintly illuminated, and the surrealist dogmatism was Isidore Ducasse, who called himself Comte de Lautréamont.

No portrait exists of Lautréamont and almost no facts are known about his life. One set of facts were indeed published about him, whereupon the surrealists, who prefer to maintain an atmosphere of mystery and anonymity about their ancestor, set about to prove, and did so, conclusively, that the published facts concerned another Ducasse. The biographical details about Lautréamont which do seem authentic, and which have been parsimoniously given out by the surrealists, may be summarized in a few sentences. He was born in 1846 in Montevideo, Uraguay, where his father, whose family originally came from the Pyrenees, occupied a post in the French Consulate. At the age of 14, Isidore Ducasse crossed the ocean and came to France. He was a pupil in the lycée de Tarbes, and then at the lycée de Pau (in the Basses-Pyrénées), where in 1865 he seems to have completed his year of philosophy, or final year at the lycée.

He then went to Paris, ostensibly to present himself for entrance at the Ecole Polytechnique. Here any accurate trace of him is pretty much lost. He seems to have studied the piano and lived in various small hotels, particularly number 15, rue Vivienne, which is named in an important passage of his writings, and number 7, faubourg Montmartre, where he died on the 3rd of November, 1870, at the age of 24. Two years before his death, in 1868, Lautréamont printed, at his own expense, the first canto of *Maldoror*. The following year, 1869, he found a Belgian publisher, Lacroix, who agreed to publish his complete work, the six cantos which compose *Les Chants de Maldoror*. The edition was printed, and then it seems that the pub-

lisher became terrified at the boldness of the text and re-fused to put it on sale. The first edition was not sold until ten years later, in 1879. The only other publication during Lautréamont's lifetime was a small work called *Préface aux Poésies*, brought out just a few months before his death, and was destined to become for the surrealists a text as im-portant as *Les Chants de Maldoror*. It was not until 1890 that a new edition of Lautréamont was brought out, this time chez Genonceaux. The work was unknown during the symbolist period. Gide states, in one of his books, that Lautréamont exerted no influence on the 19th century, although in the 20th century he became one of the most influential writers and opened up the dykes of the new literature. A new edition of *Les Chants* was published in 1920, under the direction of the writer Blaise Cendrars, and since then many other editions have appeared and made the writing of Lautréamont very accessible.

The surrealists have venerated the obscurity and the solitude of Lautréamont's life. The absence of any photo-graphic resemblance of him has incited them to create imaginary portraits based upon the literary testament which he left. *Les Chants de Maldoror* come from a single mind, from the sensibility of one man who lived in almost total solitude in the midst of modern European civilization and who, like Rimbaud (who was writing his first poems when Lautréamont died), traversed in the space of just a few years, approximately 1865-1870, a whole century of human experience. A few readings which are traceable in his work, in addition to the particular kind of solitude he lived, were sufficient to call forth from him a series of images and of themes, whose intensity and meaning go very far in explaining much of modern art. His temperament, formed by a modern genus of solitude, created a series of images, which are those of the modern artist, and which seemingly can be explained best in terms of this mysterious temperament.

II

It is important to remember that for the surrealists, Lautréamont was much more significant than a mere literary figure could ever be. He is their ancestor not so much by virtue of having created a new literary atmosphere or a new literary work, as by virtue of having created a domain inclusive of literature and art but far more extensive. For the surrealists the language of Lautréamont seems to have a dissolving power. What he literally committed to the page is striking and bold and almost unthinkable at times, but what is important is the degree of life and vision, and particularly of futurity in life and vision, which can be evoked from the work. Its language and its image may therefore dissolve into a reality greater than they, a reality which is not translatable into language.

Certain modes of experience are so ineffable that when an attempt is made to cast them into language, they appear estranged from themselves, weakened and vilified. Much of 19th century poetry is inferior to the experience with which it is concerned. It became an art which generated itself, which emoted over itself and kept within its florid bounds of rules and similes and commonplaces and clichés. Most romantic, parnassian, and symbolist poetry is starkly and laboriously conventional. Poetry had largely succumbed to its fatal and always imminent disease of facile rhetoric. When poetry becomes wholly dependent on the currently used, easily understandable language of its own period, it dies of itself, of inertia and boredom.

Lautréamont and Rimbaud, the two adolescents of French literature, have uttered the strongest invective against 19th century poets. In the work of each of them a page is devoted to a listing of names and to a violent exercise of name-calling. They were the most deeply aware of the impasse against which poetic convention had pushed poetry, and, because they were young, didn't hesitate to

use destructive criticism. Their very youth had made them more demanding of poetry and more impatient with poets who exacted nothing from language and hence were unable to create language. Lautréamont sensed the need for the poetic temperament to undergo a fundamental change. Rimbaud forced the word, the poetic communication, to undergo a comparable change.

A revolutionary—and Lautréamont was certainly that in terms of poetic sensibility—may be very easily accused of madness and perversity. Léon Bloy and Rémy de Gourmont both used the word "insanity" in speaking of Lautréamont, but the surrealists always stressed the fact that no clear demarcation can be made between a state of poetic creativity and a state of insanity. Both states are confused, and rightfully so, they believed, because in both, man has to leave himself, move out from his habitual conventional reactions and see everything in the world, and particularly his own thoughts, in a totally fresh and unpredictable manner. Therefore, according to the surrealists, chance coalitions which may take place in free imaginative states of mind are more valuable in the making of art than the logical juxtapositions we impose upon words and sounds and colors in our trained consciously focused states of mind. This is why Paul Eluard could call surrealism a "state of mind."

At the beginning of Lautréamont's work, in the first canto of *Maldoror*, we learn that the experience which is going to be related is the career of evil. On page 3, Lautréamont says that Maldoror, after living for a few years, made the discovery that he had been born wicked, and "il se jeta résolument dans la carrière du mal." This phrase, "the career of evil," is a violent announcement for a work of art. It prepares us at the outset for a sombre revelation and informs us that the work is to be read as a book of negation. The subject matter is to be the disaster and catastrophe of human experience. The narrative of *Mal-*

doror is therefore not to be what we often find in literary works—a sublimation or an embellishment of life. It is to be the reverse of all that—the going backwards of man (since evil is the negation of the good), the plunge into human existence at a point which will often appear, as we read *Les Chants de Maldoror*, pre-historical, a point in time before human existence began. The large number of animals, and particularly of sea animals (sharks, whales, crabs, frogs, octopuses) and birds of all kinds, which inhabit the pages of *Maldoror*, accentuate this important theme of the reversal of chronology, this turning back of man in order to track down the origin of his dilemma and anguish and evil.

Throughout the six cantos, Lautréamont maintains, as one of his primary themes, the relationship of man with the physical universe, with what often appears to be the prehistoric physical universe. The hero Maldoror, who is in many respects the outstanding surrealist hero, is conceived of as a man still very close to his memory of animals, still very close to the time when he himself participated in an animal existence. He is the hero closely and fervently animalistic, and hence sadistic; the being who moves and acts in accordance with cruelty. He finds himself midway between two beings: between the purely physical being, such as a shark, and the purely spiritual being whom he calls God. Maldoror finds himself equally distributed between matter and spirit, and therefore equally drawn toward animals and toward God. But since the cantos are to narrate his career of evil, he describes his sadistic impulses more exclusively than his spiritually motivated impulses. The initial phrase, "the career of evil," implies that Maldoror feels closer allegiance to the physical than to the spiritual, that he is going to attempt to live solely by sadistic evil. Yet, the career of evil never completely obliterates the career of the spirit, and Maldoror states, also in the first canto, his need for the infinite: *Moi, comme les chiens,*

j'éprouve le besoin de l'infini. But such a need as this is followed by the need to feel himself the son of a shark or of a tiger.

I suppose that never has a literary hero felt so perfectly ambivalent as Maldoror. This evenly partitioned ambivalence, unique perhaps in Lautréamont, has its antecedents throughout the history of man, in the age-long struggle between good and evil, God and Lucifer, the spiritual and the material, the unicorn and the lion. The duality of man is inescapably reflected in art. In every work of art is present an element of beauty, so persistently recognizable in every age, so closely identical with every spectator's aspiration toward the ideal, that we can call it by no other term than eternal. Undefinable and mysterious as it may be, this eternal element marks every kind of work of art, whether it be a Greek statue or a tragedy of Sophocles or a sonnet of Mallarmé or a painting of Dali. And then, secondly, to complete this duality, each work of art is characterized by an immediate temporal aspect. It may reveal some connotation of its period in history, or a system of morality, or the reflection of a personal anguish or passion. A work of art is always made by a temporal man who catches in one moment of time the color of that moment as well as its eternality. So, the Greek statue, as well as giving its intuition of timelessness, adumbrates a purely temporal marble and the ideal human body according to an historical period and mores.

The duality of man and the duality of all art are further exemplified in the very particular duality of the artist whose temperament or temperamental ambiguities are projected in highly dramatic fashion in Lautréamont. The permanent drama of man is the struggle between good and evil. This is treated directly and vehemently in *Les Chants de Maldoror*. But it is prefigured in the permanent drama of every artist. This drama is the struggle to attain some harmony between the two needs of the artist: first, the

need to be a man of the world, that is, a man who some-
how understands the world and the reasons for the customs
of the world; and second, the need to be the specialist,
chained to his palette or his marble or his language.

The conflict in every artist is the need to understand the
world and the need to live apart from it. But he has to
understand the world not in the usual moral and political
way, but in a manner which I have already described as
prehistorical. The great artist—and this I take to be the
surrealist lesson of Lautréamont—has to be able to return
to those shadowy worlds existing before birth and after
death. The great artist has to remember everything: not
merely the wars and revolutions of his time, but of time
before time, of the war in heaven, of apocalyptic wars and
infernal punishments.

Most men are simply curious about history and politics.
But in the artist, this curiosity grows into a monstrous kind
of passion, into a force which is fatal and irresistible. It
makes of him a singular being capable of all metamor-
phoses. This is, to a large extent, the subject matter of
Les Chants de Maldoror. On one level, Maldoror is able
to metamorphose himself into an animal, in much the
same way as a character of Kafka changes into a cockroach.
But on the other level, his tortuous pride and his memory
make him desirous of equaling God. Again in the first
canto, we come upon this sentence: *il voudrait égaler Dieu.*
This surrealist metamorphosis of Maldoror, which moves
in two directions, one toward the physical and the other
toward the spiritual, is really the annihilation of time, by
which the hero is able to descend into the mysterious past
when man was one with God. He has never recovered from
the haunting memory of some distant and buried crime
which turned him against God.

To use the word consecrated and especially defined in
French literature by Charles Baudelaire, the modern artist
has become the "dandy." *Le dandy* is the being dramatized

and allegorized by Lautréamont in his character Maldoror.
The dandy, according to Baudelaire, has critical intelli-
gence and a finely developed sensitivity and character, but
he is constantly aspiring to a coldness of feeling, a hardness
of character, an insensibility, an inscrutability. This is a
tight-fitting mask which he must forge every day in order
not to betray himself when in the world. The dandy learns
how to feign hostility and indifference until they become
naturally instinctive in him. His fear is the same as Mal-
doror's fear—that to appear sincere in his worldly relation-
ships would be equivalent to appearing ridiculous.

This problem or dilemma of the artist's particular dual-
ity has reoccurred in some form or other, according to some
type or other, in each age since the Renaissance, since the
so-called beginning of modern history, and seems indeed to
be one of the distinguishing features of the modern world.
It is apparent in the "gentilhomme" of the 16th century,
in the noble who wants to be at the same time scholar and
humanist. Montaigne, for example, was always fearful of
being considered a professional writer, and strove to main-
tain an attitude of detachment and even of derision toward
the pedant and the industrious scholar. In the 17th century,
the "honnête homme" is another name for the same kind
of man, who avoids becoming a specialist in order to know
something about everything and thus show his preference
for nothing. La Rochefoucauld's maxim which states that
the "honnête homme" refuses to be disturbed or involved
(qui ne se pique de rien) is a code not unlike that of the
libertine of the 18th century, who practices a licence on
morals as well as in thought, and of Baudelaire's dandy of
the 19th century. The case of Maldoror, which is our study
of the surrealist temperament, is an instance and a deep
study of the Baudelairian dandy and hence of the modern
artist—the man who has to see the world, who has to live
in its center, and who all the time has to remain hidden
from the world. Such an ambiguous rôle, which I think

can be traced to the early Renaissance when Christendom began its secularization, allows us quite justifiably to consider the modern artist the secularized priest, the one who, forced by his vocation to live apart from the world, is nevertheless the profoundest conscience of the world, the most accurate recorder and interpreter of the world's problems.

III

In this light, the experience of solitude for the modern artist is religious. It is the experience of a sacrament. Both preparation and absolution, it effects a complete change in the human being. The solitude of Lautréamont, who was known personally by so few people, whose itinerary, only eighty years ago, through such a modern city as Paris, is not traceable, and the solitude of his hero Maldoror who contemplates one scene after another in the world, only to lay waste to it when he himself participates in it, have the same secret force of a destiny. Solitude seems to be the destined climate and need and fulfillment of the modern artist. Baudelaire, in his personal journal, *Mon coeur mis à nu,* acknowledges this same thought: *sentiment de destinée éternellement solitaire.*

The center of this inescapable solitude is the scene of Lautréamont's revolt against God, made all the more dramatic and bare because of the solitude. *Les Chants de Maldoror* illustrate what Baudelaire analyzed as the modern type of beauty, namely a commingling of mystery and tragedy. *Mystère* and *malheur* were the words Baudelaire used, and he referred to Milton's Satan as a leading type of virile beauty. This Baudelairian definition of the beautiful might easily be applied to the art of other periods, to the *Oedipus* of Sophocles and the *Phèdre* of Racine, for example, but Lautréamont, writing in the wake of Baudelaire's doctrine, made a shocking and violent use of it, and the surrealists held steadfastly to this particular illustration of the theory.

The celebrated scene between Maldoror and a female shark which takes place almost at the end of the second canto, would serve to depict the Baudelairian and surrealist type of beauty, as well as to indicate the main traits of Maldoror's revolt against God, and hence the dandy's indifference about life.

The scene is prefaced by an important passage dealing precisely with the theme of solitude, of predestined solitude which may well explain the excessive action of sadism and bestiality. Maldoror says that he had searched everywhere for a kindred spirit, for a soul which resembled his, but he had found no one. By day a young man had approached him, offering his friendship, but Maldoror had turned him aside. By night he had spoken to a beautiful woman but had been unable to accept her love. This is the setting of a parable. The first act of the drama now begins. Maldoror, seated on a rock by the shore, watches a storm rise up and hurl a large ship against a reef. The drowning men try to prolong their lives because they fail to recognize the fish of the sea as their ancestors. Fetishistically, Maldoror prods his cheek with a sharp piece of iron in order to increase the suffering of the victims from the boat. This is the first strong note of sadistic pleasure which Maldoror is deriving from the shipwreck scene. He takes his gun and finishes off those few who are on the point of escaping, especially a boy who, stronger than the rest, swims to only 200 meters off the shore. But Maldoror says that he was tired of always killing, that his pleasure had diminished, that he was not really so cruel as later he was accused of being. We half see in such a statement that cruelty is a willed regimen, an experimentation. Yet Maldoror makes no effort to excuse himself: he acknowledges that, when he commits a crime, he knows what he is doing.

A second act, more terrifying than the first, begins when the ship finally sinks into the sea and the many survivors are left floundering about on the surface. A school of sharks

adds a new horror to the scene and the water becomes crimson with blood. At that moment a huge female shark, famished, arrives and destroys all but three of the male sharks. Maldoror kills one of these with his gun, and then dives into the ocean to attack with his bare hands and a knife one of the sharks while the female slays the one remaining monster. Alone, then, in the water with the female shark, Maldoror unites with her in a ferocious embrace. This, of course, is the culmination of the drama, which is in itself a kind of metamorphosis. Maldoror recapitulates the introductory theme, when he says that the shark resembles him, that he is no longer alone and that he has experienced his first love.

Such a scene as this, I might say, in the violence of its beauty and its horror, has not been exceeded in the writings and the paintings of the surrealists. For a scene of comparable power and awesomeness, one would perhaps have to go to Dante's *Inferno,* to the circle, for example, where thieves are punished by having their bodies united with the bodies of snakes. This shark scene of the second canto is exemplary of two fundamental literary qualities mentioned by Baudelaire in his work, *Fusées,* two qualities rigorously adhered to by the surrealists—supernaturalism and irony. The attraction of the shark is at least mysterious if not supernatural, and Maldoror's first discovery of love in his mating with the sea monster is strongly ironic, according to any ordinary measurement of human standards.

The act of love is here portrayed in a scene which reveals its most primitive aspect of torture—as the act of prayer might easily be portrayed in its most primitive aspect of magic. But for our specific purpose, which is an understanding of the meaning of surrealism, this scene, so strongly primitive in its ferocity and incredibility, so reminiscent of our dream world where we cohabit with monsters, might help us to establish the myth of the artist, as specifically enacted by Maldoror. Again we return to Baudelaire,

for textual confirmation in his journal, *Mon coeur mis à nu,* where he writes that only three types of men are respectable, as judged by the temperament of the artist. These are the priest, the warrior and the poet. All other men exercise what Baudelaire scornfully calls professions; that is, I suppose, perfectly measurable and conventionalized lives. With each of these three types, Baudelaire associates a verb, that is, a strong action. For the priest, it is "to know," for the warrior, "to kill," for the poet, "to create." These combined roles in the artist—of priest, warrior, poet; or of knower, killer, creator—form the myth of the artist, and are, curiously enough, quite evident in Maldoror's scene with the female shark. First he presides over it as a priest might preside over a complicated ritual: he predicts and knows it and seems even to control it. And then, like the warrior, he participates in actual destructiveness and slaughter. Finally, like the poet, he creates a new form of himself in his union with the monster.

The entire passage shows the combined contradictions of feeling which every artist experiences before the spectacle of life: the feelings of horror and ecstasy. The ecstasy of the priest, who knows transcendently, and the horror of the warrior, who kills in obedience to a deeply imbedded primitive instinct, have to be combined in the creation of the poet which is the formalized metaphor of horror and ecstasy. The orderly evolution of the three verbs, *to know, to kill, to create* is at once the expression of a temperament and the process of a myth. It is in close accord with the aesthetic doctrine which defines the beautiful in terms of mystery and tragedy.

If the mysterious and the tragic are permanent traits in all art, they are intimately related to the surrealist (or even modern) hermeticism of poetic form and content. This hermeticism or obscurity or secretiveness in both the formalized aspect and the subject matter perhaps best characterizes the intensity of the new art, and especially surrealist

art. Every human life is more characterized by mystery and secretiveness than by comprehensiveness and lucidity. For the surrealists the secret of Lautréamont's life was the sign of the inaccessible character of his work. The difficulty or obscurity of artistic form always comes from the mysteriousness or inaccessibility of the content. The content of *Les Chants de Maldoror*, as is evident from the shark episode is perhaps the most incomprehensible of all possible themes, because it is the insubordination of man to God. This theme of man's revolt against God is in almost all of the greatest literary works: in Aeschylus, in the story of Moses, in Dante's *Inferno*, where it is the only subject, in Milton, Goethe, Baudelaire. Maldoror's pride is that of the damned, whose beauty is horror and whose memory is ecstasy.

IV

The newness of Maldoror and his specifically surrealistic character is his exaggeration of revolt, its absolute quality, and the humanized and degraded portraiture he gives of God. Maldoror appears not only in a state of revolt against God, but as a rivaling and neighboring monarch to God. In his need to equal God, he utters extreme blasphemy and at the same time he creates metaphorically in his writing an important aspect of art usually called the "grotesque." The long passage which terminates the third canto is a brothel scene in which Maldoror listens to the speech of a gigantic hair fallen from God's head. The blasphemy consists of thinking of God as having committed sin and crime. The divine misdemeanors had awakened from their sleep of centuries in the catacombs under the brothel, which significantly was once a convent, the nuns who, like those of us living in the modern world, are overcome with a strange *malaise* and anxiety. So, God Himself receives the stigmata and has to strive to rehabilitate Himself in the world of men. God talks about His shame as being endless as eternity: *ma honte est immense*

comme l'éternité. In such scenes in which God is degraded, Maldoror reveals himself as an integral anarchist, as the destroyer not only of human but also of divine values.

If the writer Lautréamont was in revolt against what was currently accepted in his day as "literature," namely the well-rounded inflated sentence of romantic style, his character Maldoror was in revolt against conventionalized feelings and respected taboos. The surest and cruelest way to overcome dramatized feelings and pompous and stubbornly stated affiliations is to make fun of them. *Les Chants de Maldoror,* even in such serious scenes as those of the female shark and the hair from God's head, contain an aspect of the modern type of humor and the comic which is so important in the work of Picasso, Joyce, and Proust. I am confident that Lautréamont and the surrealists were scornful of the traditional type of comedy, as exemplified in Aristophanes and Molière. They were as strongly opposed to the exaggerated verbal logic of romanticism, of a Chateaubriand, for example, whom Lautréamont called the "melancholy Mohican," as they were opposed to the intellectual logic and rule of good common sense, which have always been extolled and exemplified by the culture of France. Lautréamont and the surrealists, in their rôle of ardently minded revolutionaries, would have been mortified in using any of the traditional forms of comedy and tragedy. Blasphemy, which is a combination of the serious and the comic, is their mode. When art is somewhat dominated by the grotesque (which is always allied with blasphemy) the spirit of modern man is more at ease in considering the serious, the tragic, the religious. I am thinking here not only of Lautréamont and the surrealists, of Picasso, Proust, and Joyce, but also, to a lesser degree, of course, of *The New Yorker,* Mickey Mouse, Charles Chaplin, Fernandel.

Maldoror, in his many experiences of violence and revolt, is trying to destroy the voice of his conscience, to forget the lessons of tradition and convention. He turns

against the family, as the prodigal son did, and initiates a fervent line of modern prodigal sons, of whom the most illustrious are Rimbaud and Gide. In him, love and hate are perfectly fused, as they must inevitably be in any real experience of blasphemy. Both the writer and his creature, both Lautréamont and Maldoror, are the same adolescent who makes of his revolt, so equally composed of love and hate, a search for the absolute. This is a mark of adolescents: they are the most fervent seekers of the absolute. As they grow older, only the few among them who become by vocation poets, philosophers, and saints remain seekers of the absolute.

So, the adolescent revolutionist turns against his family, against the books of his schoolmasters, and against his society. But after knowing during their adolescence the passion of revolution, most revolutionists become lovers. Lautréamont, as far as his book is concerned, did not become lover. His book deals only with the principle of destruction, and not with the principle which follows destruction, when the revolutionist becomes lover, namely the principle of possession. Lautréamont, then, represents the first stage of an evolution. He is the pure example of revolutionist. He will be followed by the lover, whose principle is possession, and who will be followed in his turn by the poet, whose principle is creation.

These three types, revolutionist, lover, and poet, are not always graphically discernible. The adolescent usually conceals his revolt and acts out, for the world to see, another kind of life. In Lautréamont, for example, the revolt is only parabolically manifested. The lover, also, in most cases, has to conceal his love, or at least the intensity of his love. He becomes thereby, not so much the actor which the adolescent revolutionist becomes, as the buffoon or the clown who hides his tragedy by means of mimicry. And finally the poet, in the third panel of this triptych, conceals his experience by means of a metaphor.

III · RIMBAUD: *the doctrine*

I

Without always realizing it, Rimbaud explicated by the example of his life and by the far less mysterious example of his work, an aesthetic doctrine which had been slowly formulating in France during the 19th century. Baudelaire had made the most significant contribution to the doctrine. He had almost systematized it, in a fragmentary way. He had substantiated it by his critique of the writings of Swedenborg and Poe. He had become, what Rimbaud justly acclaimed him, the first visionary (*le premier voyant*) and king of poets (*roi des poètes*). Baudelaire died in 1867, ten years after the publication of his *Fleurs du Mal,* and all during the 1860's Mallarmé wrote his first poems which were efforts toward the perfecting of this poetic theory. The poems of Mallarmé are the purest achievements of the new doctrine.

At the very end of the 1860's and during the first three years of the 1870's, Rimbaud gave vent to this doctrine, as a child might, in a veritable storm. His brief existence as poet—about four years—had the compressed turbulent beauty of a storm, of some cosmic upheaval which spends itself in brilliant flashes. The fire and heat of an earth-

quake explode after a long period of preparation, after a
long period of waiting and compressed power. In the case
of Rimbaud, the years of repression were long for a child
during which he had received no normal affection from his
mother and when his father, who might have loved him,
was absent from the home and whose name the son was not
permitted to mention. In no literary work, not even Lau-
tréamont's, is one so aware, as in Rimbaud's, of a former
existence, of a life of the spirit which grew inwardly and
deeply because of an outward life of repression. His writ-
ing is so composed of flashes, of magnificent restless flames,
that one can explain it not by the usual method of biog-
raphy and literary sources and philosophical concepts, but
by the theory that it springs from a deep and hidden life,
a former life perhaps, at least an unreal or surreal life.

To define, at first very briefly, this doctrine, intimated
by Baudelaire, perfected by Mallarmé, and given by Rim-
baud its most explosive expression, as in some violent
dream, we might say that it seems to be a belief in the re-
lationship which necessarily exists between a poem and
witchcraft or magic or *sortilège,* as the French call it. A
poem comes into being due to a process which, like al-
chemy, is magical and therefore foreign to the rules of
logic and even the rules of instinct. According to this pre-
cept, a poem originates in this hidden life of the spirit and
therefore is a reflection of this previous or submerged life.

Rimbaud never knew the writings of Lautréamont. The
two adolescents were unknown to one another, but wrote
almost at the same time. Lautréamont had just completed
his *Chants de Maldoror* when Rimbaud was writing his
first poems. With the innocency of a child, Lautréamont
stepped out of the period we designate as history or as time.
And Arthur Rimbaud did likewise. History is man's free-
dom in good and evil. The end of history will be the end
of this freedom. And the period before history we can only
call the period of God's creativeness. But into some fic-

tional replicas of that time-before-history Lautréamont and Rimbaud entered. Their freedom from good and evil was almost consummated there, because they seem, in their writing, which is their exceptional memory of time-before-history, to have ceased being men choosing freely between good and evil, and to have become personalities, now of good, now of evil. They give the impression of having been subjugated by good and evil without having made the choice themselves, by use of their own will-power. As we read their story in the hard glazed brittleness of their language, we see more and more clearly the contours of the strange myth from which their experience springs. From the myth before time and from before the incarnate expression of love. Every man, even if it is only for an hour or a day of his life, experiences, I believe, the reality of this myth. The myth of the void is as true as the myth of the creation, and for the creative artist, the first myth, that of formlessness and nothingness, is the most terrifying story of mankind.

II

The principal document on Rimbaud's method is a letter he wrote on May 15, 1871, usually referred to as the *Lettre du Voyant*. It marks the culmination of the first period of his poet's existence, characterized not so much by a poetic production as by a finding of himself and especially a discovery of a poetic theory. Most of his poetry is to be written between the summer of 1871, when he composes *Bateau Ivre* and the summer of 1873, when he completes his final work, *Une Saison en Enfer*.

The months leading up to May of 1871 had been filled with excessive kinds of living and disturbing experiences. January was largely given over to extensive readings on magic and allied subjects in the Public Library at Charleville. In February he escaped from home for the third time and went to Paris. On returning home one night, the artist

André Gill found Rimbaud asleep in his studio and sent him off with ten francs. Rimbaud returned penniless and famished to Charleville in March, only to be off again to Paris in April when he hoped to participate in the Commune and enlisted in the "tirailleurs de la Révolution." After a violent physical experience in the barracks, he returned to Charleville in May, from where he wrote the letter which is today considered a veritable poetic manifesto. He had spent much of the spring in low dives and bars drinking quantities of beer, especially when he was in Charleville, and smoking incessantly on his pipe. I mention these details because Rimbaud was only sixteen at this time and was unquestionably, with the vanity which characterizes a genius adolescent, engaging upon a kind of defiance of himself, testing himself in a willful manner. By means of physical excesses and exhaustions, of a nature that would be shocking to his mother and all bourgeois standards, he was trying to arrive at a spiritual lucidity, at a state of inner awareness which he will call *la Voyance* or vision. By degrading his physical and social self, he hoped to attain to a new functioning of his spirit. Rimbaud was actually performing during the spring of 1871 an inverted or ironic exercise of asceticism.

On May 13, he sent a letter to his teacher Izambard who had befriended and guided him during the entire year of 1870. This letter is a kind of first draft of the more important letter he is to write two days later. In it he denounces Izambard for remaining too much the school teacher, for being too bent on an academic career and being already too fossilized. Then he defines the principle of his recent life: his willful seeking of degradation: *je me fais entretenir; je m'encrapule;* and, still more important, the reason for this principle: *jè travaille à me rendre voyant* ("I am laboring to become a visionary").

Rimbaud felt that Izambard didn't understand this letter, nor the poem he inserted in it. So, two days later,

on the 15th of May, he wrote a long letter to a friend of
Izambard, Paul Demeny, from which I shall extract a few
themes which appear essential for an understanding of
Rimbaud and much of modern poetry and especially for
the aesthetic doctrine of the surrealists.

The letter is a violent revision of values, and begins,
curiously enough, with mention of the poetry of antiquity,
which Rimbaud says culminates in Greek poetry. In Janu-
ary, he had been reading books on Oriental religions, and
on the tradition of Orphism in Greek poetry. Much in
Rimbaud is reminiscent of the rites of purification and
secret initiation by means of which one attains to an
ecstasy which is the liberation of the soul from the body.
Pythagoras and Plato had been initiates of these mysteries.
In fact, the essence of the Greek spirit might be defined
as the will to mount toward spiritual unity, where the
spirit will be able to perceive pure reality. I believe it
would be false to overemphasize this influence on Rim-
baud, as Rolland de Renéville does in his book on *Rim-
baud le Voyant,* but it unquestionably exists to some de-
gree, and might well be called upon to explain the first
formal and vital pronouncement of the letter.

This pronouncement: *Je est un autre* ("I is another
self") stands almost at the beginning of the letter as per-
haps the key to the document. Rimbaud follows it by a
statement which clearly has something to do with the reason
for the kind of life he has been leading. He says that he has
been watching the birth of his thought, that he has been
listening to it, as if his thoughts were rising up from the
depths of a being different from his own being. (. . . *j'as-
siste à l'éclosion de ma pensée: je la regarde, je l'écoute.*)

This phrase, *je est un autre,* seems to mean that, in addi-
tion to the every-day familiar self we believe we know be-
cause we are constantly seeing it act and react, breathe, and
eat, there is another self which is the real self. In order to
arrive at this real self, this God-like self we would say if

we accepted a Pythagorean influence on Rimbaud, we have to destroy the familiar self which is after all only fictional. This would clearly make out of Rimbaud's doctrine of *voyance* a metaphysical contemplation of the absolute.

The passage in the letter which begins with: *Car je est un autre,* ends, a page and a half later, on an important sentence which, at first sight, appears mysterious. *Auteur, créateur, poète, cet homme n'a jamais existé.* But its meaning may well come from this partially Greek or Platonic interpretation of *Je est un autre.* When Rimbaud writes that never did an author, creator, or poet exist, he seems to mean, in the light of the preceding part of the letter, that the so-called creative or poetic work has come from the false self, from the fictional self that we believe in too much. We learn to generate words and phrases in a false mechanical way, working on them in a stupidly conscious manner, and thus equating the creator with the functionary, the hackwriter, the "literary" writer.

When the right moment for the genius comes, he has to make himself into a stranger to the land which bore him. He has to renounce, in some way or other, the society and the family into which he was born and which he never chose. This is an important ritual in the myth of the artist, and is closely allied, of course, with the ascetic discipline of the religious. In harmony with this ritual of alienation, the poet, when the right moment comes, has to make himself into a stranger of the language of his people, to the familiar language he has always heard and used, and discover the other language which exists in the other self, the real or the mythic self. This is the language to which he awakens, in—and I use here a phrase from Rimbaud's letter—"the fullness of the deep dream" (*la plénitude du grand songe*).

In any study of Rimbaud, and especially of Rimbaud's influence on surrealism, the problem of the source of language and the meaning of language is the most important

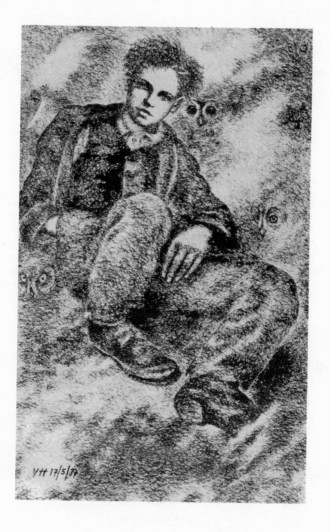

RIMBAUD, *etching by Valentine Hugo.*

GOUACHE *by Robert Desnos.*

to elucidate as well as the most tenuous and subtle about which to state any convictions. The entire movement of surrealism may one day be considered essentially an experiment with language. In order to begin a discussion of the doctrine of language, or rather the fragmentary notions which Rimbaud and the surrealists proffer concerning language, I should like to quote a line of the surrealist poet, Robert Desnos, one of the finest figures of the movement, who lost his life in a German concentration camp a few years ago. This line was recently quoted in an article of Louis Aragon, who was a friend of Desnos, and at one time an ardent surrealist himself.

The line reads: *Mots, êtes-vous des mythes, et pareils aux myrthes des morts?* ("Words, are you myths, and similar to the myrtle-leaves of the dead?") The line is curiously composed of four key words, each beginning with *m*: *mots, mythes, myrthes, morts,* the last three of which—*myths, myrtle-leaves, dead*—serve as elliptical and provocative explanations for the first term, *words*. Perhaps the best starting point in this problem of language would be to remember the sacred importance of words in all the major religions of the world. Words, and very often isolated words, are the masters and disciplinarians of religious systems. According to *Genesis,* the universe itself came into existence by an utterance or a word of God: "And God said, Let there be light." Other examples which instantly come to mind are: the incantatory power of words in prayer, repeated endlessly day after day, *Our Father who art in heaven;* the inviolate power of the words of Holy Scripture, which must mean even if they contradict contemporary notions and discoveries; and finally, the transubstantiating power of the central words of the mass: *This is my body. . . .* Lovers usually have a private code: phrases or words which evoke for them the deepest part of their experience and which one will use to call the other back to the proper state of attentiveness. You remember

the magical words of Swann and Odette in Proust's novel.
. . . Each one of us has words acquired in childhood,
which, although they no longer have any meaning for us,
are permanently lodged in our dreams and subconscious
states. In the third grade I was taught long passages from
Longfellow's *Hiawatha,* and do what I may, I am unable
to eradicate from my memory the lines:

> On the shores of Gitche-Gumee,
> Of the shining Big-Sea-Water . . .

These words are in me forever, I think, as something al-
most sacred, even if I do consider them today as an exam-
ple of bad jingling verse. . . . Other phrases exist in us
as condensed expressions of our belief and our very life, as
summarized vocalisms of what we hold to without under-
standing, and whose very articulation gives to our life a
fervent resilience: "Though I speak with tongues of men
and of angels, and have not charity, I am become as sound-
ing brass or a tinkling cymbal."

To answer the question asked in the line of Robert
Desnos, we might say that, yes, words are myths. The echo
of syllables may be so strong in men, that we are perhaps
more guided by words than by any other single power.
Slogans convince us politically, and phrases from old songs
shape us sentimentally. Rimbaud speaks of this power in
his *Saison en Enfer* when he evokes the imaginative force-
fulness in our memory of such words as tavern signs, fairy
stories, pornographic books, the Latin of the mass; and
James Joyce does also in *Ulysses* where the phrase *Là ci
darem la mano* from *Don Giovanni* forms an important
theme. In some of the still lifes of Picasso, words are
painted in, such as in the painting *Ma Jolie,* and possess
an evocative power comparable to that of the color and
composition of the canvas.

If words are myths and similar to the myrtle leaves of

the dead, we are implying that the words themselves are more real than the objects or the ideas which they signify. Words then are the reality, and not the things which they describe. To create a poem is therefore equivalent to re-arranging words, to fixing words in new unaccustomed juxtapositions so that they will show different aspects and colors of their myth. Rimbaud and the surrealists and modern poets in general will not try, in their poems, to explain experience. And Picasso, in his paintings, will not try to describe experience. They are too humble, or rather too despairing of ever understanding so complex and variable a subject as human experience. All that they are interested in doing is to show a kaleidoscope view of life, a new arrangement of signs, an unexpected set of formations which may cast new lights and shadows on life but without thereby deciphering it. Words are myths, because they are not understandable in any ordinary sense. They are similar to the myrtle leaves of the dead, because they do not describe or reveal or resurrect the dead, but because they symbolize the glory and the achievement of the dead. They "remember" the dead, as a leaf fallen from a tree ceases to be the tree but remains symbolic and evocative of the tree.

Poetry is not for Rimbaud, and hence it isn't for the surrealists who were his most orthodox disciples, a way of knowledge in the ordinary sense of knowledge. But it is the way left to us for knowledge about the multiple myths of mankind. Myths are, by definition, unknowable, and words which communicate the myths are likewise unknowable.

III

The second theory announced by the *Lettre du 15 mai* concerns what should be the first study of the man who wishes to be a poet. Here Rimbaud's pedagogic intention becomes clear: the letter is much more than a mere communication about poetry to Demeny; it

is indoctrination by a youth who considers himself, for the
moment at least, seer and prophet, a kind of poet-Samuel
who has finally understood the voice speaking to him in
the darkness. Rimbaud says that the poet must first know
himself. He must search for his soul, and then examine
it fearlessly, tempt it and finally know it. Other men may
be content with learning that they have a soul. The poet
has to know what his soul is. Man seldom knows how to
see himself as a complete being. There is an erroneous way
of knowing oneself, which for Rimbaud is self-deceit, and
which he defines as being intellectual progress. In this
erroneous technique we become learned about things not
ourselves. The new way, advocated by the sixteen year old
poet, consists in making of one's soul something *mon-
strous*. This is the way of the *voyant,* of the visionary and
his reasoned derangement of the senses. The derangements
and monstrosities which are self-revelatory are not un-
named in this text. Rimbaud lists them: love, suffering,
madness. One has to know and exhaust the poisons of life
in order to retain their essence. This is a process familiar
to medicine whereby we insert poison into a living body
in order to make the body knowing of poison and hence
resistant to it. The supreme kind of *Savant* or knower will
become that only after he has passed through malady,
crime, blasphemy. Only then does he reach the Unknown.

Rimbaud is here talking not about knowledge in the
encyclopedic or academic sense, but about the knowledge
of vision, or the surreal. The numberless unseen visions
which exist in each man may be arrived at by a discipline
of the senses, which is a derangement. Implicated in this
theory, very briefly stated in Rimbaud's letter, are all the
mannerisms and methods of the surrealists: automatism,
the subconscious, the dream in an awakened state (*le rêve
éveillé*), intoxication, occultisms, the violation of memory,
paranoiac exaltation. Although far from satisfactory, it is
probably the most lucid statement about surrealism; and

it was made by the young boy of Charleville whom Mallarmé appropriately called *ce passant considérable*.

The passage unquestionably has something to do with the memory of words. It was Bergson, I believe, who said that we are not able to have any single perception without the aid of memory. We don't learn, in any simple sense; we simply remember what we once knew. There seems to be a strong relationship between this doctrine of the soul and its memory, and the first theory about words and the other self. The new order, in the poetic creation, is explicitly this: a word engenders a universe, and then our ideas try to equal or harmonize with the words.

This use of language, which is the most revolutionary aspect of Rimbaud's doctrine, states that language is not a means of knowing, but a means of forgetting ordinary knowledge, a means of losing oneself and discovering one's monstrous nature. Our ordinary knowledge, acquired by what Rimbaud disdainfully calls intellectual progress, maintains us within standard forms, inadequate and insincere regimens of belief and action. The other method, that of losing oneself, is fairly comparable to the method of incantation in religious practice by means of which one arrives at the inexpressible. This is perhaps as close as we can come to defining the anarchical method of surrealism. The sentence, which heretofore had been the expression of logic and order, is now for Rimbaud the new unit for delirium. He expects that this new approach to words will reanimate worn-out poetic methods. Dadaism, between 1916 and 1920, practically excluded language, but the surrealists, who succeeded the dadaists, recalled words banished by other schools and readapted them provided they were magically or mythically used in accordance with this doctrine of Rimbaud.

The important precept of this doctrine or poetic mechanism is, in the creation of a poem, to start with words rather than to start with an object or a sentiment or an

idea. And this rule in surrealism is comparable to the law of the three unities in the classical theatre. It is quite as tyrannical as the older Aristotelian law. There is an enemy to be avoided by surrealists, and that enemy is what we usually designate as reality, an object or a conscious experience which we falsely and clumsily denominate as "real." Rimbaud seems to advocate that we approach words as we would magical recipes. They are self-contained myths, and not contraposed to the words of history or the words of science. They are a unique kind of truthfulness in themselves.

The first important poem of Rimbaud, *Bateau Ivre,* which he was to write soon after the letter of the 15th of May, illustrates his method as outlined in the two statements: 1. *Je est un autre,* and 2. the necessity of becoming a *voyant* and forging a monstrous soul. *Bateau Ivre* begins with this same *Je,* the self who is going to awaken to the surreal part of existence:

Comme je descendais des Fleuves impassibles.

From this first line on, in which the self, the *Je,* is described as a boat going down impassable rivers, the poem is a series of brilliantly arranged words which contain the incoherence of dreams and the madness of thought. At no point in the poem, which contains one hundred lines— and this is its most remarkable aspect—is there any use of language which is not mythical. At no moment in the poem is the imagination forced into familiar and recognizable patterns. One has only to read the first stanza to realize that the key words are not from the real world of Rimbaud, of the town of Charleville on the Meuse River.

Comme Je descendais des Fleuves impassibles,
Je ne me sentis plus guidé par les haleurs:
Des Peaux-Rouges criards les avaient pris pour cibles,
Les ayant cloués nus aux poteaux de couleurs.

No longer borne down impassable rivers,
I tracked the canal to the whim of the haulers:
Naked and spitted to barbarous totems,
The Indian yelpers had claimed them for targets.
(translated by Ben Belitt)

The rivers of the poem are passive and tremendous, scornful of suffering and frustration. The men on the banks are Indians who nail the boat's haulers naked to totem poles.

These words are thrown out as if they came from a dream. The words themselves: *Fleuves, Peaux-Rouges, poteaux de couleurs,* are going to engender the poem. They are going to explode in a series of images, each bolder and more colorful than the last. The drunken boat, the *Je* of the poem, which explicates the *Je est un autre* of the letter, is no mere symbol of Rimbaud the boy and the poet, eager to escape from the oppressiveness of Charleville and the maternal tyranny. It is the self engaging in unknown, mythic experiences. *Il arrive à l'inconnu,* the letter states. It is not only the primitive innocency of childhood, the *verts paradis* of Baudelaire, the memory of those places we know as a child although we never physically visited them. The scenes visited by Rimbaud's boat, as well as those visited by Lautréamont's Maldoror, are domains seen and conquered by a very special poetic method and talent. They come into being as a ransom for the artist's sensitivity and suffering and solitude.

We are accustomed to associating the poet or the painter with the craftsman, the man who has mastered a certain technique. And now, in accordance with Rimbaud's doctrine, we have to associate him additionally with Pygmalion. A craftsman is able to compose a poem, but only a Pygmalion, that is, a sorcerer or a magician, is able to call the image to life. The surrealist poet will have to be a combination of a poet, in the Greek sense—of a man inspired or possessed—and a maker of images in the primitive sense who effects thereby a magical change. We re-

member that the rules of magic, for the most part, involve a special use of words, a practice of incantation, and that the actual words thus used have in many cases no recognizable meaning. But these words, when submitted to a patient and systematic method, work miracles: the sick are cured, the warrior is emboldened, the child ushered into the state of manhood. Every major event of existence— babyhood, the games of childhood, religious practice, love, death—are all carried out and consecrated by a use of language.

Rimbaud's method of poetry, if it is at all clear by these remarks, is not only a very lofty experience, but it is a perilous one as well. It exacts so much destruction, of order and conventionalities, of familiar patterns, and of rules which had seemed indispensable disciplines, that it risks making of the poet a despiser of order, an anarchist in temperament and technique. Rimbaud's ambition is clearly marked in the way and the wake of the *Drunken Boat*, which is quite literally a divorce from the real world. I call this way perilous, because it opens the gates to all kinds of charlatans, of undisciplined writers, of false visionaries. Many weak and ineffectual surrealists have claimed relationships with Rimbaud and have tried to legitimatize their work by appeal to his doctrine. They are examples of artists who, heirs of a dangerous technique, bore false testimony to a poetic method because they never possessed the passion of Rimbaud's soul, nor the inner structure and discipline of his human experience.

In the wake of the *Drunken Boat*, poetry became an extreme experience in spirituality, so extreme, in fact, that some theorists believe that it will replace for modern man, unable to believe as men of other ages have, the religious experience. My personal reaction to this theory is that poetry, rather than replacing religion, will disappear if religious belief disappears. The two experiences are re-

lated: the religious experience the greater; the poetic experience the lesser.

Rimbaud's *Bateau Ivre* is at the confluence of modern poetic rhetoric, as the poem on the subconscious memory, on the other self of man, the unknown self. It is a poem of poles and zones, of tropical flowers, of maelstroms and sea monsters, of a great opening out to the beyond. That opening outward, filled with peril and silence, is the action of the unknown self of the poet. As the opening out to the unknown is the most delirious goal of the surrealist poet, so the opening out to the Absolute or to God is the most delirious goal of the mystic. Poetic belief is concerned with the unknown or the surreal, and religious belief is concerned with the unknown or the supernatural.

These beliefs converge, however, in the goal of both experiences, which is the discovery of unity. Both are opposed to conformity. The purity of the instincts in both poet and mystic urges them away from convention, which always means a separation of self from unity and oneness. The poet Rimbaud believes that the unity of the world has a perfect counterpart in the unity of each individual being. To attain to this unity of being is therefore to attain to the unity of the world. The poem—and we see this poignantly articulated in such a poem as *Bateau Ivre*—establishes the symmetry between the two structures of the world and the spirit. The word of the poet, then, creates the world of his spirit, as, on another level and in accord with another but related belief, the word of God created the world of matter.

IV

In his letter, after defining the other self of the poet, *Je est un autre,* and after defining the method of the visionary, *faire l'âme monstrueuse,* and the visionary's voyage into the realm of the unknown, Rimbaud explains a third part of the poetic experience. This has to do

with what the poet brings back with him from the un-
known, or from the source to which he gained access by
means of sensuous derangements. Rimbaud says that if
what he brings back has form, he gives it form. (*Si ce qu'il
rapporte de là-bas a forme, il donne forme.*) But if orig-
inally, at the source, it had no form, he gives to it a form-
lessness. (*Si c'est informe, il donne de l'informe.*) This
important passage seems to be concerned with the integrity
of the poetic experience. The poet is the translator of his
own truth, of what has been vouchsafed to him from uni-
versal truth and universal language.

In the letter of May 15th, Rimbaud explains the man-
ner in which to read his future work. *Une Saison en Enfer*
is a work of legend, in which Rimbaud consummated a
precious and irrevocable break with verbalisms. After de-
scribing his method at the age of sixteen, he illustrated
it in the writing he accomplished during the next two
years, and went so far in his own method that he couldn't
continue farther. This is one way, perhaps not possible to
authenticate, to explain why Rimbaud ceased writing at
the age of nineteen. The miracle is that at his age, which
is generally a flamboyant highly imitative age for writers,
he wrote, not a literary work, but a legend, the myth of
himself. The word itself, *season,* which is the title of his
last work, is a mythic word, impossible to define with any
scientific or linguistic accuracy. It seems quite appropriate
that the artist should have disappeared behind this myth.

Rimbaud was followed by two sets of hagiographers, two
sets of critics who have tried to claim and explain accord-
ing to their own beliefs this *Season in Hell.* The Catholics
are the first group, who, despite the exigencies and seem-
ing narrowness of their dogma, have written the most bril-
liantly and profoundly about Rimbaud. The second group
of exegetes is the surrealists, both the strict surrealists and
those who approach Rimbaud as essentially a surrealist
writer. Among the Catholic critics, Claudel, one of the

very first, called Rimbaud a mystic in a savage state (*un mystique à l'état sauvage*); Mauriac called him the crucified man in spite of himself (*le crucifié malgré lui*); Rivière went so far as to call him the being exempt from original sin (*l'être exempt de péché originel*). This last interpretation, no matter how one comes to it, either literally or metaphorically, is, I believe, the most illuminating critical statement ever made about Rimbaud. Surrealist doctrine is of course infinitely more difficult to articulate or even to discover than Catholic dogma, and the surrealists seem to have reproached Rimbaud for only one thing (they addressed this same reproach simultaneously to Baudelaire): for having made possible in their writing and in certain acts of their lives a religious explanation.

The Catholic thesis stresses the evolution in Rimbaud from heroism to holiness, and the surrealist thesis stresses the importance accorded the subconscious. But Rimbaud is beyond any one explanation, and the most penetrating critics, both Catholic and surrealist, would accept this. As a living poet, between the ages of sixteen and nineteen, he rebelled against everything. Today his work is rebellious and recalcitrant against any labeling, against any limited categorizing. Critics of all schools, and readers of all ages agree that the human drama contained in Rimbaud is of an unequaled intensity.

The mystically inclined, who see Rimbaud essentially as a prophet, are struck by the theme of general menace which pervades much of his writing: wars, invasions, destruction, deluge, cataclysms. The surrealistically inclined read in Rimbaud a testimonial to the personal pride of the poet as magician, to the renewed myth of Babel and language, of Titans and of Prometheus, the stealer of divine fire. The Catholically minded are struck by Rimbaud's consciousness of good and evil, and place him in company with Pascal, Blake, and Baudelaire. I say good and evil, but I might easily have given their impermanent but con-

temporary equivalents of love and madness. With madness, in our present world, usurping first place. The surrealists believe that the world is led by those whom the world calls insane: Nerval, Hölderlin, Baudelaire, Lautréamont, Dostoievski, Kafka, by all those who have deep memory of time before history.

In the penultimate passage of *Une Saison en Enfer,* the brief section called *Matin,* which Rimbaud wrote in August, 1873, when he was staying at his mother's farm at Roche, on a wind-swept monotonous plateau, he speaks of his ever-present restlessness and need to be off: *Quand irons-nous par delà les grèves et les monts?* And then he speaks, in the mysterious prophetic vein so characteristic of his work, of the two sets of readers who are going to explain his work. To the Catholics, first, he says, *Tâchez de raconter ma chute* ("Try to tell of my fall"); and to the surrealists, next, he says, *Tâchez de raconter mon sommeil* ("Try to tell of my sleep"). And then he signs off, as if for all other readers: *Je ne sais plus parler* ("I don't know how to speak").

Each age is reflected in its poetry. The profoundest study of civilization is in the secret correspondences between life and poetry. Rimbaud may be studied as the poet who turns his back on the city, the poet whose poem is about exotic marine landscapes and whose season is spent in hell, and who thereby explains his age of separation, of exile, of schizophrenia. He revived the myth of the strangest of all exiles, that taking place within words. Rimbaud's exile in words, in the myths protected by words, as the myrtle leaves protect the dead, will culminate in the prolonged exile in words of *Finnegans Wake.*

IV · MALLARMÉ: *the myth (Hérodiade)*

I

On no poem, more than on *Hérodiade*, did Mallarmé expend time, anguish and painstaking care. The poem, or rather the character who gives her name to the poem, was a kind of perpetual muse for the poet. He returned to her intermittently, as to an old fidelity, or at best, as to a well-loved habit, during more than thirty years. Mallarmé composed *Hérodiade* at the beginning of his career, soon after he arrived in the city of Tournon where he occupied his first post as school teacher. At the time of his death, at Valvins, on the Seine, where he spent so many summers, the manuscript of *Hérodiade* was open on his desk and gave evidence to the fact that it was among his last preoccupations.

Mallarmé arrived at Tournon in November, 1863, at the age of twenty-one. The following year, in October, 1864, he announced in a letter that he had begun work on *Hérodiade*. And he spoke immediately of the terror which this enterprise inspired in him, a terror which seemed to spring from the conviction that the language of the new poem must necessarily come from a new poetics. He attempted in this passage of the letter to give a definition of this poetic

theory: *peindre, non la chose, mais l'effet qu'elle produit.*
("To paint, not the thing, but the effect that it produces.")
This sentence, used by Mallarmé to describe the new writing of *Hérodiade,* has served more than almost any other definition, to summarize the art of symbolism, and especially that aspect of symbolism developed by Mallarmé. Thirty-four years later, in a letter written in May, 1898, the year of his death, he described a day of work and in referring to *Hérodiade,* put the matter in the future tense, by saying that the poem will come about gradually and that he is somewhat in possession of himself. (*Hérodiade ira lentement, mais ira, je me possède un peu.*)

Hérodiade is not simply an early poem which Mallarmé recast at the end of his life. It is a poem he lived with or rather struggled with all his life, and it illustrates perhaps better than any other piece Mallarmé's intense love for a poem and the desperate difficulty he underwent in achieving it, in finding for it a form or expression suitable to translate the idea. On one level of interpretation, Hérodiade is a cold virginal princess who stands aloof from the world of men, but she may also represent the poem itself, so difficult to seize and possess that the poet ultimately despairs of knowing it. Hérodiade is therefore both a character whom Mallarmé tried to subdue, and a mythical character whose meaning goes far beyond the comprehension of the poet. She presided over Mallarmé's life as poet in a dual rôle of princess and myth, of character and symbol.

Hérodiade was the poem of Mallarmé's winters. The three years spent at Tournon were among the most painful, in terms of material discomfort, of the poet's life. But they were also the most fruitful in terms of poetic creativeness. His correspondence of the latter part of 1864 is replete with references to *Hérodiade,* but when the winter is over, he abandons work on it for another new poem, more suitable for spring and summer, on the theme of a

faun, which ultimately is to be called *L'Après-Midi d'un Faune*. It is significant that the three major poems of this period: *L'Azur* (written possibly before Mallarmé came to Tournon), *L'Après-Midi d'un Faune,* and *Hérodiade,* all composed during the most abundantly productive years of his career, deal with the same theme of artistic sterility. Whether it be the cold bejeweled princess of the winters or the lascivious faun of mid-summer, Mallarmé is essentially preoccupied with the problem of fertility and birth, with the staggering impossibility of achieving the perfect birth of a poem. No poet, I suppose, has ever been made so completely a prisoner of his own poem as Mallarmé. He became so much a part of the poem that he was always fearful of being unable to project it outside of himself. Mallarmé's love for his own creation tended to obstruct and obscure any articulation he might give to his love. Mallarmé as a poet was in a certain sense the kind of lover who converts the beloved into a mystery and whose silence is adoration.

Mallarmé's life-long preoccupation with *Hérodiade* is significant not only for an understanding of his own poems, but also for the much wider context of modern literature, especially for the entire movement of symbolism and the so-called decadent literature of the latter 19th century, and for surrealism in the 20th century. Mallarmé's princess Hérodiade has an extensive literary genealogy. The year that he began the composition of *Hérodiade,* 1864, he discovered Flaubert's novel *Salammbô,* which was first published in 1862. Salammbô and Hérodiade have the same characteristics of aloofness. Their beauty is mysterious and hermetic. It is shattered or would be shattered by marriage. Midway between the early version of *Hérodiade* and Mallarmé's death, Villiers de l'Isle-Adam, a close friend of Mallarmé, published in 1885-86 his symbolist drama *Axel,* whose leading character Sara bears an intimate affinity with Hérodiade. Sara's death is consummated

in a blaze of jewels and she wills her own death at the moment of marriage when she is on the verge of happiness, because she, like Hérodiade, is a soul seeking to escape from the state of becoming. She, like Hérodiade, and like Hérodiade's most recent descendant, Valéry's Jeune Parque, is a young girl of a philosophical turn of mind, who is anxious to attain the preferable state of being, even if being takes on for her the form of death.

The principal thought on which Mallarmé's poem seems to depend is that expressed at the beginning of the dialogue between Hérodiade and her nurse: the thought that beauty is death. This doctrine, expounded in its most psychological form in Mallarmé's *Hérodiade,* is the culmination of a century of philosophical inquiry, which is usually defined as pessimism. When the beauty of woman, such as Hérodiade's is cold and inaccessible, it summarizes the void of life and hence translates a philosophical concept. The splendor and magnificence of Hérodiade's appearance, as well as Salammbô's in Flaubert's novel, and Sara's in the play *Axel,* symbolize sterility.

This feeling about the void of life is apparent in the very early manifestations of what we call today the romantic movement in Western Europe. Examples are numerous: at the end of the 18th century, the suicide of the young English poet Chatterton, and Goethe's early novel *Werther;* in the first years of the 19th century, Chateaubriand's stories which not only express pessimism about life but also give some of the first illustrations of the lonely and hence sterile beauty of woman. The cosmos, felt as a flux and as an eternal movement in each individual soul who seeks to find stability somewhere else, usually in death, is the subject matter of much of the writings of Nerval, Baudelaire, Flaubert, Rimbaud, Mallarmé, and the surrealists.

The poem *Hérodiade,* a creation of a poet, bears of course a strong relationship to the poet, but its theme

comes not only from Mallarmé but from many of the poets
and thinkers who preceded him. As a human being the
princess Hérodiade opposes the flow and the change of life
by her studied and concentrated frigidity. Her opposition
to normal life and vicissitude is the projection of the myth-
ical rôle of poet which Mallarmé believed in and practised,
of which there exist examples before him in the 19th cen-
tury and which the surrealists will reenact in the 20th
century. I refer to the magical property of the poet, to his
function of hierophant, of priest and miracle worker. The
poet feels all the cosmic vibrations and changes of the
world, but establishes outside of them, by means of his art,
which is the alchemy of language, a reality which by its
durability is a denial of flux and change.

The word *magical* as applied to an artistic creation seems
startlingly new in the 19th century. The poet holds the
secrets of his creation. He is the new dealer in occultism
or hermeticism. Hugo considered himself the *écho sonore*
of a world not heard by ordinary ears, of a supernatural
world not submitted to the logic of a changing world. For
Mallarmé, and, to a lesser degree, for other poets of the
century, there is a point where poetry passes into the realm
of the unexpressed. In *Hérodiade* he seems to leave poetry
just on this side of that point. But in Mallarmé's final
poem, *Un coup de dés,* it is quite possible that he takes
poetry over into the realm of the unexpressed or the inef-
fable and hence creates in a very absolute sense a surrealist
poem. But the method and principle of surrealism may be
more easily studied and apprehended in such a poem as
Hérodiade.

In considering the main function of the poet as that of
magician or symbol-maker, Mallarmé was giving to the
symbol an occult power very close to the mystical power
of the Word or the Logos. Baudelaire in his doctrine of
Correspondances had stressed the spiritual reality of the
physical world and hence the spiritual reality of the sym-

bol. In this doctrine, Baudelaire was perpetuating the lessons of Swedenborg's *Arcana Coelestina*. Novalis also had taught that the poet sees the invisible and feels the suprasensible.

This definition of the poet's function, which has sometime been called *angelism*, because in it the poet withholds his secrets, places him in a category comparable to that of the priest, and therefore to the type of individual who is isolated from society, who serves society in his isolation, in his hieratic calling. Nietzsche has said that all poetry is originally hieratic.

Thus poetry becomes one of those activities of the human mind whose nature and purpose are spiritual. The poet finds himself, by the mystery of his vocation, the guardian of creative secrets, in much the same way that Hérodiade wills to make herself into the guardian of her own being. The man who is engaged in the alchemy of his own language, like the princess who is engaged in the benumbing of her senses and emotions, is a poet not only in the creation of his own world, but in the creation of his own divinity as well. The poet in this sense is both priest and god. Here culminate the romantic dream and the romantic temperament. Rousseau had once described this quietistic state of being when nothing exterior to self exists, when one is sufficient unto oneself as God is. The modern poet has revindicated his ancient rôle of Prometheus and Orpheus, of fire-stealer and mystical singer. He learned once again, during the century that was copiously consecrated to the definition of the philosophy of science, the meaning of divine madness which Plato had once used in characterizing the poet.

Poetry's esoteric principle was explored by Stéphane Mallarmé and incarnated in his princess Hérodiade. The three leading aspects of this principle, angelism, hermeticism, and narcissism, are also the three leading characteristics of the princess. Angelism seems to signify that the poet

creates his own world and lives within it. This would cor-
respond to Hérodiade's desertion of the world, her return
to the tower, and her isolated existence. Hermeticism is
on the one hand the secret meaning of poetry, jealously
guarded by the poet, and on the other hand the magical
practices of Hérodiade or even the ritualistic manner of
her life. Finally, narcissism, by far the most significant and
most obscure of the three aspects of the esoteric principle,
is a required attitude of every poet who is himself the sub-
ject of his poetry, and is revealed in Hérodiade's words
addressed to her mirror.

II

The poem, as it appears in the most
recent editions of Mallarmé's work, is in three parts: an
overture, *Ouverture Ancienne;* a dialogue between Héro-
diade and her nurse, called *Scène,* which is the main part
of the poem; and a short detached lyric spoken by St. John
the Baptist, called *Cantique de saint Jean.*

The overture was written after the first version of the
dialogue, during the years 1865-66, when Mallarmé was
still in Tournon, but it was never published during the
lifetime of the poet. The poem, which is ninety-six lines
in length, remained among his papers and manuscripts
until long after his death when his son-in-law and literary
executor, Dr. E. Bonniot, published it in the *Nouvelle
Revue Française,* in November, 1926. The entire piece is
spoken by the nurse as a kind of incantation. It serves to
set the scene for the subsequent dialogue. The nurse talks
about what she sees from the tower. First, the landscape,
which is desolate under a dawn now abolished. *Abolie* is
the first word of the poem. It had been used previously in
the hermetic poetry of Gérard de Nerval, and was to be
used by Mallarmé in seven important passages. The dawn,
once golden and red, is now abolished or pallid, and has
chosen for its tomb the tower where the nurse awaits the

return of Hérodiade. There is the suggestion that the tower had been used by Hérodiade for propitiatory or occult practices, and its present abandonment has spread to the autumnal scene of the landscape. The room and the bed appear empty to the nurse. She wonders if the voice she hears is her own or the empty echo of some voice of the past. Everything is funereal and tenebrific and monotonous. The nurse refers to the young girl exiled in her precious heart—an early very direct allusion to Hérodiade's narcissism—but especially accumulates words of an esoteric import: prophecy, dreams, stars, books of magic. The dominant theme is the emptiness of the present. The setting and the repetition of certain words are reminiscent of Poe. The mood is built up for the strange dialogue which follows.

The cry of the nurse announces the return of Hérodiade. The older woman bends down to kiss the rings of the princess, but Hérodiade, who is to spurn everything, wards her off. In order to explain why a kiss would kill her, she speaks instantly of her blond hair which, immaculate, is the symbol of her immortality. In its fire and light, her hair is opposed to the principle of her cold body. She has just come in from a morning whose splendor is now dying (this theme was announced in the *Ouverture*), in order to be again with her nurse of the winters (*ô nourrice d'hiver*). She had been able to walk among the lions unharmed (according to legend they are respectful of virgins) as if they had represented the dangers of the outer world or the menaces to the integrity of her being. The reminiscences of the world, which she has left, are not in herself but in her hair which she asks the nurse to comb indolently before a mirror:

> Aide-moi
> A me peigner nonchalamment dans un miroir.

Her hair imitates the wild manes of the lions and the brilliantly jeweled light of the sun. The beauty and violence of the world have left her intact, but they have been reflected in her hair. She rejects all perfumes because she wishes her hair to resemble not flowers nor the languishing odor of flowers, but gold and the sterile coldness of metals. As a young child her hair reflected the iron weapons and bronze vases of the tower, and now as a virgin princess it must reflect the light of precious gold and jewels.

When the nurse holds up the mirror before her, Hérodiade's actual words addressed to it are very brief, but their meaning pervades the rest of the poem. Deep in the mirror, as in a black hole, she has searched hours on end for her memories and appeared to herself as a distant ghost. On certain evenings, when the mirror resembled an implacable fountain (at this point it is obvious that the myth of Hérodiade is joining with the myth of Narcissus), she realized the bareness or the reality of her dream: *J'ai de mon rêve épars connu la nudité!* Here she interrupts her speech by asking the nurse if she is beautiful. The nurse compares Hérodiade to a star, but when she extends her hand to raise up part of the princess' hair which is falling, Hérodiade turns violently on the woman and accuses her of sacrilege in trying to touch her. This is the third crime the nurse has almost committed: first, the kiss on the hand and rings; second, the offering of the perfume; and finally the attempt to touch Hérodiade's hair. For the princess these constitute three forebodings of disaster for this day in the tower.

The second part of the scene begins when the nurse insinuates that Hérodiade must be waiting for some hero, that she must be reserving her being and her purity for some man. Hérodiade's answer to this insinuation, which is an ironical hope of the old nurse, constitutes the longest speech of the scene. It is a kind of aria in three parts con-

taining the psychological explanation of her life and voca-
tion. It begins like an aria with a line of strong narcissistic
import:

Oui, c'est pour moi, pour moi que je fleuris, déserte! All
the themes, heretofore partially announced, are now com-
mingled and made specific in this aria, which Hérodiade
sings not merely to the nurse, but to the world, or at least
to the public in the theatre where she is performing the
scene. Mallarmé's initial project was to compose a play on
the theme of Hérodiade and in this monologue there is
something of the rhetoric of the theatre. This element of
drama was strong enough to permit Martha Graham to
compose a dance on the poem and the composer Paul Hin-
demith to write a musical setting which follows closely
each line of the poem.

Hérodiade is flowering for herself, not in the usual kind
of garden, but in a garden of amethysts and precious
stones. Her beauty is like the hidden beauty of jewels deep
in the earth which contain the ancient secrets of the world.
The first part of the aria describes the beauty of Héro-
diade's eyes and hair as essentially a sterile beauty. Her
eyes are like pure jewels and her hair is fatal and massive
because it reflects the color of metal. Jewels and metal,
originally buried in the earth, are as sterile and useless as
the eyes and hair of Hérodiade concealed in her tower
away from the world of men.

> Oui, c'est pour moi, pour moi, que je fleuris, déserte!
> Vous le savez, jardins d'améthyste, enfouis
> Sans fin dans de savants abîmes éblouis,
> Ors ignorés, gardant votre antique lumière
> Sous le sombre sommeil d'une terre première,
> Vous pierres où mes yeux comme de purs bijoux
> Empruntent leur clarté mélodieuse, et vous
> Métaux qui donnez à ma jeune chevelure
> Une splendeur fatale et sa massive allure!
> Quant à toi, femme née en des siècles malins

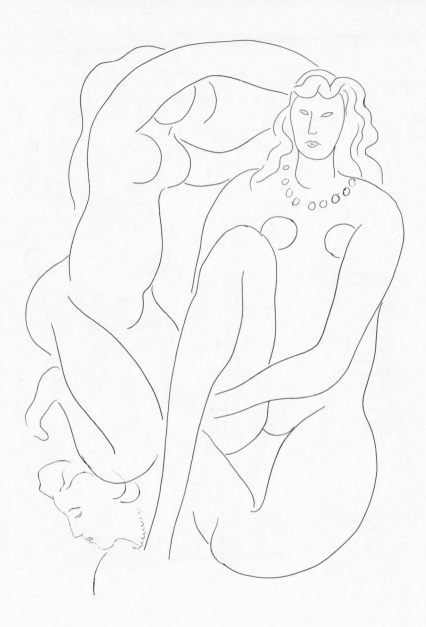

TWO NUDE GIRLS *by Henri Matisse. Illustration for Mallarmé's* Hérodiade. *Art Institute of Chicago.*

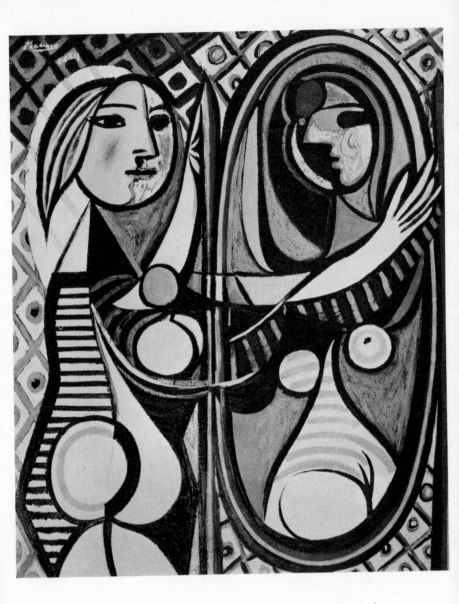

GIRL BEFORE A MIRROR *by Pablo Picasso. Museum of Modern Art.*

Pour la méchanceté des antres sibyllins,
Qui parles d'un mortel! selon qui, des calices
De mes robes, arôme aux farouches délices,
Sortirait le frisson blanc de ma nudité,
Prophétise que si le tiède azur d'été,
Vers qui nativement la femme se dévoile,
Me voit dans ma pudeur grelottante d'étoile,
Je meurs!

Yes, it is for me, for me, that I flower, alone!
You know it, amethyst gardens, buried
Endlessly in learned dazzling abysses,
Hidden golds, keeping your ancient light
Under the sombre sleep of a primordial earth,
You stones wherein my eyes like pure jewels
Borrow their melodious light, and you
Metals which give to my young hair
A fatal splendor and its massive form!
As for you, woman born in wicked centuries
For the evil of sibylline caves,
Who speak of a mortal! according to whom, from the
 chalices
Of my robes, aroma of fierce delights,
Would come forth the white trembling of my nakedness,
Prophesy that if the mild azure of summer,
Toward which natively woman uncovers herself,
Sees me in my shivering shame of a star,
I die!

The awesomeness of Hérodiade's virginity is the theme
of the second part. Her chastity burns with the same pallor
that the snow casts against the night outside.

J'aime l'horreur d'être vierge et je veux
Vivre parmi l'effroi que me font mes cheveux
Pour le soir, retirée en ma couche, reptile
Inviolé sentir en la chair inutile
Le froid scintillement de ta pâle clarté
Toi qui te meurs, toi qui brûles de chasteté,
Nuit blanche de glaçons et de neige cruelle!

I love the horror of being virgin and I wish
To live in the terror which my hair gives me
So that at evening, lying on my bed, inviolate
Reptile, I may feel in my vain flesh
The cold scintillation of your pale light,
You who die, you who burn with chastity,
White night of icicles and cruel snow!

The night, which is cold and dead, is called the eternal
sister of Hérodiade.

Et ta soeur solitaire, ô ma soeur éternelle
Mon rêve montera vers toi: telle déjà
Rare limpidité d'un coeur qui le songea,
Je me crois seule en ma monotone patrie
Et tout, autour de moi, vit dans l'idolâtrie
D'un miroir qui reflète en son calme dormant
Hérodiade au clair regard de diamant . . .
O charme dernier, oui! je le sens, je suis seule.

And your solitary sister, O my eternal sister
My dream will mount toward you: such already
Rare lucidity of a heart which dreamed it,
I believed myself alone in my monotonous kingdom
And everything around me lives in the idolatry
Of a mirror which reflects in its sleeping calm
Hérodiade with her clear diamond gaze . . .
O last charm, yes! I feel it, I am alone . . .

This is the third and last movement of the song in which
a fusion takes place between the sterile night and the ster-
ile image of Hérodiade in the mirror. The poem at this
point reaches culmination in its inner action whereby
Hérodiade attains to a oneness of being, to a vain state of
beauty in her monotonous kingdom.

It is narcissism pushed one degree farther than the limit
which Narcissus reached. Whereas the adolescent in the
Greek myth was content with watching in the mirror-
fountain the reflection of himself and in the reflected traits

the world he loved and the being with whom he wanted
to unite himself, Hérodiade represents the other sex, the
narcissism of woman. She seeks to establish not merely soli-
tude and her reflection in a mirror, but an absorption of
her being (of her beauty and her chastity) with the mate-
rial world. In order to know the secret of existence, she
wants to be as closely absorbed in the cosmos as the dia-
mond is one with the earth in which it is embedded.

Every theme in Hérodiade represents some aspect of
night: the literal fall of night outside the tower which
covers the monotonous landscape of approaching winter;
the night inside the tower; the night of necromancy and
dark magical rites; the perpetual night inside the earth
where the jewels and the metals sleep; the night of the
mirror which is like a black hole into which Hérodiade
looks in order to see all the remembered and forgotten
memories of her life; and the final night of the reflection
in which Hérodiade's being becomes useless and sterile.

From these various aspects of the night theme we are
led to realize that the poem of Mallarmé involves a vaster
and more profound myth than the simple story of Narcis-
sus. It might be called the myth of self-destruction which
lies at the core of every human being and which the prin-
ciple of life and the principle of religious belief are con-
stantly trying to submerge or conquer or forget. The myth
of self-destruction is more closely associated with us than
we willingly acknowledge. It seems to be an important ele-
ment of many of the so-called principles of life, such as
birth, love, love of God, artistic creation. In order to ac-
complish anything, we have to destroy ourselves to some
degree. *Hérodiade,* which we are considering a mythical
poem, is a symbolic or even choreographic expression of
an impulse which is deeply and natively human. Mal-
larmé's princess wills to become an image of herself, un-
real and untouched, as each man wills, in his solitude of

sleep or love or work or prayer, to become more one with the principle of his being, more harmoniously or intimately himself.

What we have called the principle of self-destruction in the poem *Hérodiade* might justifiably be named the principle of transformation or metamorphosis. The eyes and hair of Hérodiade are not only compared with jewels and metals but also seem to be converted into the inert material world. One remembers the suicides in Dante's *Inferno,* canto 13, whose bodies have been metamorphosed into tree trunks and one may well be struck by the analogy between Hérodiade's desire for material immobilization and the Dantean punishment accorded to the sin of suicide. Once in the Mallarmé poem Hérodiade compares herself with an inviolate reptile (v. 105-106). This is a further allusion to transformation which also has its counterpart in the *Inferno,* in the circle where thieves are punished by having their bodies changed into snakes or fused with the body of a snake.

If the deepest aspect of this will or action on the part of Hérodiade is self-destruction, a more immediate aspect is the desire to know oneself and the world, to know the unity of self and the world. During the past one hundred years, and even slightly more if we include works of prose, poetry has been submitted to a philosophical use. The romantic period in the first half of the 19th century, the symbolist period in the second half of the 19th century (at the beginning of which *Hérodiade* sets the décor and introduces the principal vocabulary), and the surrealist period in the 20th century, might easily be considered as one literary period or one artistic movement characterized and unified by a unique philosophical preoccupation. *Hérodiade* stands therefore midway between the *Correspondances* of Baudelaire and the activities of the surrealists in the 1920's and 1930's when experimentation is pushed very far in studying the relationships between man

and the material world, when the figure of man and objects in the purely material world are commingled in dreams and artistic creations. In the surrealist period the meaning of man and of his existence is deliberately confused with the meaning of art. Never was so much demanded of art and poetry, in terms of knowledge and philosophy, as in the surrealist period. Hérodiade stands as a figure on the threshold of surrealism. The poem is an initiation not so much to the methods of surrealism as to the goal of surrealism. We have seen Mallarmé's princess partaking of the material and the spiritual worlds, joining them, and thus explaining them and the unity which binds them. The action of Hérodiade does not merely involve a fusing of subjective and objective elements, but much more than that, an attainment to surreality, in a literal sense. She enters a domain above or apart from the real world.

III

No such figure as Hérodiade can exist alone. She must have ancestors and descendants. When related to them, she loses some of her enigmatical character. She is not fully explained by them (no mythical figure is ever fully recognizable) but they help to localize and situate her in relation to our own changing world and our paltry understanding of it. Her immediate ancestors are women created by the romantic temperament and by romantic artists, and her descendants are to be found in the works of the surrealists: in books like *Naja* of André Breton and in certain paintings of women by Picasso.

A first clue to Hérodiade's ancestors might be in the romantic equation of beauty and death. We saw how Hérodiade and night were fused as sisters in Mallarmé's poem. Beauty and death would be the equivalent abstractions used constantly by the romantics, or at least, on a more elementary level, beauty and sadness. It is quite

possible that in the myth of woman the most important factor is the proximity or simultaneity of beauty and sadness. Beauty of woman is real for man only when it is imperiled, threatened with dissolution. The sentiment of the beautiful generates immediately the sentiment of melancholy. Chateaubriand has taught us that when we look at nature, at an exotic landscape, we experience both exaltation and melancholy. As pleasure and pain are inseparable, so any intense knowledge of the beautiful is synthesized with a knowledge of suffering. In many poems of Baudelaire, such as *Hymne à la Beauté,* and throughout his personal journals, we read of the inevitable commingling of voluptuousness and sadness.

The implacable cold beauty and virginal aloofness of Flaubert's Salammbô and Mallarmé's Hérodiade would not have been celebrated soon after 1860 if this type of woman-goddess had not been preceded by the type of fatal or persecuted woman. The Medusa head is an example of beauty allied with the repulsive, and there persists an element of the Medusan beauty in the countless examples of beauty allied with physical suffering and torture in the late 18th century and early 19th century heroines. Examples might be chosen from both good and bad literature, and from all countries: Gretchen in Goethe's *Faust,* Atala in Chateaubriand's novel, Antonia and Agnes in Lewis' novel *The Monk,* Mrs. Ann Radcliffe's tales of terror, especially *The Italian,* the Marquis de Sade's stories, such as *Juliette* and *Justine,* where voluptuousness is achieved in scenes of crime and destruction.

This theme of crime and perversion, associated with love and the beauty of woman, is not only an important background for such a poem as *Hérodiade,* but it is also a theme renewed and recapitulated by the surrealists, although not perhaps in their major works. In fact, what has been called the attraction of the horrible and the monstrous in surrealist art is not so apparent or so strong as

that in the early and post romantics. The urge to commit
a crime or a mortal sin in order to discover in it an innate
element of beauty is more easily studied in Sade, Baude-
laire, and Dostoievski, than in Breton, Eluard, and Desnos.
In Flaubert's *Tentation de Saint Antoine,* there is a closer
identification of lust and death than in the writings of
Lautréamont. The richest documentation on the study of
beauty as springing from the paradoxical source of horror
and suffering would be, first, in the poems and prose of
Baudelaire; that is, in the example of his poems and the
critical judgments and exegeses of his prose writings; and,
second, in the paintings of Eugène Delacroix whom Baude-
laire admired so unreservedly. Beauty, on the canvases of
Delacroix, is almost always translated in terms of frenzied
action and scenes of sadism. Baudelaire, in his poem on
painters, *Les Phares,* in the stanza on Delacroix, calls him a
"lake of blood" (*lac de sang*). Delacroix illustrated some
of the more terrifying scenes of Goethe and Byron, and
chose as subjects for his paintings: the interior of harems,
or drowned Ophelia, or the sack of Constantinople. In the
many names with which Baudelaire apostrophized his
mistress, Jeanne Duval, we begin to see the transformation
from fatal woman or suffering heroine to the type which
culminates in Hérodiade: tigress, cruel beast, demon,
vampire, frigid idol, black Venus, Amazon. Jeanne is
feared by Baudelaire, almost as if she were a Clytemnestra,
who, like the women of Lesbos, murdered her husband.

The evolution from early and late romanticism to such
a work as *Hérodiade* marks the shift from the drama of
sadism, as illustrated in such writers as the Marquis de
Sade, Baudelaire, and Lautréamont, to the drama of oc-
cultism, as illustrated by Gérard de Nerval, Villiers de
l'Isle-Adam, Mallarmé, and Huysmans. These two dramas
cannot be fixed chronologically. Lautréamont, for example,
wrote his sadism-permeated cantos after Mallarmé had
composed his first version of *Hérodiade.* However, the

drama of hermeticism seems to succeed in time the drama
of sexual violence, although there always remains an ele-
ment and a memory of sadism in occultism. These two
words might easily be translated by the Nietzschean terms:
Dionysos and Apollo. Nietzsche's work, *The Birth of
Tragedy,* which states that art contains something of both
the Dionysian and Apollonian strains, was first published
in Leipzig in 1872, just three years after the first appear-
ance in print of *Hérodiade.* The terms we have been using
of sadism and occultism seem to be narrowed and particu-
larized synonyms of what Nietzsche means by Dionysos and
Apollo. They represent two traits of distinction or dis-
tinctiveness by which the writer is able to isolate himself
from the rest of society: first, as a psychological man whose
instincts seem shocking and reprehensible; and, second,
as artist whose work is difficult to understand. The artist-
Dionysos is the reprobate and pariah in terms of bourgeois
society, such as Baudelaire and Rimbaud. The artist-
Apollo is the priest and guardian of creative secrets, such
as Mallarmé and André Breton. In *Hérodiade* it would be
possible to point out elements of sadism, as well as the more
obvious elements of occultism and the general romantic
temperament, but all these elements appear conventional-
ized and disciplined. Mallarmé has condensed in a single
poem much of the literary and artistic efforts of a century.
He has, therefore, in a certain sense applied a classical
method to romantic traits and themes.

In the Gothic tales and the so-called "romans noirs" of
Sade, Lewis, and Radcliffe, the heroine or the beautiful
woman is treated as victim. The scenes of orgy and destruc-
tion show her as a kind of sacrificial victim and the means
by which man's passion and frenzy are aroused. But, as it
often occurs in the evolution of religious practice when
the victim becomes god, so in this literary evolution the
victimized or fatal woman of the romantics becomes a
goddess in such a work as *Hérodiade.* The art form in

which she appears is so placid and bejeweled that it re-
sembles Byzantium art and is often referred to by the term
Byzantianism. Hérodiade in her final state attains to a
closed metallic useless perfection. The words of the poem
take on something of the vain beauty of jewels. The hair
of Hérodiade as the symbol of a cold and golden treasure,
becomes a commonplace in literary symbols of the latter
19th century. It was a facile transcription of the psycho-
logical moment when the dream about life had succeeded
in exhausting the impulse to live.

The exoticism of such a state of mind as well as the
simple exoticism of Hérodiade's appearance are types very
easy to confuse with mysticism. At best, Hérodiade's might
be called a mystical exoticism since it takes her outside the
actualities of time and space. This will be a goal repeatedly
announced and described by the surrealists. Whereas the
real mystic seeks to move outside the world in order to
unite with Divinity, Hérodiade's exotic goal appears much
more narcissistic, more closely allied with the enigmatical
and androgynous mystery of Leonardo's *Gioconda,* cele-
brated by Walter Pater, and with the psychic powers of
Keats' *La Belle Dame sans Merci.*

> I saw pale kings, and princes too,
> Pale warriors, death-pale were they all;
> They cried—'La Belle Dame sans Merci
> Hath thee in thrall!'

The shift from Baudelaire's Jeanne Duval, called ti-
gress and vampire, to Mallarmé's Hérodiade, virgin and
priestess, is paralleled in the shift from Delacroix' paintings
of women to Gustave Moreau's. After the fiery drama of
Delacroix' oils we come to pictures of a cold static state in
Moreau. Mario Praz in his book *The Romantic Agony* has
pointed out how Moreau worships his subjects from out-
side, how they are all ambiguous and androgynous figures,
as Hérodiade is.

Huysmans in his novel, *A Rebours,* imagines that his hero, des Esseintes, acquires two paintings of Moreau: one, *Salomé,* in oil, and the other, *L'Apparition,* in water color. These two paintings depict the two aspects of woman emphasized by the romantic and decadent movements of the 19th century. In the water color, *L'Apparition,* Salomé is cowering half-naked and horror-struck before the severed head of John the Baptist. In the oil painting she appears as a symbolic deity, reminiscent of ancient Helen, and holds in her hand a Lotus flower, the Egyptian and Indian symbol of fertility. Mallarmé uses for Salomé her mother's name because she is the woman who has conquered terror, who incarnates at the beginning of the modern world female beauty and cruelty, and who thus perpetuates a particular myth of woman which had been fashioned earlier by the Sphinx, by Pasiphaea, Leda, Europa.

The same character, in Mallarmé's own time, was treated by Flaubert and Laforgue and Oscar Wilde as well as by Richard Strauss in his opera. But Mallarmé's creation is more significant psychologically. It is, in a sense, a synthesis of the entire symbolist and decadent movement in art. His Hérodiade, a kind of Emma Bovary become priestess, represents the anguish of loneliness. One idea dominates Hérodiade: the triumph over all her longings, the effort to make of herself a human star (*un astre humain*). In Picasso's painting of 1932, *Girl before a mirror,* we have an example in painting of what Mallarmé did in poetry: a psychological or even surrealist portrait of an hysterical girl overcome by a kind of hieratic indolence. Mallarmé's *Hérodiade* and Picasso's *Girl before a mirror* both speak to the mirror as if they are speaking to the stars and to the void.

V · APOLLINAIRE: *the poet*

I

Prophet-like, Rimbaud, during his life as poet, existed quite alone and separated from his age. Guillaume Apollinaire is another type of writer, solidly a part of his age, and so integrated with a group of artists that his work has been somewhat overshadowed by a period. He was so flamboyantly the initiator and spokesman of a period, the first decade and a half of this country, that it is difficult to think of him as an individual writer. His close friend Max Jacob once jokingly referred to "Apollinaire's century" (*le siècle d'Apollinaire*). The joke indicates the rôle of leader he played in the Paris art circles. He dominated his age and his friends, investing them with his sense of life and vigor and humor, and thereby diminished, without wishing to do so, perhaps, the importance of his poetry. Apollinaire became, first, his century, and then, one of the poets of his century.

For Paris, he created out of himself such a legendary character, ubiquitous and colorful, that this self-made legend became more important for his friends and contemporaries than the verse he published. He was preeminently the character in Paris: the impassioned and

Bohemian artist who spoke volubly and wittily on art and
any other subject; the exuberant and affectionate friend
who was seen everywhere: in the offices of newspapers and
publishers; at the Bibliothèque Nationale looking up some
erudite subject, because he earned money as ghost writer
for eminent professional authors; along the quais where
he walked endlessly and untiringly; in the various cafés
frequented by his friends. And always, no matter where he
was met, an article or a poem, unfinished, was stuffed into
his pocket. The excessively lived character of Guillaume
Apollinaire has always made it difficult for critics, those
who knew him and those who came after him, to look at
his work. It has encouraged everyone to consider the legend
of the man. The real fantasy of Apollinaire, however, is
that of his work, to which we shall come. But first, since it
is inevitable and unavoidable, a word about the fantasy of
his life and his personality.

His life was like a brilliant reign. In many ways he was
comparable to an artist-monarch, both real and symbolic,
whose energy and humor formed in Paris for ten years a
veritable art-civilization. And yet the elements of this
life-reign seem to be a curious mixture of tragedy and
caricature-burlesque, of mystery and childlike naïveté.

He was born in Rome on the 26th of August, 1880, not
with the name Guillaume Apollinaire, but rather Wilhelm
Apollinaris de Kostrowitsky. His mother seems to have
been Polish, but actually she is just as mysterious as her
son in everything that concerns accuracy of biographical
detail. The darkest mystery in Apollinaire's life is his
father. Some claimed that his mother once said he was an
Italian officer, but most friends of Apollinaire believed
the father was a prelate in Rome, and quite probably a
cardinal. A few even insisted, somewhat maliciously, that
he was the pope himself. Such obscurity of birth is an as-
sured beginning of legend, and Apollinaire's friends made
the most of it. Picasso, who made many portraits of Apol-

linaire, shows him in one, clothed in a bishop's vestments, a mitre on his head, a bishop's staff in one hand, and the pastoral ring on the other hand. Investigations of the Polish-Lithuanian background have tried to prove that the ancestors were noble and warlike, and thereby explain Apollinaire's bravery and love of duels.

His mother was very rarely present in his life. The boy received a Catholic education, first at the Collège de Monaco, then at Cannes, and then at Nice. This Mediterranean climate was his first, where he developed a nostalgic predilection for ancient civilizations and for varied kinds of exotic cooking. By eighteen, when he completed his studies, he was independent, and came to Paris where he secured employment as a bank clerk. He became almost immediately the friend of many young artists and writers who were to become later leading figures in the French capital: André Salmon, Picasso, Paul Fort, Vlaminck, Max Jacob, Marie Laurencin, Jarry. Apollinaire depended upon the continual presence of his friends. His close friends were always worried about the ease with which Apollinaire talked with strange and sometimes dangerous characters in the streets or cafés, and his habit of bringing them home with him to continue endlessly whatever conversation was underway.

With his earliest friends, André Billy and André Salmon, he began his literary career of journalist, art critic, and poet. Apollinaire always seemed to become leader and animator of the various groups of artists, of the "cénacles poétiques," which met at the favorite cafés: la Closerie des Lilas in Montparnasse, the Lapin Agile in Montmartre, the Bateau Lavoir of the rue Ravignan where Picasso lived and where he received his "Bohemian" friends. Apollinaire protected and encouraged the painters. Two, especially, owe him a great deal in the rôle of publicist and personal encourager: Rousseau le douanier and Marie Laurencin. Apollinaire participated in innumerable and

ephemeral art-literary magazines. Three were more or less
founded in his honor, one of which, *Les Soirées de Paris,*
appearing between 1911 and 1914, contains many precious
documents for any historian of the period.

The year 1908, which was exactly ten years after Apol-
linaire's first arrival in Paris, might conveniently be taken
as the time when the new century had begun, when new
forms of art and new philosophical forces had replaced
much of what we consider 19th century art and thought.
Inspired by Bergson's lessons on the primacy of intuition
and dreams, artists were looking for a more "real" world
than the exterior world. The music of Debussy and jazz
music, the nostalgic quality of the "blues" and the exciting
rhythms of Negro rag-time music, were affording a kind of
irrational remedy for much that was considered worn-out
and dated in 19th century art forms. The canvases of Pi-
casso and the poems of Apollinaire at this time were con-
cerned with a series of strange "saltimbanques," of clowns
and acrobats who represented pictorially and metaphysi-
cally a defiance of common sense. The ballets russes were
providing a vast caricature of the period in their buffoons
and multi-colored marionettes. Petrouchka was the hero
of the age, half-comic, half-tragic, half-real, half-surreal.

The kingdom of the poets extended from the Café des
Deux Magots on the Boulevard St. Germain to the Boule-
vard Montparnasse, and throughout it reigned a curious
form of *inquiétude* or restlessness or subdued pessimism,
often projected in a tense staccato kind of gaiety. The
poets drank and smoked and quarreled in an atmosphere
of cynicism and witticism, the very kind of atmosphere
which serves as cloak and disguise for the deepest feelings
of uprootedness and dereliction.

Apollinaire grew out of this atmosphere and created it
at the same time. He became the critic of painters, the
exponent especially of cubism, which is the most calculated
and mathematical of all arts, the most barren of incident

and story and representation. Apollinaire's love for cubism is in striking contrast with his own poetry, so irrational by nature and definition, so suffuse with its subdued and fragmentary narrative quality. One thinks instinctively of Delacroix' love for Mozart, of the strange principle whereby an artist harbors within himself opposing loves and dreams. It almost seems that a great artist creates his art only by opposing a whole side of his nature, by disciplining and castigating a rich instinct and love of his nature. Apollinaire was a thinker, a critic, almost a philosopher for an entire generation of French artists, for a period that was truculent and unruly, fascinated by the early films of the cinema and the movie-characters of mechanical Petrouchka-like gestures.

He was for his age both sorcerer and legend. His curiosity over things of the spirit was as closely followed as his love for good food, for the various national cuisines: Provençal, Chinese, Jewish, Spanish, Russian, Arabian, Greek, Polish, Turkish. Highest in his estimation were Italian and French cooking. Lowest was the British with its monotonous red meat. He liked almost everything from fried onions and *petits fours* to goulash with paprika. In September, 1911, when the *Mona Lisa* was stolen from the Louvre, Apollinaire was accused of the theft and put in prison for six days, at the end of which he was found to be innocent and released.

In 1914, he joined the French army. He wasn't a French citizen and hence not mobilized. I suppose there was no single motive for this act. It was perhaps love for his adopted country, or desire for adventure, or belief that he would be able to reenact the legend of war. He was seriously wounded in March of 1916, by a piece of shell which struck his head. He underwent two operations, two trapanations, and his appearance in Paris afterwards, with his head heavily bandaged, provided a final chapter for his legend. Picasso made another drawing of him in this

ultimate disguise. He became literally the "star-head poet," (*le poète à la tête étoilée*). In late October, 1918, he fell sick with grippe, and died a few days later, on the 9th of November. On the day of the Armistice his body was being carried through the streets of Paris in the direction of Père Lachaise, while the crowds ironically were shouting his name Guillaume, *Conspuez Guillaume,* but meaning by it the German Wilhelm.

II

The story of his life was the effort he made to guard secrets and mysteries, and to create for his friends and his public a character whom they would love and yet not know too intimately. The buffoonery of his character, his endless anecdotes and pranks, permitted him to conceal or disguise the nostalgia and sadness and even perhaps the tragedy of his life. But the poetry of Guillaume Apollinaire is not mask and deceit. It is fantasy in the deepest sense of the word. It is lawful fantasy: its images rightfully conceal and communicate at the same time the emotions he experienced.

His poetic fantasy was, first, that of revolt, by which he always remained precious and close to the surrealists. He broke with the familiar patterns of thought, with the poetic clichés and literariness of the Parnassians and Symbolists, and with the familiar units and rules of syntax. His poetry comes together in a great freedom of composition, as if he allowed the images and emotions to compose themselves. In his poetry, phantoms, wanderers, mythic characters bearing sonorous names, appear and disappear as the laws of syntax and prosody do. His verse is not literary in any strict sense, and in that, he marks a revolt against the poetic research and endeavor of the entire preceding period. He didn't read the obvious books that were being read in his time: Stendhal, Zola, Whitman, Rimbaud (although he was decidedly influenced by Rimbaud). But

he read *Fantômas* avidly, which was a series of popular detective-mystery stories.

It was quite appropriate that Apollinaire, coming after the highly self-conscious and studied literary school of symbolism, would, in rebellion against such artifice, seek to return to the most primitive sources of lyricism. I have a feeling that only because such a fully developed literary tradition was in him, as a part of his background, was he able to allow in his verse the seemingly spontaneous mixture of emotion and irony, of nostalgia and cynicism. Both by the form and content of his poetry, he seems to be making a kind of plea or defence for moral disorder, or moral relaxation. The adventure of Apollinaire, if we were to extract such a subject from his work, would closely resemble the adventure of Gide: the lessons on freedom and gratuitousness and individual morality, which were being formulated at the same time. Apollinaire thus prolongs the lesson of Rimbaud and Mallarmé, in considering poetic activity as a secret means of knowledge, self-knowledge and world-knowledge.

A legitimate part of poetry must therefore come from hidden occult forces in us. To seize them, or to cause them to rise up, we may have to set traps: play the fool, enact farces, experiment with chance and free association. The image may be seen in its full autonomy when we risk everything in poetic composition on the unpredictable, the unforeseen. Magic exists everywhere around us, and not solely in the artfully contrived. It is unexpectedly found in the trivial and commonplace. Poetry is perhaps the opposite of literature. The poetic is perhaps the opposite of the formalized.

In all this aesthetic dogmatism, the moral is impossible to dissociate from the poetic. Surrealism is an entire way of life, and not merely a set of rules governing an artistic production. As the soul of the artist learns how to free himself from the usual restrictions and enslavements and

the formal habits of society, so the language which exists in the deepest regions of our being, in the state of pre-articulation, learns to rise up to our consciousness freely and unhampered. The poet learns how to give voice to a stammering and stuttering which have always existed in him. The original sound of words, which is not usually very audible, becomes a clear and resounding echo when the poet is able to establish an interrelationship between the real and the imaginary worlds.

The example of Apollinaire's life and character strongly influenced the surrealists of the 20's and 30's, but today, in the few years which have followed the end of the Second War, the influence of his poetry on the young poets is more marked than it has ever been, stronger and more apparent, I think, than the influence even of Rimbaud's poetry. During the season of 1947, Poulenc's opera on Apollinaire's play, *Les mamelles de Tirésias*, was a major event. Doctrinally he taught the surrealists by the actions and habits of his life, by his anecdotes and oracular statements, so many of which have been piously remembered. Apollinaire became a kind of patron saint and intercessor of surrealists. But in the 1940's, in the new poetry, the actual form and resonance of his verse have been recaptured. He has finally become the poet, and more preeminently the master poet, than any single surrealist poet who followed and revered him.

The practical example of Apollinaire's poetry is a warning against the two most dangerous temptations of poetry, the two traps everlastingly set to stifle its life vigor: first, didacticism or moral preaching; and secondly, over-conscious intent or exaggerated artifice. When poetry avoids these two pitfalls, as Apollinaire's does, it is able to become a complete and autonomous universe, capable of encircling us and assailing us. When we read this kind of poetry, we know that a world is being organized and constructed around us. It gradually becomes so ordered and achieved

that we end by recognizing this new country and end by recognizing ourselves in it.

The universe of great poetry is always composed of passions and images: passions which are the experiences of suffering and therefore of knowing; and images which in their rhythmical form are the unique way a poet has to express his passion. Apollinaire's volume, *Alcools*, of 1913, is this kind of universe. The poems have the quality of folk-lore and fairy tales. The inhabitants are nymphs and blond Loreleis, pot-bellied prelates, clowns and saltimbanques, thieves and little girls. These are all projections and images of Apollinaire himself, selves of the poet which permit him in the joyously free realm of poetry to marvel at everything and compose anything into the unity of a poem or of a book. Critics have pointed out that Apollinaire is the only one of the major poets who never sounds the theme of mysticism, who, unlike a Péguy or a Claudel or an Eliot, seems impervious to the religious problem in any form. This critical statement seems to me too absolute because of the primitive mystical quality in magic. There is no true or matured mysticism in Apollinaire's poetry, that is certain, but the way between the mysterious and the mystical is not very far. The poet Apollinaire is like a mystical child, enchanted but not inspired, too humble and too fearful, too wondrously imaginative to consider or need the experience of religious ecstasy.

The first poem of the volume *Alcools*, called *Zone*, was actually the last poem to be composed. One evening in the summer of 1913, Apollinaire was in a small bar on the boulevard de Clichy, between the Place Blanche and the Place Pigalle. His companions, among others, were Marcoussis, Juan Gris, and Raoul Dufy. As far as one can tell, Apollinaire was depressed. It was the time when Marie Laurencin, whom he loved, had deserted him. The conversation, inspired by a very fine white wine, had caused him to consider the whole expanse of his life, the develop-

ment and evolution of his character. He went home alone
to an apartment on the boulevard Berthier, lent to him by
a friend, and in the space of one night composed the
poem *Zone*. It is an expansive freely written piece, a kind
of spiritual autobiography and a condensed history of
Apollinaire's period. At the beginning of the poem stands
the Eiffel Tower in the image of a shepherdess watching
over her flock of bridges:

Bergére, ó Tour Eiffel le troupeau des ponts bêle ce matin.

Initially in the poem this line illustrates an aspect of
surrealist art in its unexpected and slightly humorous
analogy. Throughout the poem Apollinaire accentuates an
urban magic, the new poetic force visible in bridges and
machines, in automobiles and airplanes. During the café
conversation, which perhaps initiated the poem, Juan Gris,
in pointing to some *affiches:* some billboard signs or ad-
vertisements, had exclaimed: *Voilà notre poésie!* Some of
the brutal and multi-colored modern advertising is carried
over into Apollinaire's verses. Catalogues, billboards, and
newspapers have their own dynamic rhythms, which are
those of the modern city and machines, and they represent
legitimate experiences of the poet on which he may draw.
Apollinaire's poem *Zone* originated in a Paris *bureau de
tabac* (*devant le zinc d'un bar crapuleux*) on the boulevard
de Clichy in 1913, and W. H. Auden's poem of 1947, *The
Age of Anxiety,* originated in a New York bar on 3rd
Avenue. The two titles *Zone* and *Age* are not dissimilar,
and the prewar *inquiétude* of Apollinaire, or his lassitude
of the first line (*A la fin tu es las de ce monde ancien*) bears
relationship with Auden's war-engendered existentialist
Anxiety.

III

Poets, in order to live and create, have
to destroy the poetic tradition out of which they came. In

such a poem as *Zone* and the other earlier poems of Apollinaire which follow it in *Alcools,* one can sense the revolutionary use to which poetry is being put. The strong 19th century poetic tradition was hard to kill. Apollinaire opposed to its formalized emotion and rhetoric, a poetry of irony and paradox and indirectness. All the familiar childhood and religious nostalgia is still there in his poetry, but it is treated in a new freshness and humor. In referring, for example, to the Ascension of Christ, Apollinaire says that He goes up to the sky better than aviators:

C'est le Christ qui monte au ciel mieux que les aviateurs.

One of the longest poems of Apollinaire, and in many ways his finest writing, is the third in this 1913 volume: *La Chanson du Mal-Aimé.* The remarkable and ambiguous effect of this poem is that it illustrates surrealism in technique, theme, and expression, and at the same time resembles very ancient poetry of France by its form and texture. It is as new as surrealism, as old as Villon, and as old-fashioned as Verlaine. It is impossible to read it without hearing the resonances and remembering the affinities it has with Villon and the tragic mask of Verlaine, and yet it is also brilliantly unique: Apollinaire's poem and only his.

I have alluded many times to the magical property of poetry, to the contained magic of words, and believe that in *La Chanson du Mal-Aimé* we have an admirable example of poetic phrases, which, when recited over and over again, take on new and unexpected meaning. Formally, in the literal and accustomed meaning of the words, we learn one thing—and then gradually, as if in another part of ourselves, rarely exposed to words, we may hear an echo of this poem, an elucidation of our own experience, which is the poem's also. In every great poem, there is always an aspect of eternal childhood, which in Apollinaire's *Chanson* becomes identified, almost miraculously, with our own. And

there is also, in every great poem, the apocalyptic tradition, the threatening image of mortality and the threatening image of some period in time, which in *La Chanson du Mal-Aimé* is tragically that of our own age. According to this theory, which is a very personal one of mine, every poem begins by being the poem of an angel (which is the memory of childhood and childhood innocency), and ends by becoming the poem of an exiled angel. Rimbaud would be the most dazzling example of this theory. Apollinaire would be a more moderate, or more modest, example, but quite as authentic.

The dedication of *La Chanson du Mal-Aimé* to Paul Léautaud, director of the *Mercure de France,* is easily explained. One day Léautaud met Apollinaire on the boulevard Montparnasse and asked him why he had sent nothing to the *Mercure.* Apollinaire replied that he had sent in a poem a long time ago and had heard nothing from it. On his return to the office, Léautaud discovered the poem, *La Chanson du Mal-Aimé,* in a pile of discarded manuscripts, read it, and published it.

In no other poem of Apollinaire does one feel so persistently the presence of an intimate kind of suffering, which however is never made precise. It is quite certain that the *Chanson* is about some secret catastrophe, some incurable sadness, but the poet-Apollinaire so completely disappeared from his own life that we are never able to formulate a specific dilemma. His friends liked to believe that the poem is about his unhappy love for the painter Marie Laurencin, but Apollinaire at all times led so strictly a surrealist life that we have no documents about him, only anecdotes; no biography, only legend.

The title of the piece is perhaps very meaningful. It is not a love poem, it is a love song. A poem would be more organized, more exclusively and pointedly on the subject of love. But a song has no strict form and *La Chanson du Mal-Aimé* is seemingly on many different subjects. The

theme of love becomes subtly and significantly prominent throughout the work because it is the one subject always carefully avoided. It is the subject changed into all other subjects. The poet here is no lover. He is the timid singer of a song. His life has been transformed into songs for sirens, but those are precisely the songs we seize and understand so profoundly at certain moments of self-lucidity.

The poem begins like a ballad or old romance:

> Un soir de demi-brume à Londres
> Un voyou qui ressemblait à
> Mon amour vint à ma rencontre
> Et le regard qu'il me jeta
> Me fit baisser les yeux de honte

I don't know of any more ambiguous beginning of a poem than this first stanza of *La Chanson du Mal-Aimé*. The *mal-aimé* (or lonely lover or poet) is walking through a London fog when he meets a *voyou*. The word is untranslatable, but refers to a young boy of dubious character and appearance, a kind of city tramp, usually associated with Paris, who exploits the feelings and pocketbooks of those he encounters. This *voyou* of the poem, Apollinaire tells us, resembles his love, and the boy's expression makes the poet look downward in shame. I call this initial stanza ambiguous because in the light of what follows, it is not what one thinks it is, and yet one is never sure!

The second stanza continues with the strange narrative:

> Je suivis ce mauvais garçon
> Qui sifflotait mains dans les poches
> Nous semblions entre les maisons
> Onde ouverte de la mer Rouge
> Lui les Hebreux moi Pharaon

The *mal-aimé* or poet follows the *voyou* who, whistling and his hands in his pockets, plays the predictable rôle of studied indifference and nonchalance, a kind of inverted

adolescent Pied Piper of Hamlin luring the nobler souls
of the city. But three of the five lines in the stanza are a
strikingly pure surrealist image of this pursuit and flight.
The street is the Red Sea, the *voyou* is the children of Israel,
and the poet is the Egyptian Pharaoh. We have suddenly
left the restricted area of narrative and entered the bound-
less region, where we stay henceforth in the poem, of allu-
sion and imagery.

We soon arrive, in the fifth stanza, to another episode of
resemblance and recognition. This time it is an intoxi-
cated woman coming out from a pub who reminds the
poet of his love. The *voyou* wasn't quite a man, in the
poet's first encounter, and this woman of the second en-
counter is inhuman (*c'était son regard d'inhumaine*). She
bears a scar on her neck, as if she might be a victim of vam-
pirism. These two apparitions in the London fog, the
whistling *voyou* and the vampire woman (the type of
femme fatale), objectively describe the overwhelming pre-
monition of the poet around which the romance is to be
constructed: the falseness of love itself: *La fausseté de
l'amour même.*

This ends the introduction of the *Chanson.* The fog
dissipates, as in a dream, and it never forms again. This
initial thought is cruel and startling, and yet it is spoken
with the gentleness and the ellipsis of a ballad. We were
introduced only to the dream and the two characters who
half emerge from the mistiness of the dream as the per-
verted or transformed characters of legend. Apollinaire, in
his rôle of *mal-aimé,* accepts the falseness of his love with
the humility of a simple man, like the surrealist who learns
how to submit himself to the miracle and magic of exist-
ence where the world of dreams and the conscious world
are eternally interdependent.

There is a difference between the romantic attitude and
the surrealist attitude. The romantic's is a pose: his heart
and his pride have been offended, and he stands off from

the world in a magnificent sullenness. His grievances mount up in resonant periods and he vituperates directly against the false mistress or the false society. But the surrealist attitude is the discovery of a curious and pathetic unity between falseness and truth, between the real and the surreal world. In the 11th stanza of *La Chanson du Mal-Aimé* there is another boat of memory, another metaphor of sea voyage where Rimbaud's drunken boat is sobered, where the final stanzas of *Bateau Ivre* with their deep pathos, are remembered in even greater ballad simplicity.

> Mon beau navire ô ma mémoire
> Avons-nous assez navigué
> Dans une onde mauvaise à boire
> Avons-nous assez divagué
> De la belle aube au triste soir

The violence of Rimbaud's experience, so equally sharing in the romantic and surrealist attitudes, is here in Apollinaire subdued into the most gentle kind of irony where the impossibility of love is the experience of the ineffable, of the unspeakable. The loneliness of the *mal-aimé* is best transcribed by the distant milky way of the heavens (*Voie lactée ô soeur lumineuse*) in the 13th stanza, and by the memory of another year, in the 14th: *Je me souviens d'une autre année*.

Bohemian Apollinaire, his favorite characterization, is here a poet who sings about himself a romance so totally mysterious, so totally indecipherable, that he sings about every man. The lonely *voyou* of the first two stanzas never really leaves the poem. He is joined with the poet himself in his need to tempt life without resolving it, in his will to live without assuming responsibility for life. What is going to become the surrealist attitude—namely, the childlike acceptance of reality and surreality, the childlike acceptance of the oneness of life—is prepared in the Bohemian poet of the first decade of the 20th century, in Apolli-

naire's *mal-aimé*, who is really a *voyou*, in Petrouchka
whose tiny heart beats in a straw-stuffed body, in the *sal-
timbanques* of Picasso, in the real clowns of the Cirque
Médrano, who were so admired by Apollinaire and Picasso
and Cocteau, in Charlie Chaplin's eternal rôle of the tramp,
the American version of the European clown and the inno-
cent *voyou*. In Chaplin's most recent film, *Monsieur Ver-
doux*, he abandons the rôle of tramp for the dandy, the
other choreographic expression of the modern artist. The
clown is the poet who doesn't speak. He is like the *mal-
aimé* who so compresses language and experience that he
sings them. He pretends that love is dead (*L'amour est
mort j'en suis tremblant* says Apollinaire's *mal-aimé* in
stanza 20) but who remains, throughout all his pretence,
"faithful and sad" (*Je reste fidèle et dolent*, stanza 20).
This is the characterization of Chaplin in all his early films:
the vagabond who wanders from saloon to saloon in try-
ing to convert a real experience he never refers to, into a
fictional pattern, a surreal ballet.

If we are unable to see very clearly the *mal-aimé*, an-
nounced in Apollinaire's title, we are able to follow the
transposed version of his drama. In it there are no traces
of realist art or analytical art. What remains in the poetry
is the human drama, but so grief-stricken and obscured
that it has become mythical. The poem engenders a dark-
ness, both a physical and metaphorical night, in which all
kinds of opposites cease opposing one another, in which
all kinds of contraries are harmonized: sadness and joy;
memory and actuality; a poet and a *voyou;* a poet and a
vampire woman. The two deepest opposites are the con-
scious and the subconscious which are so unlimited by their
nature that they have to create myths in order to give them-
selves some boundaries whereby they may see themselves
and reflect themselves. Thus, in *La Chanson du Mal-Aimé*,
where the inner world of the ego and the exterior world
form only one world, the poet truly becomes the child or

the angel who is able to pass from one world to the other without perceiving any difference between them. This unified climate of the poem is the climate of the myth, where, for a Rimbaud a mosque is seen in the place of a factory or a drawing room at the bottom of a lake, or a family as a litter of puppies, and where for Apollinaire his beloved appears to him as a *voyou* or as an inhuman woman coming out from a pub.

IV

The profoundest lesson of surrealism has to do with unity or unification, and Apollinaire's poetry may be considered a transcendent part of this lesson. A true poem, according to this doctrine, should reveal some aspect of the original unity of the universe. This seems to signify that poetry, which is created out of suffering (as the world itself was created out of chaos), preserves the memory of suffering (as the world preserves the memory of chaos), teaches man how to bear it and weaves a marvellous myth which then becomes a part of all the myths of mankind.

The surrealist is hereby stating a thesis not at all unfamiliar: that poetry is a method of knowledge, a way of knowing. In the history of French poetry, Baudelaire was the first to be explicit with this idea. Modern poetry owes almost everything to Baudelaire. Mallarmé, in a sense, became the philosopher of this theory, the most extraordinary dreamer and abstractionist of modern poetry. Lautréamont and Rimbaud were the dazzled initiates, the victims of the strange illumination. Apollinaire, without possessing the poetic genius of a Mallarmé or a Rimbaud, was very necessary in the unfolding of this poetic theory. He was able to bring poetry back from its Mallarmean hermeticism and Rimbaldian violence to tenderness and nostalgia, to the gentleness of the clown. With Apollinaire's period the clown became the most sensitive of the modern

heroes, the living receptacle for all dramas, the hero who refused to see them as tragedies. The surrealist hero is visibly the clown: whether he be Chaplin or Donald Duck, the sad *saltimbanques* of Picasso and Apollinaire, or the *voyou* who temporarily has forgotten the meaning of his heart, Jean Gabin or the habitués of the rue de Lappe, or their great ancestor Hamlet. There is a significant *rapprochement*, quite easy to make, between the adjectives *clowning* and *surrealist*. One might read the *Chanson* of Apollinaire as if Petrouchka were the *mal-aimé*.

This is the psychological diagnosis of the poet in Apollinaire's poem, *La Jolie Rousse,* the final poem of his volume *Calligrammes,* published in 1918. He is judging the order of Adventure. In the 19th century the romantic hero was always judging the order of his heart, but in the 20th century the surrealist hero judges the order of his adventure. The word *adventure,* when considered in its strict etymological meaning (*advenire*), explains a valid aspect of surrealism. It is experience without design, a hazardous enterprise of uncertain issue, a peril or a jeopardizing of oneself. But this order is limitless: it is the future, the adventure of the spirit which lies ahead of us. Adventure is the drama of the conscious and the subconscious, of the vast and strange domains we know and don't know. The most courageous type of hero to embark on such an adventure is the clown-*voyou*. The final stanza of the poem, *La Jolie Rousse,* is Apollinaire's cry of a clown. It begins:

> *Mais riez riez de moi*
> *Hommes de partout surtout gens d'ici*

> But laugh laugh at me
> Men everywhere and especially you here.

This is Pagliaccio's invitation to laughter, the clown's dismay in the ring which incites laughter in the public. Then comes the confession:

Car il y a tant de choses que je n'ose vous dire.

For there are so many things I don't dare tell you.

which is the silence of the songs, the literal silence of the performing clown, the hermeticism of Mallarmé and the surrealists. And the second confession:

Tant de choses que vous ne me laisseriez pas dire.

So many things you wouldn't let me tell you.

In no other line do we read such an explicit statement concerning the drama of the clown as clown, or the poet as poet.

The public always ends by being irritated by the clown who controls his silence. And that is why the clown portrays so admirably the artist in the solitude of the world, and the surrealist far from the real world. In the very last words of the poem, *Ayez pitié de moi* (Have pity on me), are summarized the burning humility of the clown and his universal pathos.

VI · BRETON: *the manifestoes*

I

During the fall term of 1942, most students in American universities were preparing to leave for the war. Classes were beginning noticeably to diminish in size. I was teaching French literature at Yale, and remember particularly, about that period of deep unrest, the unusual attentiveness of students during their last classes and their concern over which books they should take away with them.

On December 10th, on the invitation of the French and Art departments, André Breton, who was then working for the O.W.I. in New York, came to New Haven to deliver a lecture on "The situation of Surrealism between the two wars." A large gathering of students, faculty, and townsfolk turned out to hear the lecture. M. Breton spoke in French, which was a strain for many of those present, and some passages in the lecture he read were difficult to follow even for those who knew French well. His style is highly polished and intricate. His ideas, which might in a more simple form be easily recognizable, are in his own form intensely abstracted and intellectualized. Breton's writing, and this lecture he gave at Yale was essentially a written

text, is devoid of the facile and the obvious and the cliché. However, during the entire lecture, slides of the well known surrealist paintings were constantly being thrown on a screen placed over Breton's head. At the beginning, I, like everyone else present, I am sure, tried to see the relationship between what was being said and what was being shown. But it soon became evident to me that there was no direct relationship. The pictures didn't illustrate the lecture. They formed a moving and colorful background: a kind of second lecture in graphic form which one might follow, if one tired of oral expression or found it incomprehensible.

Breton's appearance was majestic and noble. It was very easy to credit him with the first rôle of leader and spokesman and theoretician of surrealism. He is a very large man with a handsome leonine head. His countenance bore an expression of solemnity which I don't remember his ever breaking with a smile. His gestures were sober and reduced. His voice had resonance and great beauty. At the end of the lecture, he read more eloquently than I have ever heard a poet read, poems of Apollinaire, Tzara, Eluard, Péret, and one of his own poems.

His speech, which was very pointedly directed at the students present, has become, since its subsequent publication, a kind of third manifesto of surrealism, or at least a summation of the first two manifestoes which Breton published in 1924 and 1930. He was very much aware of the strangeness and uniqueness of that occasion on December 10, 1942. A world war was going on. He was in exile while his country was governed by Vichy and Nazi-Germany. He was speaking on the subject of surrealism in a provincial New England city, to a group of American students who, no matter how impressed they were with seeing the celebrated leader of surrealism, were thinking above all about the gravity of their imminent departure. Even if they had learned the names of Apollinaire, Breton, and Lautréa-

mont, other names such as Guadalcanal, Stalingrad, Libya were uppermost in their minds. But because of the very unusualness of the situation, Breton was unable to explain and heighten certain aspects of surrealism which appear to be among the most important.

He exalted the appeal which surrealism has always made to the young. Surrealism has been kept alive by the particular kind of genius we associate with the young. Breton and the early surrealists were all young themselves and affirmed a boundless faith in the type of youthful genius: in Lautréamont, who died at twenty-four; in Rimbaud, whose writing was completed at nineteen; in Chirico, who painted his best canvases between the ages of twenty-three and twenty-eight; in Saint-Just, member of the National Convention, who was guillotined at the age of twenty-seven; in the German writer Novalis, who died at thirty; in Seurat, who died at thirty-two; in Jarry, whose play *Ubu Roi* was composed when he was fifteen and characterized by Breton as the great prophetic avenging play of modern times (*la grande pièce prophétique et vengeresse des temps modernes*). Breton himself was twenty-three when in 1919 he published with Soupault the first chapter of *Les Champs Magnétiques,* illustrative of the new automatic method of writing.

Surrealism was founded in the years which immediately followed World War I when the young intellectuals, returning from the front, discovered in the older thinkers and artists an inadequacy and an unrelatedness to their own thought and state of mind. Those who like Breton were to become surrealists turned against Barrès, Claudel, and even Bergson to some degree. The death of Apollinaire, at the precise moment of the Armistice, had upset them. His had been the intellectual adventure they had followed the most confidently and joyously, as they had literally followed the large figure of the man in his pale blue uniform of first lieutenant to the Café de Flore on

the boulevard de St. Germain during the war years. They were tired and disgusted with the literary eloquence and verboseness of the 20th century. Their age had become a verbal nightmare for them. The radio, with its perpetual flow of words, was converting the world into a delirious cacophony. The language of man was being prostituted and degraded as it had never been before.

Breton was one of the first Frenchmen, who was not a psychoanalyst, to study Freud. He told us, in the lecture at Yale, that when he was twenty, on his various Paris leaves from the army, he tried successively to interest Apollinaire, Valéry, and Gide in Freud. But they all turned him down with indulgent smiles and a friendly pat on the back. Breton's enthusiasm and veneration for Freud, as far as I know, have never diminished. He believes that Freud is one of the greatest forces in helping modern man to rediscover the meaning and the vitality of words.

In his first manifesto of 1924, Breton emphasized the meaning of the word *liberty* as being a basis for surrealism (*le seul mot de liberté est tout ce qui m'exalte encore*) and in his speech of 1942, he used the word again with all the fullness of meaning it had at that time and on that occasion. The sentence he quoted from Saint-Just, the "conventionnel" at the time of the French Revolution, had a deep resonant effect and appropriateness: *Pas de liberté pour les ennemis de la liberté.* ("No freedom for the enemies of freedom.") He interpreted liberty as being the guiding motivation of all surrealist activity, and explained the many excommunications which he, André Breton, performed as surrealist pope, in terms of infidelity to liberty. The excommunicants were those artists who disqualified themselves by some infringement on the sanctity of this doctrine liberty.

Liberty for the artist, according to Breton, means first a liberation from rules of art. The artist expresses his liberty iconoclastically. In poetry, the leading examples would

be Lautréamont, Rimbaud, Mallarmé in his final poem, *Un coup de dés,* Apollinaire—especially in his "poèmes-conversations" of *Calligrammes.* In painting, the examples would be Van Gogh, Seurat, Rousseau, Matisse, Picasso, Duchamp. These lists vary from year to year with Breton. His life is a series of fervent friendships and violent denunciations of former friends. At the time of the New Haven speech his most eloquent invective was leveled at Dali, who had been excommunicated on two grounds. First, for having bartered his soul for money. Breton had devised a humorous anagram out of the name Salvador Dali. He refused even to say the real name but spoke only the anagram: Avida Dollars: a half-Spanish, half-American clue to Dali's current sin. And second, for having revealed Fascist tendencies in painting the Spanish ambassador, who, because he was the representative of France, was implicated in the oppression of Spain and even in the death of Dali's friend, the great Spanish poet, Garcia Lorca.

The disquisition on liberty would constitute the prolegomenon or the preamble to the surrealist creed. From all the writings of Breton, especially the two manifestoes of 1924 and 1930, and the *Situation du Surréalisme* of 1942, as well as from other theoretical writings, one might draw up a kind of program in five parts consisting of those beliefs which seem to have fluctuated the least in the minds and the works of the leading surrealists.

1. The importance accorded to dreams and the subconscious life of man. Here the teachings of Freud are all important and seem to validate the practice of automatic writing or direct note-taking of one's subconscious states.

2. The second belief would be a corollary or a result of the first. It has to do with a denial of what we usually consider contradictions or paradoxes in our experience. The human mind is able to attain a state where forces which appear opposed are harmonized and unified

into one force. The sentence of Breton's second manifesto which states this belief is so important and so admirably composed that it should be quoted in its entirety: "There is a certain point for the mind from which life and death, the real and the imaginary, the past and the future, the communicable and the incommunicable, the high and the low cease being perceived as contradictions." This sentence is actually a development of a passage in the first manifesto where the resolution of dream and reality is conceived of as being absolute reality or surreality.

3. The third belief is concerned with the most puzzling of the so-called contradictions: the antinomy between man and nature, the conviction that one is of a different order than the other, and that hence there exists between the two a perpetual state of discord. The Breton-surrealist answer to this contradiction is obscure for the surrealists as well as for the outsider. The action of "chance" (*le hasard*) or "coincidence" seems to be the mystery to decipher and the key to this particular contradiction. It is possible that as we learn to progress along the way of the subconscious, we shall learn more about the phenomena of "chance" which do appear to play a part in our daily existence as well as in such a humanly or consciously calculated enterprise as a war.

4. The fourth part we have already somewhat discussed in the emergence of the surrealist attitude as the result of the experience of war, of the psychic upheaval caused by war. Wars are fought by young men at an age when they, if they weren't engaged in warfare, would be organizing, systematizing, and planning their lives and their careers. They would be choosing a philosophy, learning and imitating the art and the thought of older men. If, at the age of twenty, one wears a uniform and engages in warfare, one is thereby dissolving the permanencies and stabilizing beliefs which usually form the architecture of a life. The young Frenchmen of 1919, Breton and the others,

returned from war, having learned there how to attach
very little importance to matters considered important in
terms of peace. Their greatest sacrifice had been the sac-
rifice of thought, and they immediately turned upon their
philosophers and poets and demanded of them the same
sacrifice. Having fought, as they were told, for ideas, for
the safety of democracy, for example, they turned against
ideas in a paradoxical but recognizable psychic reaction.
There is a kind of humor which is visible at the most
solemn and even tragic moments of existence. Nerves can't
stand too much tension and often are relieved by a para-
doxical explosion. The comic aspect of early surrealism
and its program of destruction so often carried out as an
embittered joke, may well be explained in this way.

5. The fifth belief is essentially psychological in
nature. It is concerned with the distinction between the
self and the *ego*. The French words *soi* and *moi* are per-
haps clearer translations of these two terms. The *self* (*soi*),
as opposed to the *ego* (*le moi,* or the consciously aware be-
ing of man), is composed of all manner of powers stolen
from man's conscience and kept separate from any control
of conscience and consciousness. This *self* is the area, or
the arena, if we use the image of Freud, in which a signifi-
cant and central fight is waged. Freud calls it the fight
between *Eros* or the instinct of love, and the instinct of
death or self-destruction, which we discussed in connection
with Mallarmé's *Hérodiade*. This is the area or arena
where the permanent myths of man, as we saw in Lautréa-
mont, are recognized and reenacted. It is precisely here in
this domain of the *self,* as separate from the domain of the
ego, that the surrealist believes he may take down the dic-
tation of his thought during a time when there is a total
absence of any control exercised by his reason or by any
aesthetic or moral code. It is the absence of any consciously-
arrived-at codification. This activity of the *self* might easily
be compared with what Baudelaire said about the image-

provoking power of opium. The images induced by opium are surrealistic in that they rise up spontaneously and despotically without the man (smoker) invoking them. They are involuntarily generated images.

II

These five categories of belief might serve as the theoretical bases of surrealism. They were evoked and discussed during a period of fervent artistic activity and experimentation. Each one corresponds to experiments and quarrels and expositions and exposures. Surrealism might conveniently be analyzed in its history of scandals and manifestoes.

The movement, in anything that resembles an organization or conscious group activity, seems to have been initiated by its "sleep period," by its so-called *époque des sommeils.* This was experimentation with sleep and dreams, a whole new manner of thinking, in which the sleeper or dreamer might experience unprecedented images in their strangeness and richness. Some, and especially Robert Desnos, who was champion in this trick, learned how to fall asleep at will and hence live, whenever he wished, in a surrealist panorama of dream-images which he had not willfully induced. The dream-image of the subconscious eliminated for the surrealists any enigmatical character of prophecies and dreams, in the Bible, for example. They could see a poetic unity joining such words as Nebuchadnezzar's dream in the book of *Daniel,* and the revelation made to St. John on the island of Patmos, and *Les Chants de Maldoror,* and *Une Saison en Enfer.*

By the time of Breton's first manifesto, in 1924, the surrealist attack on the novel, as a form of art, was in full swing. The form of the novel, as exemplified by a Balzac, answered man's craving for logic and description wherein false and ludicrous practices would be employed such as giving a name and an age to a character. It is apparent that

a surrealist, accustomed to living in a dream-world where factors of time and space are not rigorous, would deplore an art in which the physical setting for an action would be minutely described.

Anatole France died in this same year of the first surrealist manifesto. He served the surrealists as a horrible example of conventional writer whose art was empty and false. In a pamphlet, lugubriously called *Un Cadavre,* they went to work to achieve the artistic demise of Anatole France. This attack on one of the most loved and eminent writers of the day brought attention to the surrealists and their potentialities as iconoclasts. In the good French tradition they had chosen a café where they congregated regularly, the *Cyrano,* at the Place Blanche, conveniently near the rue Fontaine where André Breton, their acknowledged and self-appointed leader, was living. The Place Blanche is a section of Paris frequented by prostitutes, pimps, and circus people. The Cirque Médrano, a favorite spot for the surrealists, was close by.

It was approximately the following year, 1925, that some respectful attention began to be paid to the surrealists from those outside their ranks. Both Eluard and Aragon were assuming the proportions of poets. Max Ernst and André Masson were being approached by art dealers. It looked as though surrealism might even pay. I believe this was the year that Breton read Trotsky's book on *Lenin* and announced his allegiance to the Communist Party. His approval of the Russian Revolution is quite audible in the new name he devised for the contemporary world: "the period," as he called it, "of Lautréamont, Freud, and Trotsky."

The year 1928 is generally singled out as the year of pronounced surrealist achievement Their rival movement in popularity and notoriety was the Catholic revival among intellectuals and artists. Conversions and reconversions had made almost a vogue out of Catholicism. The exam-

ples of such men as Maritain, Massis, and Cocteau (who at least temporarily reoccupied his place at mass) did not prevent the surrealists from denouncing bitterly and unremittingly any religious solution to the problems of modern man. By this time surrealism had been in current fashion long enough to have circulated misleading emphasis and belief about itself. However, in all justice, it must be said that the surrealists themselves have been largely responsible for some of the misconceptions about surrealism. They flaunt a startling theory or practice before the public, and then when the slow-moving public mind finally accepts or understands the theory, the surrealists begin denying it and accusing the public of falsification or over-simplification. This is the period when the surrealists vociferously attacked all the various stands or beliefs with which the public wanted to associate them: Freudianism, relativism, gratuitousness of thought and expression, the cult of Rimbaud, the mania for suicide, automatic writing.

The surrealists are irked by having their work defined and categorized. To name a theory, as to name a character in a novel, is to limit its freedom, to diminish its vitality and meaning. The surrealist's fear of academic definition is another aspect of his love of freedom. It is true that surrealism is a state of mind or a view about art which is constantly changing and growing. Its adherents and detractors move about as men on a chessboard. The actual works of surrealist art, poems and paintings, seem always to be overshadowed by the stronger works of a polemical nature, by the argumentative and only slightly disguised didactic works, such as Aragon's brilliant *Traité du Style* of this same crucial year, 1928.

The second manifesto of 1930 enlarged somewhat the scope of the surrealist program, but gave especially the inspired statement, already quoted, about the point which the mind must reach in its unifying and uniting power.

One senses in this second document that the fight has really been fought, that it is a more verbalized and philosophical expression of the strong program of the first manifesto. Breton now rejects all the early patronages of Rimbaud, Baudelaire, Poe, Sade. He excommunicates more abundantly than ever, and allies himself closely with the revolutionists. But those whom the leader castigates, join forces against him, and Breton himself is the object of an attack by surrealists. A pamphlet against him, given ominously the same name as the earlier one against Anatole France, *Un Cadavre,* is full of personal animosities and party jealousies. Among those who participated in the effort were Queneau, Desnos, Prévert.

They fought among themselves, but let one be attacked by any outside force, and they would all rally generously to his defence. This happened in 1931, when Aragon, who had attended the 2nd International Congress in Karkhov, published his poem *Front Rouge,* and was prosecuted for provoking or extolling assassination. Breton, supported by his followers, led the defence with the watertight surrealist thesis that since a poem is the manifestation of the subconscious, the author cannot be held responsible for it. At the conclusion of this "Affaire," Aragon withdrew from surrealism in order to become whole-heartedly communist.

But if surrealism lost in 1931 an important figure, it had gained a few years before, a luminary from Spain, Salvador Dali, a kind of "enfant terrible," of the movement. From the outset he was the scandalizer and practical joker, but in creative terms one of the most prodigiously gifted of all the surrealists. Natively he was surrealist before becoming one literally in Paris. When he was a student at the Madrid School of Fine Arts, his teacher gave the class one day the subject of a Gothic Virgin to paint. Dali painted a pair of scales, and when the teacher remonstrated, the premature surrealist replied that if the others saw a Virgin, he saw a pair of scales.

Dali had been interested in the Italian Futurist school and especially in the other Italian school, headed by Chirico and Carrà, known as the *scuola metafisica*. This school, with its emphasis on the inner perceptiveness and metaphysical concern of the painter, was an excellent background for surrealism. On his first visit to Paris in 1928, he met Picasso, and when he returned the same year, he met Mirò and the writers Desnos and Eluard. He found immediately a vocation in surrealism which opened up to him many means by which to discredit the world of reality. In Freud, he read a justification for the intense love he had always felt for his childhood, for the terrors and ecstasies of his childhood. He learned, as a very special revelation, about the womb-like protection which sleep affords. Enthusiastically he accepted the leadership of André Breton and the principal doctrines of the manifestoes.

Dali added a further term to surrealist jargon: his private method which he called *paranoiac-criticism*. He always insisted that he was much more the madman than the somnambulist. His method sounds at first like accredited surrealism when he claims spontaneous and irrational knowledge, but when he bases it on an interpretive-critical association of phenomena which arises from states of delirium, he is adding to original surrealism a paranoiac sensitivity. The hidden meanings which Dali finds in the phenomena he studies, come to him, he claims, from temporary states of insanity. The paranoiac is the man who appears to have a normal kind of health and attitude, but who privately is fashioning the world in accordance with his own desire and the imperiousness of his desire.

Dali directed his paranoiac criticism on the legend of William Tell, which, rather than illustrating for him paternal love, is an example of incestuous mutilation. He saw in Millet's famous painting of the *Angelus* an example not of religious humility but of sexual repression, and uses it in paintings of his own to stand for that idea. He

was interested in combining the worlds of the animate and the inanimate, and hence in his painting of Vermeer, the painter, whom Dali admired unreservedly and whose technique he imitates closely, he represents Vermeer as a ghost extending a leg which becomes a table. Movie technique has employed this interpenetration of the animate and inanimate, and Dali, who, contrary to Matisse who attends the movies frequently in order to forget his labors, goes very frequently, but for stimulation and inspiration. One of the striking Dali objects at the International Exposition was a taxi in which sat the wax figure of Columbus. Rain was constantly falling in the taxi and drenching the immobile Columbus. The work, which was hooted at, takes on some meaning when one realizes that Dali believed Columbus, like himself, was a paranoiac. By his conviction that the world was round and by his voyages which therefore would be endless, Columbus revealed his fear of persecution and his hope that he might always escape from his persecutors.

By 1935, so many of the surrealists had joined the Communist Party that the movement itself seemed to be allied with the cause of communism. The statements of Marx about the need of world revolution were said to find support in Rimbaud's sentence that life had to be changed (*il faut changer la vie*). The advent of Dali had brought a second youth or new impetus to surrealism. The reign of the "marvellous" in art (*le merveilleux,* as Breton called it) which came from man's passiveness and submission to his subconscious, seemed to have definitely displaced symbolism, with its emphasis on artificiality or contrived artfulness. The International Exposition of 1938 was the culmination of surrealism, when seventy artists from fourteen countries were represented. It was a success despite the wrath and acrimony of many of the critics. The war dispersed the surrealists. Breton, Eluard, and Péret were mobilized at the beginning, in 1939. But Breton soon came

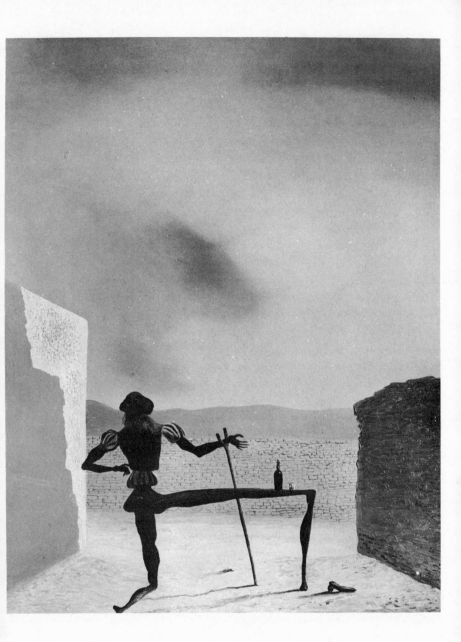

THE GHOST OF VERMEER OF DELFT *by Salvador Dali. Collection of Mr. and Mrs. A. Reynolds Morse.*

ANDRÉ BRETON. *Photo Izis.*

to New York, where he broke completely with Dali, and where he founded the surrealist magazine *VVV*, which had a brief existence. Péret spent the war years in Mexico; Tanguy and Masson in Connecticut; most of the others remained in France.

III

In addition to his critical and polemical writings Breton has produced works of a more purely creative nature, which are not only independent works of art, among the best written of the century, but are also illustrative of the surrealist preoccupations. There is especially *Nadja,* first published in 1928, another work of that central year in the history of surrealism. I should like to describe the book briefly and then relate it to the manifestoes: to the promises and the principles of surrealism.

Nadja is divided into two parts: a long preamble or introduction of seventy pages which is almost half of the book, and then the story, if so meagre a narrative can be called a story, about the character Nadja.

The introduction is a kind of illustrated essay on surrealism, a preparation for the strange tale Breton is going to give of his encounter with Nadja. The opening sentence is a question: *Qui suis-je?* ("Who am I?"), which I have mentioned in other contexts as being the key question in all aspects of modernism, whether it be surrealism or existentialism, as opposed to the key question of the preceding age: "What should I do?" The inquiry about action has shifted to the inquiry about being. There is throughout surrealism a deep metaphysical concern, not usually couched in philosophical terms, but present nonetheless and distinctly audible in the early pages of *Nadja,* where Breton answers his own question by saying that he is going to learn a small part of what he has forgotten. But his attempt of memory and recollection is going to be involuntary. He is going to remember effort-

lessly what happened to him, relate it without commentary and without investigation, and hence hope to arrive at some knowledge of what constitutes his differences from other men, his uniqueness in this world where everything and every being seem to be patterned and standardized.

His method therefore will be to speak without any predetermined order and plan, to embark with one strand of memory and to proceed with whatever forces itself on his consciousness. His point of departure is to be the Hôtel des Grands Hommes at the Place du Panthéon, where he lived about 1918. But before actually beginning, Breton refers to an unrelated series of episodes in his life which came about by an extraordinary and mysterious chance of coincidence. One of these might suffice as example. At the première of an Apollinaire play (*Couleur du Temps*), Breton was speaking in the balcony with Picasso during the intermission, when a young man broke into their conversation and immediately excused himself by saying that he had mistaken Breton for a friend who had been killed in the war. Soon after that, Breton, through a mutual friend, began corresponding with Paul Eluard whom he had never met. When he did finally meet him, on a leave from the army, Eluard turned out to be the same fellow who had spoken to him at the theatre.

Several stories and reminiscences of this nature skillfully induce in the reader the mood of surreality in which to read the illusory tale of *Nadja*. It begins on the rue Lafayette, in the late afternoon of the 4th of October when Breton is walking aimlessly in the direction of the Opéra. Suddenly he sees, about ten steps away, a young woman poorly dressed, who looks at him at the same time. She has beautiful eyes, curiously made up, and Breton speaks to her without hesitation. She pretends that she is going to a hairdresser on the boulevard Magenta, but he knows and she knows he knows that she was going nowhere. They sit down on the terrace of a café near the Gare du Nord where

she relates various fragments of her life. The name she
chose for herself is Nadja, which in Russian, is the begin-
ning of the word for *hope*. When they are about to sepa-
rate, Breton asks Nadja the question which according to
him, stands for and summarizes all questions: *Qui êtes-
vous?* ("Who are you?"), the very question with which he
had begun the book, and which this time receives a worthy
answer, when Nadja replies: *Je suis l'âme errante* ("I am
the wandering soul").

The next day they meet at a rendezvous at a bar on the
corner of the rue Lafayette and the faubourg Poissonnière.
Nadja accompanies Breton home in a taxi and leaves him
at the door. She says that she is going first to return to the
place where they began at the rue Lafayette and the fau-
bourg Poissonnière. They had fixed a rendezvous for the
6th of October, but before the time appointed, they met
by accident on a different street, rue de la Chaussée d'An-
tin. She confesses that she had planned not to come to the
rendezvous. No meeting was fixed for the 7th, but from
a taxi Breton felt he had seen her turning down a street.
He followed his hunch and found her. This is the kind of
meeting that continues to occur for several days: fortuitous,
almost resembling an intervention on the part of destiny.
There are only rapid glances into Nadja's life of debts and
distress and childishness. She disappears only to reappear
unexpectedly. Often, when they are seated at a café she
draws herself with the features of Mélusine and feels that
she is close to that mythical character. By means of the
brief diary-like entrances of his meetings with Nadja, Bre-
ton draws a mental landscape where it is impossible to see
any clear demarcation between sanity and madness. Even
after Nadja has been committed to an asylum, Breton con-
tinues to think of her as the one character who was not
enigmatical, the one who by the strange power she had of
substituting herself for other characters passed beyond the
state of enigma. "Beauty," he tells us in the last sentence

of the book, "will be convulsive, or will not be." (*La beauté sera CONVULSIVE ou ne sera pas.*)

Nadja, as a piece of writing, seems to escape the narrow limiting aspect of surrealism which demands that a book adhere to the one process of automatic writing and dictation, and to reach a larger view of the doctrine, which is a philosophical attitude and even mystical attitude. A chance meeting on the street of a man and a woman, an event which I am confident would be called in one kind of language a "pick-up," becomes the source of a new kind of poetry of incoherences. A "pick-up," which on one level of existence is thoroughly commonplace or even vulgar, might become the source of deep happiness and exultant discovery. The movies have made out of this theme a real kind of beauty. It often happens that when we are waiting for someone, in, say, Grand Central Station, the people who go by and whom we are, alas, not waiting for, are far more attractive and mysterious than the one we are waiting for. Surrealism, and movie technique in so far as it is surrealistic, provides for the lyrical transformations of reality, for all those chance meetings, unpredictable, unusual, out of which a new meaning of life may be evolved. In such meetings we make up stories about ourselves, as Nadja did, who in her partial state of dementia was probably falsifying many things: but lies, under such conditions, reveal some of the deepest truths about ourselves, truths we are unable to face when we talk with people who know the facts of our biography and our background.

If the realist is concerned with establishing the contact between a man and his life (the physical objects and forces which touch his life), the surrealist is concerned with establishing the contact between a poet and his destiny (the physical objects and the supernatural forces which form his destiny). This latter, the coming together of an artist and his destiny is always the mark of a great work of art. One has to break with the things that are in order to unite

with the things that may be. Breton, in his first manifesto defined man as that "definitive dreamer" (*l'homme ce rêveur définitif*). Poetry, if there is to be poetry, has to be conquered in the midst of great danger. It is comparable to the chance meeting of a man and woman on a Paris sidewalk, comparable to the danger for the man in the mystery and the unknowable in the woman's past. Poetry is the domain of the marvellous (*le merveilleux*) which becomes so familiar that it becomes real. The surrealists refrain from analyzing this experience of the marvellous in order to safeguard and preserve the power of the imagination, and thereby belong to the tradition of the visionaries (of the *voyants*) who see without explaining.

The initial question which Breton asks himself in *Nadja:* "Who am I?" might easily be transcribed in the light of the story by "Whom do I haunt? Whom do I go with? Whom do I see in my dreams?" Because the ineffable or the unspeakable is always stifling the poets, they have to cheat. Surrealism is a most honorable form of cheating. The poet jumps from the invisible to the visible, from the angel to man, from Nadja or Mélusine to woman. His uniqueness, and this is discernible in such a work as *Nadja,* is his symbol-making power of the savage forces which are in us and which the social machine suppresses. So, the poet is the prestidigitator but one who always works with his sleeves rolled up. And this name of prestidigitator leads us quite naturally to the case of Jean Cocteau.

VII · COCTEAU: *the theatre*

I

Like a true citizen and genius of the Renaissance, like one of Castiglione's perfect courtiers, Jean Cocteau is a man of many parts and diversified accomplishments. He is poet, critic, novelist, draftsman, actor, play producer, movie director. But his greatest rôle, that on which I believe his fame will have its surest foundation, is playwright. Cocteau is essentially a man of the theatre. The universe he has created is opposed to the natural universe. He is seen best in the artificial light of the stage, from the confined night world of the theatre where a very secret alliance is formed between actors and spectators, and where a still more mysterious connivance is established between that ill-assorted but all necessary trio: the author, the cast and the audience. I don't know how the miracle is produced, but it often seems to be that Cocteau is all three at once: magician, rabbit, and delighted child-spectator.

For thirty years—it is impossible, by the way, that this boy is growing old—he has produced in Paris at regular intervals plays of great diversity. Even a partial list is impressive: the now distant *Parade* of 1917, a ballet written

à mon ami
Jean Cocteau
Picasso
1916

COCTEAU *by Pablo Picasso.*

in collaboration with Satie and Picasso and presented by the *Ballet Russe* in the Châtelet; *Le Boeuf sur le Toit,* a pantomime with collaboration, this time, from Darius Milhaud and Dufy, played by the clowns Fratellini at the Comédie des Champs-Elysées, in 1920; *Les Mariés de la Tour Eiffel,* hailed in 1931, as a surrealist play; his three plays on Greek themes, where Cocteau is the real forerunner of the contemporary interest in the Greek theatre illustrated in the works of Giraudoux, Anouilh, and Sartre: his plays *Antigone* of 1922, with music of Honegger and settings of Picasso; *Orphée* of 1926, played by the Pitoëffs; *La Machine Infernale* of 1934, his greatest achievement, perhaps, in the theatre. Then, just before the war, in marked contrast to his Greek plays *Les Parents Terribles,* an excursion to the "théâtre de boulevard." During the German occupation, his new work *Renaud et Armide,* played at the Comédie-Française, seemed an example of the French classical theatre. At the beginning of 1947, exactly thirty years after his début with *Parade,* Cocteau was holding first place in the theatrical season in Paris by occupying two large theatres and selling out every night: *Les Parents Terribles,* in a revival of tremendous success at the Gymnase; and his newest play, *L'Aigle à Deux Têtes,* in the Théâtre Hébertot.

This last play, presented in New York in translation and hence in inferior form, with Tallulah Bankhead, is still a different kind of writing for Cocteau, a romantic melodrama, and this time, more immediately than usual, he converted a large public in Paris to his work. The critics have been divided, but that is usual in Cocteau's case, and even those who dislike the play, seem certain that it will continue for more than one hundred years. The story, like that of Victor Hugo's *Ruy Blas,* out of which Cocteau is now making a film, is the tragic love between a queen and a man of the people. He said that he wanted to write a play about an anarchist queen and an anarchist with a

royal soul. *L'Aigle à Deux Têtes* is a new proof of Cocteau's extraordinary sense of the theatre, of the uncanny relationship he is able to create between a text and a public.

His career, which one day will be studied with the minuteness and critical acumen it deserves, is one long series of ruses in artificiality, so prepared and carried out that he has become the legend of himself before his time. He is the city or the urban poet. More than that, he is the poet of a small closed-in space, of a room, of a child's room peopled with phantoms. That room easily became the stage, when the child grew up, where in the limited space between the footlights and the backdrop he could continue to play with phantoms who spoke words he devised for them, in order to create and recreate an illusory world.

A Cocteau play is the demonstration of a mystery. His real voice has often been heard in actual performances of the plays. He recited the part of the chorus in *Antigone,* for example, through a hole in the center of the set. It is his voice that is heard in *The Blood of a Poet.* Even in the most serious plays, the principal scenes are converted into séances of prestidigitation through the writer's persistent need to amaze and startle. The secret connivance by which he captivates the public is always something in the form of a miracle. His theatre is close, closer than that of any other contemporary dramatist, to the original and ancient function of drama: that of religious ceremonial, during which the myths of the people will be reenacted. People are joined with one another only in the presence of a miracle. This function of the theatre was once purely religious, and in the age of surrealism, Cocteau religiously created magic out of the theatre. The simplest of objects, when placed together in startling juxtapositions, create a surrealist décor and upset the monotonous routine of daily life. Cocteau presents the most commonplace objects, but from such a new or surrealist angle, that the spectator may well believe in the presentation of something new. Puns,

enigmas, puzzles, oracles, tricks, coincidences, premoni-
tions are all means of satisfying our permanent appetite
for a miracle, for a wonder-working change of the usual.
This deep human need which the theatre is able to satisfy,
has always been consciously and brilliantly exploited by
Cocteau.

Not only in his plays, but in his life as well, Cocteau has
played the prestidigitator. By his voice when he is actor,
by his opium, by his conversion, by his conversations, by
his remarkable friendships, he is constantly changing his
world. His personal genius is like the surrealist genius of
Giorgio di Chirico, who in his paintings creates a magical
world where a Greek temple may cohabit with a glass-
covered wardrobe, where a perspective and *trompe-l'oeil*
convert a familiar world into a mystery.

Poetry Cocteau has called the secular mystery (*le mys-
tère laïc*), because the poet, like the alchemist and the
astrologer, has his fetishes and his miraculous tricks. The
ultimate miracle to be achieved by a poem is its self-suffi-
ciency. Words lose their usual meanings and connotations
by cutting themselves off from their native world, by sever-
ing all the bonds which hold them back. Then they are
able to mount platonically toward their essences away from
their objective forms. This theory invites the image of
magic. The poem finally exists alone, as a trick does, as a
house of cards, without any of the usual props. Words of
a poem bear the minimum of their daily alliances. This
research in magic might also be called the search of preci-
osity where a word will exist in a new and unpredictable
meaning.

Cocteau belongs natively not to Bohemian Montmartre
or Montparnasse, but to the section of the Champs-Elysées.
His Paris is the elegance of the Madeleine, or, in his won-
der world, the flora and fauna of the deep ocean. His leg-
end of scandal and surprise has been eagerly promulgated
by the Paris public, but behind the legend is a man guided

by his sense of proportion and purity and labor. His début
was like the eruption of a ballet russe. He was ushered into
the world of art as a brilliant fêted genius. His first real
teacher was Picasso through whom avowedly he learned
the low depths of his bad taste and the universe of beauty
which up until his meeting with Picasso he had not known.
The deepest part of our life seems to be formed by an en-
counter with some person, very often a chance encounter
with the one being who is able to illuminate what we had
always been looking at without seeing.

The early examples of painting and music, especially
those of Picasso and Erik Satie, turned Cocteau, at the
very beginning of his career, in 1917-18, into a critic. His
critical method, which he has developed throughout his
life, is comparable to his poetic method in that it must per-
form a kind of chemical action whereby the critic will dis-
cover the unknown and hidden forces of a work of art,
whereby he will reveal the spiritual climate pervading the
work. This definition of the artist by which he is seen to
be the man in contact with the obscure powers which
engender an art may explain somewhat the statement of
Picasso that the technical aspect of the profession is what
can't be learned: *le métier c'est ce qui ne s'apprend pas.*
By *métier* is usually meant the rules and habits, all the
mechanical devices by which a work is assured. In other
words, the *métier* is usually that which is taught, and
Picasso, in his maxim, seemingly overthrows a well-estab-
lished belief. The career of Cocteau illustrates perhaps
what Picasso means. Each new book of his has been dif-
ferent from all the others. The *métier* in this sense is the
art, which is not an experience but an experiment, an
attempt, a risk. The works of Cocteau form a series of at-
tempts and experiments, of tricks that may come off or
may not. And this might well be said for Picasso and for
every great artist who inevitably gambles on a chemical
formula.

II

From the work of Cocteau, which has by now reached considerable proportions, I propose to choose two examples, a play and a film, to illustrate the miraculous aspect of his art. They are both defiances of public opinion, the play in the 1920's and the movie in the 1930's, and they have both by now won a public for themselves. They are two works on the subject of death, or at least they are works which make a magical representation of the world of death.

The play, *Orphée,* was first performed at the Théâtre des Arts in 1926, with Georges Pitoëff as Orpheus and his wife Ludmilla Pitoëff as Eurydice. The tragedy, as the prologue tells us, is played very high up in the air. That means, its action is as purely magical as could be devised. Like a poem, in the Cocteau sense, it has cut itself off from all material and realistic strategies, and, like some trapeze formation, it is enacted in a sphere other than the usual one. And yet, as in a tight-rope stunt, we recognize familiar beings and occurrences: a man, a woman, a horse, a window-repairer. But the danger exists throughout the tragedy that the players may fall, and our excitement is enhanced by knowing that there is no net to catch them.

Orpheus and Eurydice are engaged in a domestic quarrel. On the one hand, Orpheus is under the spell of a horse, an unusual horse which has given him such a strange message that he is going to immortalize it in poetry. And Eurydice is under the spell of a wicked woman in town, Aglaonice, who seems to be bewitching all the women. When Orpheus recites to his wife the mysterious phrase of the horse, *Madame Eurydice reviendra des enfers* ("Mme. Eurydice will come back from hell"), the whole action is thrown into the future, or higher into the air than ever. The sense of the supernatural grows stronger and we are willingly convinced that the actions we watch are being

dictated by the gods. The context seems to be both super-
natural and comically natural. Orpheus as well as the spec-
tators feel the need of a bomb or a scandal to clear the air.
The quarrel culminates when Orpheus darkly suggests that
Eurydice breaks a pane of glass each day in order to have
the window repairer come up. He himself breaks the win-
dow this day and leaves his wife with Heurtebise. We be-
gin to see the multiple services and uses of this man. He
has brought from Aglaonice some poison, in the form of
a piece of sugar, for the horse, and a self-addressed enve-
lope in which Eurydice is to return a compromising letter.
Just before the poison is administered to the horse, Or-
pheus returns unexpectedly for his birth certificate. Heur-
tebise jumps on a chair and pretends to be busy at the
broken window. When Orpheus absent-mindedly removes
the chair, the man remains quite placidly suspended in the
air, and in a few moments the chair is put back under him.
But Eurydice has seen all. It was not enough to have a
speaking horse in the house, now she has a friend who is
able to float in the air. We begin to realize that the large
panes of glass which Heurtebise carries strapped on his
back are perhaps wings. Orpheus has gone out again, but
Eurydice, for whom all mystery is an enemy, has lost con-
fidence in her friend. She licks the envelope for Aglaonice,
only to collapse a few minutes later. She has been poisoned
by Aglaonice who with her wicked women are gradually
taking on in the play the form of the bacchantes. Heurte-
bise puts Eurydice in her room and goes out to find
Orpheus.

The action of the play has been slowly accelerating ever
since the beginning, but we become especially aware of its
increased tempo in the next central scene, when Death, as
a beautiful woman in evening dress, with her two aids
dressed as surgeons, Raphael and Azrael, come in to per-
form the death of Eurydice. Death first gives the sugar to
the horse who disappears, and then enacts a ceremonial

half-surgical, half-mythical on the absent body of Eurydice.
It is over and they have gone, when Orpheus and Heurte-
bise return. When Orpheus in his grief swears that he will
take his wife away from death, Heurtebise says that there
is a way, since Death forgot to take with her her rubber
gloves which are still on the table. The way to Death is
through the mirror, and Orpheus, wearing the rubber
gloves, enters the mirror, and disappears for a second of
our time when the mailman delivers a letter to Heurte-
bise. Orpheus comes back through the mirror leading
Eurydice. Only one detail has to be remembered: Orpheus
must never look at his wife or she will disappear. But the
myth is inexorable, for this is exactly what happens dur-
ing the course of the renewed domestic quarrel. Orpheus,
alone with Heurtebise, now reads the letter which had
come when he was in the realm of the dead. It is anony-
mous and announces that Aglaonice and her women, in-
furiated by discovering that the first letters of Orpheus'
celebrated sentence, *Madame Eurydice reviendra des en-
fers,* spell a vile word, are marching on his house and want
his death. The play ends rapidly with the murder of
Orpheus by the bacchantes and with the disappearance of
his body. Only his head remains and finds its place on a
pedestal. The last scene is in heaven where Heurtebise
is undisguisedly the guardian angel and is taking lunch
with his two wards, Orpheus and Eurydice, who have
finally brought peace to their domestic situation.

Such an action as I have just outlined, permits Cocteau
to treat lightly and subtly very profound preoccupations
and problems and causes of human anxiety. As children
often do, Cocteau willfully tries to puzzle and perturb by
the fantastic secrecy of his writing. A sentence in Breton's
manifesto might apply to *Orphée:* "What is admirable in
the fantastic is that it ends by becoming real." We are so
accustomed to seeing miracles all around us, that we cease
calling them miraculous. Picasso once said that a miracle

occurred every time we take a bath. It is a miracle that a
man doesn't dissolve in a tub of water as a piece of sugar
does.

Orphée is a meditation on death wherein Cocteau mi-
raculously rescues death from disappearing in a void. We
might say that in the play death escapes death or the fate
of nothingness. Cocteau can usually be found wandering
between life and the void. This is what is meant by Coc-
teau's angelism, or the lesson of equilibrium he is always
teaching. His favorite setting is the circus tight-rope, with
heaven above and death below. He is the Parisian artist,
the upstart who was trained by severe muses, but who has
rid himself of all pedagogic traces. His simplicity is very
deceptive. *Orphée* should be played with the swiftness and
directness and ease of a trick in prestidigitation. But it is
a play of condensed richness, a surrealist enactment of the
most tender and the most profound myth of mankind: the
descent of a living man into the realm of Death and his
return from there. Men cannot accept truth directly. Coc-
teau says in one of his aphorisms that truth is too naked:
it has to be at least partially clothed in order to attract or
excite men. (*La vérité est trop nue; elle n'excite pas les
hommes.*) It is almost in these terms that the surrealists
attacked realism.

I know of no more pathetic or moving interpretation of
death in French literature than Cocteau's *Orphée*. This
may seem like an exaggerated claim, but no other work
succeeds so well as *Orphée* does for me in making of the
myth of death, or the fantasy of death, something extraor-
dinarily real. At the beginning of the play Orpheus is at-
tracted toward death by the horse whose messages come
from the realm of the dead, and then he is attracted toward
it, more insistently still, by the death of Eurydice. Cocteau
conceives of death as a magical substitution for life, as a
passage through a mirror. The limits which separate life
from death lose in his play all hardness and precision. The

swiftness of the action and the mathematical neatness with
which everything is evolved are in themselves sufficient to
create the illusion of the supernatural. Orpheus and Euryd-
ice fulfill their destiny on time, as Cocteau, who has very
little sense of the mystical, places his bet on the magic of
the myth: conundrums, mirrors, poison.

III

Cocteau's film, *Le Sang d'un Poète,* is a
further preoccupation with the mysterious properties of
statues and objects, and especially a further meditation on
death. The title of the work is explained in the preface of
the film. A poem, it says, is like heraldry or a coat of arms
on which the symbols may be deciphered after the shed-
ding of blood. The film is dedicated to certain painters of
heraldry and blazons: Pisanello, Paolo Uccello, Piera della
Francesca. (One remembers the surrealists' admiration for
Uccello.)

Here, more solemnly than in *Orphée,* Cocteau defines the
poet as hierophant or as a priest whose function is to ini-
tiate the public to mysteries. The film, which is made pub-
lic, is about a poet whose secret symbols are distinguish-
able only after the expenditure of his blood. This is not
unlike the hermeticism practised by Mallarmé in his priest-
ess Hérodiade. Nor is it unlike the art of surrealists who,
content with expressing the language and image of dreams
and of free association, do not seek to interpret the dreams
or the images of their work. A mystery exists in itself and
must be felt as a mystery. And thus with a poem, which if
explicated and paraphrased ceases to be a poem. Fantasy
may be enjoyed only as long as it remains fantasy and
totally closed off from the logical and the rational. A poem,
a mystery, a fantasy, or the film, *Le Sang d'un Poète,* may
appear at first too inaccessible, too personal or private in its
symbols. And precisely this charge was made of Cocteau's
film: it was denounced as *oneiric,* as being incompre-

hensive to anyone save Cocteau himself. But surrealism, largely because of its important affiliation with psychoanalysis, has taught that what is often called a personal symbol, occurring in the dreams of one individual, is really universal. We meet the past and the future in our dreams where nothing is absolutely private. Time has a oneness, a uniqueness. We actually live many more lives than our own. We are responsible for many more souls than our own.

The tower which we see falling at the beginning of the film and whose collapse is completed at the end of the film, indicates that what we see in between is a dream or some psychic experience which cannot be denoted by the usual concept of time. The rapid tempo of *Orphée* and of Cocteau's plays in general, is here pushed even farther thanks to the art of the cinema. We have to suspend our usual belief about time in this film, where there is no date and where there are costumes of different periods, as well as our belief about natural laws, because we see a man go through a mirror as if it were water, as Orpheus did in the play, and a young girl fly up to the ceiling. Cocteau never forgets for long his symbols of deep-sea diving and of tight-rope walking.

I. The film has four parts, the first of which is called: *La main blessée ou la cicatrice du poète* ("the wounded hand or the poet's scar"). At the beginning of this part we hear Cocteau's voice say: "While the cannon at Fontenoy thundered in the distance, in a simple room. . . ." And the story begins with a young man, obviously the poet-hero, drawing sketches of a face. He is Cocteau, at least spiritually, because on his shoulder he bears Cocteau's star-signature as well as a scar, and graphically he is the movie hero, resembling Rudolph Valentino. After a knock is heard on his door, he notices that the mouth of his drawing is living, and tries to rub it off with his hand. The visitor, who is horrified, leaves almost immediately, and

the artist sees that the mouth is now on the palm of his hand. It begins to breathe and ask for "air." The man kicks an opening through the window and puts his arm outside. But the mouth remains on the hand. With it the poet now caresses his body and falls asleep. On awakening he places his hand on the face of a woman's statue and the living mouth is transferred to hers. Her voice is heard to say: "Isn't it foolish to dry oneself on furniture? Isn't it foolish to awaken a statue from its sleep of centuries?"

The central symbol of this part—the mouth, which originally is drawn by the artist on paper, and then adheres to the palm of his hand and is finally clapped on the lips of a statue—combines the experience of eroticism and poetry. The mouth both kisses and speaks. It is used both to arouse the sensations and to transform them into art. It might well be a convenient symbol for the dual nature of art: the madness and the reason of art, the Dionysian and Apollonian aspects of art. It would represent the indulgence of sensuality and the origins of form. This first episode is also reminiscent of the myth of Pygmalion, whereby the created work of the artist takes on a life of its own and literally ends by transcending the life of the artist. This is implied in the mysterious words of the statue, which awakens from a long sleep. A statue, as it is being made, is enslaved to the genius of the sculptor. It is almost victimized. But when the statue is completed and released, it becomes, in its turn, the victor and the master. The "sleep of centuries" is the sleep of the subconscious which awakens in dreams only to dominate and victimize the sleeper.

II. The second episode is entitled: *Les murs ont-ils des oreilles?* ("Have the walls ears?") The mouth of the statue says: "Do you think it is so easy to get rid of a wound, to close the mouth of a wound?" The room is more than ever a prison for the artist's isolation. But the door becomes a mirror and he dives through the mirror as through water, as Orpheus did in the play. And this time,

we follow the poet into his hell which appears as a hotel corridor. He becomes a *voyeur* in looking through four keyholes as he moves down the corridor.

1. In the first room he sees a Mexican being assassinated by a firing squad. The film is then reversed and we go backwards in the action of the shooting scene. The voice says: "At daybreak, Mexico, the boulevard Arago, the ditches at Vincennes and a hotel are equivalent." The seeming free associations of four places are united by the ever-imminent possibility of life becoming death. Life continues by the very cycle of life-death-life. So, time continues and is reversed also. This second corridor scene is a kind of dream within a dream, or a movie within the movie. The eye of the artist-dreamer is the camera and his brain is filled with the pictures it records.

2. The second room which the poet-*voyeur* observes is an opium den. Here again, it is the vision of a dream, or the dream of a dream which he sees. An unwinking eye looks back at him. In a dream one is seen by what one sees.

3. The third room is called *leçons de vol* ("flying lessons") in which we see a young girl punished by a woman who is obviously a schoolteacher armed with a whip. The girl rises up to the ceiling from where she is able to mock her teacher. In dreams we are able to do what we dream of doing in life.

4. The fourth scene, *Un rendez-vous désespéré,* is the only one in which the poet ceases being a *voyeur* in order to participate in the action. We see a bull's eye revolving on a screen, a sofa with the head of a woman and legs of a man, a hand holding a revolver, and we hear a voice which gives the command to fire. After the explosion, the poet appears dressed with laurel and a robe —and the voice says: "I open the way to glory." Then he tears his laurel and robe, and returns through the water-mirror, as we hear the words: a typical Cocteau pun: "Mir-

rors ought to reflect a little before giving back their images." With an axe, the poet destroys the statue. And the voice ominously warns: "In breaking a statue, you risk becoming one yourself." (*A casser une statue, on risque d'en devenir une.*)

These two episodes are united, and magically so, because one is the world of the living and the other the world of the dead. They both take place in rooms or closed-in spaces which emphasize the mystery on which they are founded. The four scenes in the hotel all bear some relationship to death: 1. the execution of the Mexican peasant; 2. the opium death of consciousness and the senses; 3. the death by terror and sadism in the schoolteacher scene; 4. and finally the suicide of the poet. If the first episode of the speaking statue represents, among other things, the Pygmalion myth, the second episode of the hotel corridor represents the myth after Pygmalion. After the myth of the creation and life comes the myth of destruction and death. In his act of creation, a poet is inexorably destroyed by what he creates.

III. The last two episodes are united as the first two are, and the setting this time is outside. In the part called "The snowball fight" (*La bataille des boules de neige*), Cocteau uses the opening scene of his novel, *Les Enfants Terribles,* and even the name of one of the characters, Dargelos. During the course of the snowball fight between school boys playing in a courtyard, a bronze statue disappears as if it had been made of snow. Dargelos, "the fighting cock of the class," the bully, stands beside the vacant pedestal, strong and defiant, almost as if the hardness of the statue had gone into him. After Dargelos hurls a snowball, which he has made hard and icy, at his friend, he runs off. The voice says: "The snowball marked the heart of the victim, and marked the blouse of the victim erect in his solitude, the dark creator whom nothing protects."

The fatal snowball is probably the origin of the poet's

wound which we saw in the first episode where the hero appeared naked to the waist. The wound on the boy's heart changed to his shoulder in manhood and is confused with the star, which is Cocteau's personal signature of his work. The physical snowball wound symbolizes the spiritual heart wound of the boy who was in love with Dargelos, and hence victimized by him. Later, when the boy victim becomes poet-victor, the wound becomes star: the boy becomes Cocteau. The boy, once victimized by the "coq" of the class, became Cocteau (a pun possible only in French). The literal experience which killed him, or which caused him to suffer, is transformed into the art-experience which makes him creator. In the first two episodes, the action perpetrated by the artist on the statue—first, in giving it life, and second, in destroying it—is now recapitulated in the third episode, which is a throwback to childhood when Dargelos, the hero-bully of the class, inspires love in his schoolmate and then kills him with a hard snowball.

IV. The fourth and last episode of the film, *La Carte Volée* ("The Stolen Card"), is a continuation of the third. After seeing a statue come to life, we now witness the reverse: a living boy turn into a statue. The murdered boy lies on the snow, a kind of statue in death, with which the slayer, now the poet, is to be victimized. When the poet grows up, he is both Dargelos and the boy slain by Dargelos. A card table has been placed over the boy's body, and a scene takes place strongly reminiscent of the scene of Death and her two aids in *Orphée*. At the table, playing cards, are the hero, dressed in tails, and a woman in evening dress, who is the statue. At some distance from them are two groups of people in open loges who follow the spectacle indifferently. The poet draws out from the coat of the boy under the table the ace of hearts. Any human experience, hidden under its symbol, might be compared with a card trick, whereby an artist both realizes himself as artist and deceives the spectators. The people in the

loges represent the public's incapacity to follow the poet. A naked Negro, whose oiled body is in appropriate contrast with the snow of the scene, is the guardian angel or even possibly St. Michael himself, who takes the dead boy away. He plays the part of Heurtebise in *Orphée* in directing the action of the dénouement. He takes the ace of hearts from the poet who shoots himself. The woman walks off and we see at the end of the film the bull of Europa, the lyre of the poet, the head of the woman now become a statue, and we hear the voice saying: *ennui mortel de l'immortalité* ("the mortal boredom of immortality").

IV

Le Sang d'un Poète is a story in reverse action. We begin by seeing the poet. The first episode is dominated by the symbol of the mouth, which is the symbol of poetic speech. It is the story of poetic creation. The second episode, dominated by the symbol of the eye, is the effort of the poet to see into himself, to see back of the present and the symbol-laden poetry he is composing. The third episode is the specific scene of childhood which has dominated the poet's life, the scene in which he received his poet's wound, and which he has come upon in this deep exploration of himself and his past. Here the sense of touch is the most exalted in the film, both the sensation of making the hard snowball and of feeling its impact. The fourth episode is apothesis. The card trick might be taken as the symbol of art, surrounded by its various signs of immortality: the angel, Europa, the lyre.

In a way, the film is a season in hell. But hell is conceived of as being within a man, an inner darkness of strange moving figures, quite independent from any theological hell. All the writings of Cocteau, and not only the specific works of *Orphée* and *Le Sang d'un Poète,* raise the problem of artistic subterfuge, of the poetic lie or transformation. It is a central problem for every artist.

Montaigne, Rousseau, and Gide advocate the need of confessing everything. A literary work should be a public avowal. Flaubert said just the opposite. In many of his letters to Louise Colet, he emphasizes his unwillingness to reveal anything of his personal life in his writings. The surrealist method of confession is the dream relation, the bringing to life of all the shadowy figures who stalk us in the obscure parts of our being. The pure surrealist method would be the direct narration of these experiences as they come to us in free association. Cocteau takes this method one step farther, or leads it to its necessary conclusion, by imposing on the confessional dream-world a very deliberate and calculated form. His works are formalized by a provocative relationship with the persistent myths. Myths come to life over and over when an artistic work has enough formal solidity to contain them.

The difference between Montaigne's confession and a surrealist confession might be the difference between sincerity and lucidity. It is one thing to be sincere and another thing to be sufficiently lucid to have something to be sincere about. There is also the problem of having someone to be sincere to. Pascal pointed out, for example, that the Catholic Church doesn't oblige the sinner to tell his sins to everyone. Gide has pointed out that lying isn't one of the capital sins, and that Christ never formally forbade lying.

In the soul of the lucid man, of the man who heeds both his conscious and subconscious states, there seems to be an equal proportion of tragedy and ambiguity. Much of surrealist art and Cocteau's theatre are concerned with the existence of ambiguity. In Cocteau's use of fables, he snares heroes, Orpheus, Oedipus, Pygmalion, Galahad, who are too gigantic for us and who have to be reduced somewhat by means of comedy and enigma. In one of his poems, he says: *Je suis un mensonge qui dit la vérité.* ("I am a lie which is speaking the truth." *Opéra.*) Art may well be that

form of a lie which leads us closer to truth. Montaigne in speaking of the make-up which women use, their disguise, as he calls it, makes the point that thereby deception is honorable. We are led to the truth by a false door. (III, V)

The main struggle we go through each day is with those forces which prevent us from being authentic. The surrealist believes that this struggle is resolved in the method of free association where we may have a revelation of the basic truths about ourselves. Of course, very few are able to stand these truths. Surrealism was first attacked on the grounds that it was not understandable. Then, when people began to realize that it was understandable, it was attacked on the grounds that it revealed too much, that there are some secrets about us which should be left secrets. As soon as truth begins to invade the realm of the taboo, it will be ostracized.

I have often thought that *The Blood of a Poet,* and for that matter, all the writings of Jean Cocteau, might be explained in terms of the Greek hero Philoctetes, the warrior who is wounded and who holds the bow in his hand. Philoctetes relates the ambiguous myth of the genius, who is both strength and weakness, who is both power and impotency. It would seem that the genius of the artist has a propitiatory or sacrificial origin. Genius is allied with illness, and in many cases literally with the loss of blood. Strength cannot exist without mutilating itself. The writer is like the trapeze-artist who has to practice all day long in order not to break his neck at the evening performance. And so, the artist holds the very ancient privilege of fool and idiot and quasi-prophet. He reappears today as clown, *voyou, voyeur,* card-dealer, and as that newest incarnation of magician: the movie director.

VIII · ELUARD: *the doctrine on love*

I

In February of 1917, Max Ernst, a German artilleryman, was engaged in bombarding, at the distance of a kilometer, a trench in which Paul Eluard, a French infantry soldier, was standing guard. Three years later, Max Ernst, the surrealist painter, and Paul Eluard, the surrealist poet, were friends in Paris, engaged in a movement which for them went far beyond aesthetic doctrine and criteria. It was taking on for them the form and the potentiality of the total emancipation of man.

It seemed for a moment, at least in the early part of its history, that surrealism was obliterating the solitude of the artist, of that special kind of solitude which I described in the second chapter as the most important characteristic of the modern artist. True poetry for the surrealists was seen to be a part of every force which was working for the liberation of man. The poet was no longer the inspired man; he was the one who inspires. And because he is involved in the life of every man, in the common life, his art seeks to reduce the differences which exist between men. The most exultant claim which the surrealists made for poetry is this absolute force it possesses for purifying

man. Eluard and the other surrealist poets often repeated Lautréamont's statement that poetry must be made by all and not by one man. If surrealism is, according to one of its major propositions, an instrument of knowledge, it must work to reveal the profoundest conscience of man. Knowledge of self will lead to knowledge of all men and from there to the union of all men.

If we say that the greatest fear of man is that of losing his freedom, we may say the same thing about poetry. Throughout its long history, which appears to be quite as long as the history of man himself, poetry has always trembled at not possessing sufficient freedom, at having to give up some precious part of itself to the institutions of man: to religion, to politics, to morality. Poetry fights for its purity as man fights for his freedom, and both are usually degraded. The history of poetry (and we might say the same thing about the history of man) is so exclusively the history of its degradations, when it was made the accomplice in very subtly arranged compromises, that we hardly know what poetry, in its pure state, is. Poetry has been allowed to exist only when it would renounce or enslave some part of its being.—We will let you sing, it was told, only if you sing such and such a subject and only if you sing it in a specific way.

The enslavement of poetry parallels the enslavement of man. Its history might be written in terms of the gains and losses of man's freedom. It embraces so generously the problems of man that it is impossible to separate them, that we cannot speak of one without speaking of the other. It has often occurred to me in reading surrealist texts that surrealism considers the history of man as if it were a long sleep filled with the phantom-like movements and patterns created by the characters of a myth. At the beginning of time, as soon as man felt himself a being distinct from the universe, his conscience was formed, and the main activity of man's conscience has been the engendering of his myths.

In his myths, he accomplished the universe, by returning to it and by seeking to establish his relationship to it. Man's poetry is a very obscure and very incomplete search for precisely this knowledge of what his relationship to the universe really is.

But poetry may not be considered a history or a myth or the history of a myth. The only thing we can feel certain about poetry—and to this the experiment of surrealism has made an illuminating and reassuring contribution—is that its essence has something to do with the present. It has something to do with the revelation of the eternal present. Poetry must recapitulate that feeling of oneness, that reality of the ego which was the birth of man's conscience at the beginning of time. Poetry is a kind of explosion of that ego, a release of the ego in its way back to the universe. Like every explosion, poetry takes place after a period of compression and repression when disparate elements can no longer cohabit together, when they must break asunder and return to their primitive sources, as fire returns to the air. This image may help us to understand the surrealist belief that poetry is born from the destruction of principles, of superstitious rule and artistic prejudice. The surrealists called for the suicide of art and the renascence of poetry in the same way that they called for the demolition of social and political barriers and the emancipation of man.

The surrealist poets, Breton, Eluard, Tzara, Soupault, continued the tradition of the *voyants* of the 19th century. In the wake of Baudelaire, Rimbaud and Mallarmé, poetry continues to be for them the effort to find a lost language. The image or the metaphor is the result of a certain kind of chemistry. In symbolism, the chemistry was too conscious of its means and ends. Surrealism tried to go beyond the elaborate consciousness of symbolism to the very source of poetic imagination, to the very sleep in which the myths of man are preserved.

The miracle of poetry or the wonder of its history is, I suppose, its uselessness, its total lack of value. In the light of certain theories of history in which man is characterized by an economical struggle for survival, the persistence of poetry is a difficult fact to account for. Poetry is the history of man's disinterestedness. Among all the occupations of man, which have no value or use in a material sense, the art of poetry is the most impressive. And he comes to it, usually at the end of adolescence, just at a time when he might well be considering more practical matters. Most boys from fourteen to eighteen spend a good deal of time dreaming and day-dreaming. A dream, however, is not a poem. These boys become poets from eighteen to twenty-two, if they convert their dreams into images. It has been said that it is no proof that a man is a poet if he writes poems at twenty. The proof is if he writes them at thirty and at fifty. The period of images, which is the period of poetry, may be succeeded by a period of thought. The poet may become critic or philosopher. The philosopher is an old poet whose communication is no longer made by use of images. The engagement of thought is one of the surest means of defeating the anguish of solitude. The limitless solitude of Baudelaire, for example, was never defeated by his activity of poet. The reason for this has perhaps something to do with the nature of the image itself.

I feel there is some connection between the limitless solitude of the poet and the magical properties of the image which are, in another sense, limitless. In this effort to define the image, I am thinking particularly of certain emphases which the surrealists gave to its character. In the poetic images, everything is comparable to everything else: Evening may be spread out against the sky, as Eliot says, like a patient etherized upon a table. In the image everything finds an echo and a resemblance. It may be defined by its power of becoming and discovering, by its limitlessness. It contains both resemblances and oppositions, and

illustrates what Baudelaire called in his *Spleen de Paris:* the logic of the absurd (*la logique de l'Absurde*).

As the dreamer preceded the poet, so the dream precedes the poem. Behind every poem exists a vision which is dead and consumed. A dream sensitizes the universe, but a poem desensitizes it and permits man to see a different world, or to see the same world differently. The greatest privilege which the artist enjoys, and we might say it is his only privilege, is that of being himself and of being anyone else he wishes to be. The poet's means of exercising this privilege is the creation of an image. The image has the same compulsion for the poet that color has for the painter and that three dimensional form has for the sculptor. When the surrealist painters undertook to illustrate the surrealist poets, they made no attempt to describe the images of the poems; they created further images which serve to enlarge the meaning of the verbal images. This process may be studied in Picasso's drawings for Max Jacob (*Le Siège de Jérusalem*), in the drawings of Ernst for Breton's *Château étoilé,* in Tanguy's illustrations for Péret (*Dormir dormir dans les pierres*), in Marcoussis' illustrations for *Alcools* of Apollinaire, in Dali's pictures for Lautréamont, and in many other collaborative works.

An image is a pure creation of the mind. No surrealist was ever able to create, as he would have liked to, a purely spontaneous image, whose nature was entirely private and oneiric. The memory of each one of them was so densely crowded with images from the romantic poets and others, that their images are often traceable. But their images are recognizably surrealistic in their quality of precipitates. They are more diaphanous and imponderable than the images of other poets. Their aim is to avoid the danger of using the image to communicate some point. The image must not be useful; it must be innocent. Surrealist art must be stripped of rhetoric: it must never seek to prove anything. The great common error which the surrealists never

ceased attacking was the belief that language was created
in order to help men in their relationships with one an-
other. This was an aberration, for André Breton. The
highest goal of language, for which it was created, was the
attainment to a disinterested purity. So, poetry is some-
thing other than language. It is the deviation from ordi-
nary human speech, a deviation in which words are juxta-
posed and pressed against one another in unusual combina-
tions. If ordinary language is the communication of what
is thinkable with what is thinkable, poetry is the communi-
cation of what is thinkable with what is unthinkable.

In the creation of romantic poetry, the initiative was
always taken by the poet's sentiment and feeling. Then
the words were found to correspond to or to translate the
sentiment. In surrealist poetry the initiative is left to the
words which then embark upon an extraordinary adven-
ture of discovering the sensation or the dream or the ob-
scure experience of the poet. In romantic art, sentiments
register and engender words. In surrealist art, words, the
most innocent ones which form with the minimum of pre-
meditation, engender and register the sensations and the
experiences of the poet. So, it might be said that the poet's
words, and the images which magically come together in
his words, construct the poet. He is made out of his words.
There is no such thing literally as immediate poetry or
the spontaneous creation of a poem, but there is a species
of passivity and of submission by which the poet is worked
upon, which, beyond any doubt, plays an important part
in the creation of a poem.

II

Modern poetry has been obsessed by a
search for purity. During eighty years this obsession has
been constantly expressed in such poems as *L'Invitation
au Voyage* of Baudelaire, *Hérodiade* of Mallarmé, and in
all of his writings for that matter, in *Fragments du Narcisse*

and *La Jeune Parque* of Valéry. These poems, which are among the finest poetic achievements of our age, have led the art of poetry almost to a mortal extremity where its very attainment to purity seems equivalent to self-annihilation. In all of these poems, the purity of the formal expression is inextricably allied with the theme of the absence of love. The figure of Narcissus, of self-love, of evasion of love in the ordinary sense, has settled down over the poets' obsession for purity and justified it by serving as its solitary and deepened myth. André Gide, in his early books especially, exalted the thirst for love and depreciated its satisfaction. Narcissus replaced Eros as god for poets. The art of poetry became equivalent to the evasion of life, the evasion of living by assuming the ordinary responsibilities. Love was not celebrated as much as the fear of love. The poet would dare to fall in love only with the phantom of an unknown woman met in his dreams. This is the subject of Verlaine's *Rêve Familier:*

> Je fais souvent ce rêve étrange et pénétrant
> D'une femme inconnue et que j'aime et qui m'aime.

The solitude of the genius was more firmly barricaded than ever, and his poetry was reproached for its hermeticism, for its purifactory ideal which had driven out all the familiar stories and sensations. Rimbaud was admired as the poet-magician, the poet-alchemist, and not as the poet-lover. The last of the great love poets was Baudelaire, but his conception of love had been so tragic and anguished, that he had perhaps been more responsible than anyone else for the poets' abandonment of love.

The surrealist revolution, when it first broke out in its eloquent statements and histrionic behavior, called for total liberty in all human activities, including the activity of love. At the beginning, this freedom of love, in the surrealist sense, seemed to be fairly synonymous with the

freedom for licence or licentiousness. Love was an experiment with unusual sensations. Rimbaud's celebrated phrase, "the derangement of the senses," was easily interpreted as being an encouragement to the practice of perverted forms of love. The problem of love in the lives of Lautréamont and Rimbaud—a problem which I should like to say will always remain obscure and indecipherable but which if we knew more about it and if we understood more deeply the meaning of love, would appear more sane and universal than many now believe—seemed to justify waywardness and experimentation in love. But this initial intoxication with freedom in love never developed to any degree within the ranks of the surrealists.

The two leaders especially, Breton and Eluard, due perhaps to the very freedom they felt about such problems, discovered in the experience and the meaning of love a lesson of purity quite opposed to the purity of love's absence. They discovered (or rediscovered) the pure love of woman and have sung of this love as ecstatically and vibrantly as any Ronsard. Their very intoxication with liberty seems to find an outlet in their love of woman, in their joy over this love. The secrets of the human spirit were revealed to the surrealists, one after the other in accordance with the surrealist process of free association, of spontaneous and involuntary revelation. Their concept of woman seems to spring from the deepest part of their subconscious and to rise up to their consciousness with a primitive and almost sacred insistence. It would not be exaggerated to say that the surrealists have contributed to a rehabilitation in literature of the rôle of woman as the fleshly and spiritual partner of man.

Love, even when it is treated negatively as a force *in absentia,* is the essential theme of all poetry and all literature. . . . Love is at the same time, paradoxically, our surest way of escaping from the world and our profoundest way of knowing the world. Paul Eluard is perhaps

the most eminent among the surrealists, as D. H. Lawrence is perhaps the most eminent modern writer outside the ranks of the surrealists, who have maintained an extraordinary and lofty awareness of this truth. They both knew that behind the multiple hyperboles and absurdities of love, behind the delirious profusions of love, it is the one force in man capable of breaking through the iron gates of language and reason: the two obstacles to love which have been inherited from man's age-old fear of love and its falsely named debilitating power.

I thought for a long time that Eluard's particular conception of love was comparable to the system of chivalric love, to something quite similar to courtly love of the early romances of the troubadours, to the *dolce stil nuovo* of Guinizelli and Cavalcanti, where man lives in an idolatrous submission to his lady. There are moments in his poetry when this comparison might justifiably be made. But on the whole, I now see his conception of love possessing a somewhat different emphasis. Woman is quite often absent from his poetry, but his love for her has made practically impossible the kind of solitude which is so characteristic of previous poets. The experience of love has finally dominated the experience of solitude, or has made out of the literal experience of solitariness another kind of possession. The eternal presentness of love is the new experience which Eluard explores in his verse.

III

It would almost seem that his volume of 1926, *Capitale de la Douleur,* is a new approach to the doctrine of love, a new erotology, one in which love is reconsidered as the great cosmic drama for man and in which the particular rôle of woman is accorded a new preeminence.

Eluard's thought plays with the reality of love as if it were the poet's magnet. He moves toward it and then

moves away. Although his amorous ecstasy is always severe
and illuminated, one feels that love itself is an experience
which has taken place at a great distance from the earth
and beyond the limits of time, in some dark abyss. Love is
the experience greater than man himself which he records
and reproduces. It is older than he and more rigorously
solitary than he is. It is also that experience in the midst
of which man is unable to rest or establish himself with
respect to space and time. Love is so perfectly composed
of desire and despair that it is always in motion. Man is
unable to fix himself within any part of it. He lives and
grows and changes in love. And poetry is his metaphysical
book on love, his guide book perhaps, the *summa* of all his
questions and answers. Love is the supreme experience
where the flesh and the spirit cease contradicting one
another, and this is the exact phrasing which Breton used
in defining surrealism in his first manifesto. After all the
poems on the obsession of purity, *Capitale de la Douleur*
comes as a book on the obsession of love in which man is
portrayed as being both tragically and spiritually depend-
ent on love.

The poem *Première du Monde* (p. 101) is dedicated to
Pablo Picasso, and contains in its images, as many canvases
of Picasso do in their lines, the secret of woman, of the
first woman, and the secret place she holds in the universe.

> Captive de la plaine, agonisante folle,
> La lumière sur toi se cache, vois le ciel:
> Il a fermé les yeux pour s'en prendre à ton rêve,
> Il a fermé ta robe pour briser tes chaînes.

In the first of the five stanzas, the images of the plain and
of madness describe the unlimited power of woman and
the strange uniqueness of her vision as contrasted with
that of man. Light, which is a usual image to describe the
infinite, is hidden on woman, and the sky itself is con-
ceived of as closing its eyes in order to attack her dreams.

The sky closes her dress in order to break her chains. This is her myth: she is not dependent on the light of the sky because she has it within her. She is the being who is uniquely free. Man looks at the universe and can see only a woman.

> Devant les roues toutes nouées
> Un éventail rit aux éclats.
> Dans les traîtres filets de l'herbe
> Les routes perdent leur reflet.

The second stanza, with its startling juxtaposition of wheels and a fan, describes woman as the circumference and the womb and the sex of the world. The tied-together wheels, which bear the weight of the world and propel it through its destiny, designate the physical responsibility and function of woman. But the laughing fan, the other symbolic circle of woman's power, is the object of her charm and seductiveness, the simple lure by which she accomplishes the rotation of the world. So, woman is both principle (the world's wheel) and every particularity of the principle. In the same stanza the image of the grass where roads lose their reflections and their character, describes the drama of man and woman. She is the grass (as she was first the plain and the limitless light of the sky) and he is the road which first cuts across the grass, only to be lost in the new growth, covered and absorbed by woman's principle of eternity. Man loses his original form and personality in the experience of love. Woman is, and man is always trying to be.

By comparison with such images as those of the wheel and the grass, the cult of man in the 19th century and his vehement regimen of individualism take on an almost absurd aspect. Eluard surpasses in such a poem as *Première du Monde* the glorification of the solitary male genius. In his poetry man is no longer looking at himself for he has begun to contemplate the mysteries and has quite right-

fully begun with the mystery of woman. Ezra Pound made once a profoundly prophetic statement when he said: "Our time has overshadowed the mysteries by an overemphasis on the individual." The poetry of Eluard marks a great increase of illumination on an idea which has been subtly growing ever since the hermetic sonnets of Gérard de Nerval. He was perhaps the first of the modern poets (and modern men) to be subjugated by the meaning of woman in somewhat the same way that Eluard makes so explicit. Baudelaire fought and struggled tragically, like one of the damned, against this idea of woman. Nerval seems to have foreseen what Eluard feels: the magic of all the objects of his desire, the all-encompassing realm of magic which woman represents and creates.

> Ne peux-tu donc prendre les vagues
> Dont les barques sont les amandes
> Dans ta paume chaude et câline
> Ou dans les boucles de ta tête?
>
> Ne peux-tu prendre les étoiles?
> Ecartelée, tu leur ressembles,
> Dans leur nid de feu tu demeures
> Et ton éclat s'en multiplie.

The next two stanzas of *Première du Monde* pose two questions which are overwhelmingly revelatory. The man asks these questions of the woman (or we might say that the poet asks them of Eve). The first question: "Can't you hold the waves in the palm of your hand?" signifies woman's possessiveness of all that is unruly and vain, her power of control and the physical supremacy of her being. The second question: "Can't you hold the stars?" is an image of the marvellous in the surrealist tradition. Woman resembles the stars because she is *écartelée;* that is, she is extended on a rack (this is the recurring wheel image of the second stanza) and drawn toward the four opposing

directions. She is everywhere in the universe, as the sky
is spread out, and she is unique at the same time. She is
one being and all beings. Her brilliance is multiple like
the myriad fires of the stars, and it comes from a prodigious
distance in space and time.

> De l'aube baillonnée un seul cri veut jaillir,
> Un soleil tournoyant ruisselle sous l'écorce.
> Il ira se fixer sur tes paupières closes.
> O douce, quand tu dors, la nuit se mêle au jour.

In the final stanza, the dawn is gagged (*l'aube baillon-
née*) as the wheels, in the image of the second stanza, were
tied together (*les roues toutes nouées*). It is as if the sun
were trying to pour out from under the bark or some
covering. (*Un soleil tournoyant ruisselle sous l'écorce.*)
Then the image is explained when the poet speaks of the
sun on the closed eyelids of the woman. During the sleep
of the woman, night is joined with day. She is the being
synonymous with light, independent of light because she
contains it all. *O douce quand tu dors, la nuit se mêle au
jour.* She is like the dawn, bound and gagged; like the
wheels of the sun chariot, tied together during her sleep.

In such a poem, it is quite possible to see what surrealist
inspiration, largely under the influence of Rimbaud,
whose methodology in *Les Illuminations* is here appro-
priated, has been successful in creating. What once was
epic drama and historical recital, is now cerebral and psy-
chic. The drama of love is played in the mind. It is lyricism
of one moment, a flash of time, that is never over, that is
anonymous and universal and hence mythical. The mind
appears before itself, filled with the image of woman so
resplendent in her nudity that she is all degrees of light:
angelic and demonic, carnal and spiritual, unique and
universal.

The final poem of the volume, *Capitale de la Douleur,*
is appropriately placed at the end because it summarizes

the work and the theme, and appropriately entitled: *Celle de toujours, toute* ("She of all time, all"). The poem is the apothesis of song, the opening out of meaning and deliverance in which we may see more clearly than anywhere else in the book the relationship between man and woman. The other poem I have just analyzed is principally a poem about woman. But now the poet tells us that woman is not the femaleness of his body—*C'est qu'elle n'est pas celle de mon corps*—and that explains why he has to abandon her. He has never boasted of accomplishing absolute union with woman. As the fog through which he has moved doesn't know whether he passed or not, so woman, in her eternal and all-encompassing principle, is unaware of the passing or the accident of man in her life.

> Si je vous dis: "j'ai tout abandonné"
> C'est qu'elle n'est pas celle de mon corps,
> Je ne m'en suis jamais vanté,
> Ce n'est pas vrai
> Et la brume de fond où je me meus
> Ne sait jamais si j'ai passé.

That is the introduction. In the second stanza, which is the longest part of the poem, the man speaks of woman and proclaims that he is the only one to speak of her, the only one who is surrounded by the mirror of woman. Here is a further notation on the mirror-symbol, where Hérodiade saw herself, in Mallarmé's poem, and through which Orpheus passed, in Cocteau's play, and through which every poet must pass as into the ocean, into the principle of maternity, which may be disguised by the words *ocean, sky, stars, cloud, fog*. All of these images of woman recur persistently in this poem, and in the others of Eluard. At the end of the stanza, the generosity of woman, her principal characteristic so clearly opposed to the selfishness of the male, which has already been described by the image of limitless light, is translated now by the image of blood,

le sang de la générosité, with all its multiple meanings of
life, sacrifice, birth, sexuality.

> L'éventail de sa bouche, le reflet de ses yeux
> Je suis le seul à en parler,
> Je suis le seul qui soit cerné
> Par ce miroir si nul où l'air circule à travers moi
> Et l'air a un visage, un visage aimé,
> Un visage aimant, ton visage,
> A toi qui n'as pas de nom et que les autres ignorent,
> La mer te dit: sur moi, le ciel te dit: sur moi,
> Les astres te devinent, les nuages t'imaginent
> Et le sang répandu aux meilleurs moments,
> Le sang de la générosité
> Te porte avec délices.

The ending of the poem, the final eight lines, is the
definition of the poet. He is the singer, the one who sings
the joy of singing about woman, whether she is present
or absent. This would seem to be the key to the new ero-
tology of Eluard. Woman, by her very existence, suppresses
the concept of absence. She also suppresses any meaning we
can give to the words *hope, ignorance, oblivion.* The mys-
tery of the poet's song is that mystery in which love created
him and liberated itself. Creation is freedom. By the fact
of his existing, he knows that woman exists and surrounds
him at all moments. His principle is defined by his freedom
to move within woman. She is everything that he is, but in
a higher degree, and this is set forth in the final line where
woman's purity is sung of as being purer than man's.

> Je chante la grande joie de te chanter,
> La grande joie de t'avoir ou de ne pas t'avoir,
> La candeur de t'attendre, l'innocence de te connaître,
> O toi qui supprimes l'oubli, l'espoir et l'ignorance,
> Qui supprimes l'absence et qui me mets au monde,
> Je chante pour chanter, je t'aime pour chanter
> Le mystère où l'amour me crée et se délivre.

On a very superficial level, on a narrow psychoanalytic level, the particular relationship which man bears to woman, as shown in this poem, might be defined as masochistic. But the meaning seems to me to go much deeper than that. Man is attached to woman, as he is attached to all the mysteries through which his life unfolds. He is attached to woman because he is man and dependent upon her for the event of his life. Eluard's is not the worship of the chivalric poets. They had nothing of the deep sense of tranquility which is the principal character of Eluard's love. The particular suffering of love, generated by the coming together of the Christian concept, the *Agapé*, with the Pagan concept, *Eros*, which became the drama of love in the Western world from the story of Tristan to the novel of Proust, is not completely absent from the poetry of Eluard, but it is strongly counteracted by a worship of the mystery of love, by a tranquility in the presence of love which seems far more primitive than either Christian or Ancient. Picasso, more than any other single artist in Europe, helped to reveal during the years which just preceded the surrealist movement, the power and the character of primitive or Negro art. Something of the tranquil worshipfulness of woman as a mystery, which Eluard may have first seen in the paintings of Picasso, as well as those of Gauguin, has been carried over into his verse, where there is an abundant song of woman without the harassing agony of sexuality. Love is not for Eluard, as it is for Tristan, the experience and the desire for death; it is rather the sense and meaning and ambiency of life.

IV

Appearing more than ten years after *Capitale de la Douleur*, Eluard's volume *Chanson Complète*, of 1939, has an opening poem, *Nous sommes*, which demonstrates his continued and deepened preoccupation with the doctrine of love.

The first part of the poem, 24 out of the entire 34 lines, is dominated by the motif *tu vois* and the category of things which woman sees. In the first category, woman sees such things as the evening fire, the forest, the plain, the snow, the ocean; and almost each one of them is characterized by a brilliant image, such as the evening fire which emerges from its shell: *Tu vois le feu du soir qui sort de sa coquille.* This is the list of immensities and infinities with which woman is so often compared in Eluard's verse. Then we read a kind of second category, of more humble and more finite objects: stones, woods, towns, sidewalks, a square where solitude has its statue and where love has a single house. These are the second things seen by woman which have their place and their name within the limitlessness and the namelessness of her vision. Animals are here, too, like twins or perfectly resembling brothers who are comprehensible to woman in their destiny of blood sacrifice.

At the end of the categories, a climactic stanza brings back the mirror-symbol of woman, so suitably conclusive to the elaborate litany of her visions. She is one with all the women who preceded her, who come down from their ancient mirror bringing her their youth and faith and especially their illumination which permits her to see secretly the world without herself. Woman sees the universe, but man is myopic. He sees solely himself, or he sees himself in the objects he looks at. The mysterious vision of woman is the key to her sensitivity.

The title of the poem, *Nous sommes,* is explained at the end, where men are described as harvesting their dreams. They are first the workers, the laborers, but they are especially the dreamers and hence the poets. "We are," according to the poet, *Nous sommes,* in relationship to woman, who sees, who, sun-like, illumines all. Man is defined by a mystical dependence on woman. He is, when he is with her, when he is sleeping in her or under her shadow.

The complete song of man, the *Chanson complète*, which serves as title for this volume of Eluard, is lullaby (*berceuse*), love song and lamentation at death, all so ingeniously composed by man the poet, and all reflecting himself in the mirror which is woman.

The mystery of passion—I have studiously avoided this word until my conclusion of the chapter—is a dialectic in which man makes an extraordinary request, but one which is clearly articulated in the most serious part of the surrealist program. In asking for the experience of passion, he asks for the resolution or the dissolving of the antinomy between the subject and the object, between love and death, between man and woman. It is because of love that the universe is dissonant, and it is also because of love that the universe is still resonant with the most wonderful harmonies that man is able to hear. The world has a kind of weight about it, a heaviness and a materiality; and love is precisely that one force or that one mystery capable of so condensing the world that it becomes weightless, summarized into a few words which have no more weight than the tiniest breath of air, the briefest exhalation from the lips of a man. The power of love is able to convert the material world into an imponderable dream, into as immaterial a reality as hope.

Love is the immediate (Eluard has brilliantly entitled one of his volumes *La Vie Immédiate*); it is the domain of immanency, and it is described only by its ever-forming images. We can begin to see the distinguished lineage of surrealism, first in the images of Rimbaud (the most important literary background for Eluard), and then behind him in Baudelaire, and so on back through Poe to Coleridge, whose imagination was so influenced by *The Monk* of Lewis. Kenneth Burke is quite right in calling *Kubla Khan* a surrealist masterpiece, which even follows the rule of automatic writing. But more perhaps than in the mystery poems of Coleridge and the Gothic tale of Lewis, a

distant example in the English tradition of this contemporary doctrine on love would be found in certain passages of *Wuthering Heights* by Emily Brontë, who, in the approved surrealist tradition, had composed her novel at an early age. The heroine of *Wuthering Heights,* Cathy, is hard to describe in ordinary terms of a vibrant and passionate girl. Emily Brontë is more at ease when she compares her to the elements, to the wind and snow on Wuthering Heights, to the moors and crags, to the earth mysteries and the fidelity of supernatural phantoms. When Cathy tries to describe her love for Heathcliff, she does it in terms of the ineffable, of an all possessing spirit in which Heathcliff is absorbed, where his identity is lost in her. She says: "He shall never know how I love him: and that, not because he is handsome, but because he is more myself than I . . . My love for Heathcliff resembles the eternal rocks beneath. . . . I am Heathcliff."

After Cathy's sickness, she makes no real effort to recover, but says one day to her servant: "I'm sure I should be myself were I once among the heather on those hills." She represents a vegetative principle, and dies when prevented from living in accordance with her limitlessness and nature-ness. Heathcliff, dark as a demon and a kind of spirit himself, is the only one to understand this, and he says in speaking of Cathy's husband: "He might as well plant an oak in a flower pot, and expect it to thrive." With such images as these, with such love as Cathy feels for Heathcliff, in the world and beyond the world, with the constant interpenetrating of reality and the supernatural, *Wuthering Heights* is not only the greatest of the Gothic tales, but a surrealist novel as well. Cathy is like the woman compared by Eluard to the grass of the earth or the heather of the moors which bear the footprints of man and then efface them in the duration and the presentness of love.

IX · PICASSO: *the art*

I

 The theory of chance, or objective hazard, as related to the creation of art, so copiously analyzed by the surrealists in their manifestoes and critical writings, might be justified by stories from many schools of art, throughout the entire history of art. A story, connected with some work of Picasso, not only defines this theory but contains in the words of Picasso an explanation of the theory.

At the dress rehearsal of Cocteau's play *Antigone,* in December, 1922, one part of the backdrop which had been painted by Picasso was still unfinished. Cocteau and the actor Dullin and others were in the orchestra looking at the stage. Picasso was on the stage walking up and down in front of the set. It was painted blue with an opening on the left and right. In the center was a hole through which the rôle of the chorus was to be recited by Cocteau himself by using a megaphone. Over the hole Cocteau had hung masks of women, boys and old men, and had placed under them a white panel, which remained to be converted into a part of the set. After considering the white panel for some time, Picasso rubbed a piece of red chalk

(*bâton de sanguine*) over the surface which gave it some-
what the aspect of marble. Then he took a bottle of ink
and traced some majestic-looking motifs on the panel. Sud-
denly, when he blackened a few empty spots, three beauti-
ful and appropriate columns emerged, so unpredictably
and so much to the surprise of the few spectators that they
couldn't refrain from applauding. Later when Cocteau left
the theatre with Picasso, he asked the painter whether he
had calculated the appearance of the columns or whether
he too had been surprised by their sudden emergence.
Picasso replied that he had been surprised, but then he
added the surrealist explanation that an artist is always cal-
culating without knowing that he is.

The privilege has been accorded to Picasso, as it has
been to very few artists, to prove his life before his death.
His greatness, acknowledged during his lifetime, has proved
him to be a man equal to the world. His statements, many
of which already appear apocryphal, have often the ring of
a man able to sustain an individual's competition with the
world: "When I haven't any blue, I use red," he once said.
(*Quand je n'ai pas de bleu, je mets du rouge.*) His posi-
tion in the world of art is in good harmony with existing
schools, such as surrealism, in whose exhibitions he is al-
ways represented and in whose manifestoes his name occu-
pies a place of honor, and at the same time his position
is far beyond any facile classification, isolated actually in
its own created universe. The event of Picasso in our world
serves to prove once again that in the history of art there
are not really any schools, there are just isolated geniuses,
strong makers of art.

The same case might be made out for Mallarmé, whose
work, usually classified with symbolism, appears more and
more now to exceed the doctrinal limitations of that
school. Mallarmé's poetry, vastly more limited in output
than the paintings of Picasso, has a comparable strength
of uniqueness, which, remaining in some sense an art of a

period and closely allied with a school of that period, is
in its deepest sense the example of an art characterized by
its heroism, its solitude, its extraordinary equation with
the world. Both Picasso and Mallarmé have the same kind
of greatness in that imitation of their art may well be dis-
astrous. Less original artists may be imitated profitably
and skillfully, but the style of Mallarmé and the style of
Picasso, when attempted by others, degenerates into carica-
ture and weakness. Such painting as Picasso has done is a
world by itself. It is completed by him: there is nothing to
continue.

Mallarmé and Picasso are also alike—and this is perhaps
always a characteristic of their particular stature of great-
ness—in the secrecy of their heart, in the absence of any
real knowledge about them as men and personalities. Many
of Picasso's closest friends have tried to write about him
personally: Gertrude Stein, Apollinaire, Max Jacob, André
Salmon, Cocteau, Maurice Raynal; but none has succeeded
in revealing anything more than anecdotes and sayings and
picturesque but vaguely outlined portraits. Picasso's work
is so projected outside of himself, and rendered so com-
plete and autonomous, that there are no ties between him
and it. This mark of heroic completeness is the mark of
anonymity, the mark of a work, as Lautréamont and the
surrealists wanted it, done by all. The work is the person-
ality, because the artist's personality, so completely used
and absorbed, disappears into it. Picasso draws his profile
countless times, but never a profile that resembles his own.
He is recognizable in his style, not in his features, as Mal-
larmé is recognizable in the style of *L'Après-Midi d'un
Faune* and the sonnets and never discoverable in any self-
related traits.

Picasso's career has been a series of revolutionary acts,
close in spirit if not in literalness to the revolutionary stim-
ulus of surrealism. He does the varied and the unpredict-
able in the constant depiction of himself which is not a self-

portrait. He was a revolutionist when, in 1917, he went off
to Rome with Cocteau and Diaghilev to paint the sets for
the ballet *Parade*. This desertion of the Café de la Rotonde
in Montparnasse, which at that time was the center of
painting, to become a theatre decorator was just one of
many such abrupt turns and discoveries composing a life
of constant rejuvenation and reanimation. In Rome he
painted for the ballet a horse which Mme. de Noailles
described as a tree laughing, and blue acrobats which
Proust compared to the Dioscuri: Castor and Pollux. (In
the program notes which he wrote for *Parade*, Apollinaire
spoke of the "surrealism" achieved in the ballet. This was,
I believe, the first appearance of the word in print.)
Picasso's existence, so unlike that of most men and even of
most artists, became inseparable from the existence of the
world. The creation of art is always the way taken between
the subject and the object, and in Picasso's art the way back
and forth between the two poles is so frequently and so
feverishly covered that the poles finally merge into one.
The way of art becomes the existence of art.

II

 The career of Picasso has been briefly
chronicled many times. His so-called periods of style, char-
acterized by a dominant color, have succeeded one another
rapidly and overlapped, until the principle of his life as
painter seems to be his perpetual need of self-renovation.
This need of discovery and fresh contest with the world
so dominates his art that it may be wondered whether
painting itself isn't something accessory to Picasso, whether
the act of painting isn't the outer manifestation of another
principle or goal. Picasso doesn't seem to be a painter in
the more narrow and the purer sense that Matisse, for ex-
ample, is a painter. The work of Braque is more exclu-
sively and fervently the work of a painter for whom the
universe was made to end in a painting, if we appropriate

and modify the formula once used by Mallarmé to characterize the poet.

Picasso is much more than a painter and is constantly breaking through the bounds of painting. He is prophet, interpretive historian, magician, and necromancer. He is perhaps the great psychologist of the century, the Spanish doctor who replaced the Viennese. By the recklessness with which he views art and by the lyric frenzy in which he works, he exemplifies the surrealist precept that art is not so much the production of an object—a poem or a painting—as it is the expression of an attitude, of a revolution of a metaphysics. The artist works in a kind of anonymity, in collaboration with many more beings than himself. The traditional act of the artist is that of reproducing the world, but for Picasso and the surrealists the major act might be defined as that of participating in the world, moving within it, understanding it. It is no longer a question of painting a human figure against a background of the material world, but of trying to untie some of the hundreds of complications in the relationship where man finds himself with nature. When Picasso painted the backdrop for Cocteau's *Parade*, in 1917, the painted figures combined with the living actors on the stage. For the first time, the set participated in the action.

Before Picasso, the impressionists had made tremendous innovations in pictorial art, and the Spaniard from Malaga carefully studied all the school of French painting. He knew the recipes of Poussin, Corot, Cézanne, Toulouse-Lautrec, and he has used them all. But his greatest paintings are those in which he demonstrates a scorn and an avoidance of traditional technique and method. Like the surrealists, he makes a *tabula rasa* of the past, but like the surrealists also his memory is full of the art of the past.

Picasso came to Paris at the turn of the century, and during the first ten years moved successively and swiftly through his "periods," denominated by blue, rose, Negro,

and cubist. He was in his twenties and living most of the time in his studio on the rue de Ravignan in Montmartre. He was poor (he willingly sold his drawings for twenty francs each) and his friends were poor. They were for the most part writers, André Salmon, Max Jacob, and Apollinaire, precisely those who, with Picasso, were to stimulate and guide the early surrealists. His first paintings have a strong literariness about them. Picasso helped to reinstate the anecdote or narrative element in painting, and this aspect of his work was continued and explored by the surrealists.

The paintings done between 1901 and 1905, placed together would resemble a court of miracles. It is a blue world of pathos and misery: beggars, blind figures, emaciated children and mothers. Between 1905 and 1906 the colors became more diversified and the figures more graceful. The emaciated children now became circus children, tumblers, and youthful acrobats. The sad youths are now sad clowns and athletes, Harlequins who are more elegant in their sadness, more detached and nostalgic. These are all true paintings, in that they have remarkable plasticity of form, but they show such tenderness on the part of the painter, such an affectionate union between him and the figures on his canvas, that it is impossible to look at them without experiencing a pathos and sentimentality usually associated with literature. These first paintings were exercises in seeing, in liberating the painter's vision, in attaining to what Rimbaud had called *la voyance*.

Picasso followed the inevitable principle of art in these early paintings by choosing, simplifying, and deforming to some degree. A studio is always a laboratory, and as far back as the rue de Ravignan period, Picasso showed what he found, according to his celebrated phrase, *Je ne cherche pas, je trouve.* Guillaume Apollinaire, who spent so much time with painters, and especially with Picasso, influenced them deeply by the sensitivity of his *mal-aimé* and his feel-

ing for the strange isolated existence of the clowns and the *saltimbanques* at the Cirque Médrano. Picasso, who is going to learn through the years how to question severely the universe and to exact from it an increasingly tragic subject matter, learned first how to question it with the tender nostalgia of Apollinaire. His Harlequins and *salttimbanques* belong to the species of *voyou*-poet (Villon and Rimbaud in certain aspects of their poetry, but especially Apollinaire) whose heart is disarmed in the midst of his more cruel brothers. The clown-Harlequin, the type of incomplete and lonely hero, ever since Watteau painted *Gilles* in the early 18th century, has been continued and has reached in modern art a unity of tragic attitude and spiritual fervor, whether it be in Stravinsky's *Petrouchka,* or the poetry of Verlaine, or in the painting of Picasso and Rouault, or the films of Chaplin. These artists have been fascinated by the rôle of the clown who is able to give back to the dull unknowing public a compressed picture of itself, a parable of man condensed into a face of white greasepaint and a few wild antics. The performance of a clown was seen to be not unlike a poem or a painting, not unlike the strange subterfuge of an image in words or in oils. The behavior of a clown is sufficiently improvised, sufficiently drawn up from a deep subconscious understanding of the world, to make it resemble the creation of a poem or a painting in the surrealist sense, namely the sense of spontaneous or automatic creation, of dictation from the subconscious.

Many of Picasso's brief elliptical statements about painting, which have been piously collected and preserved, corroborate much surrealist doctrine and in many cases have, I suspect, helped to formulate it. The age of Picasso in Paris, which began at the turn of the century and seems to have reached some kind of conclusion in the Salon exhibition of the autumn of 1944, held right after the liberation of Paris, is best characterized by an enriching and

fervent interchange of ideas between poets and painters. Not only do poets write about painters: Apollinaire on cubist painters, Cocteau on Chirico and Picasso, Valéry on Degas, Breton on Matta; but painters engage upon the art of writing, and in forms more creative than journal-writing, such as Delacroix had done. Rouault published prose poems and Picasso a play. It is a period when many barriers are broken down between the arts, heretofore so carefully departmentalized, when canvases might be described as gratuitous, in the same way that Lafcadio's act in Gide's *Caves du Vatican* is called *un acte gratuit,* and a certain kind of writing is called gratuitous. Picasso has said that a painting is not decided upon or arranged in advance, that in the actual act of painting, everything may be questioned and changed. As the process of thinking constantly changes and develops, so a canvas changes as it is being painted, and continues to change, after it is completed and exhibited, when submitted to all the various attitudes and states of mind of the spectators.

The surrealists are in accord with Picasso in believing that the emotions or feelings of the artist which are to produce the art, may come from every possible source: from the expanse of the sky or a spider's cobweb, from a forest or a snail, from a bit of celluloid or an empty wine bottle. The artist has to choose what is suitable for him to depict, and even then in the state of fullness over whatever he has chosen, whether it be the figure of a woman or a candlestick, he has to channel or delete or evacuate much of his feeling of fullness before he can work. One assumes an emotion when the idea of a work of art occurs, and then one deliberately expels the emotions when the work begins. Painting for Picasso is not the application of any doctrine, of anything that might be called a canon of beauty. It is a conception of his mind and instinct, quite independent of any program or precept of painting. "A picture

comes to me," he has said, "from miles away—and yet the next day I can't see what I've done myself."

In 1906, Picasso was twenty-five years old. He had already produced two hundred paintings and several hundred drawings: or what might be considered the work of a lifetime. The "blue" paintings had described a *fin-de-siècle* despair and pessimism. The acrobats of 1905 and the "rose" paintings had shown a more tranquil and classical state of mind. He had begun his series of cubist paintings under the influence of Cézanne, El Greco, and primitive masks. *Les Demoiselles d'Avignon* (1906-07), the large painting in the collection of the Museum of Modern Art, marks the shift from a narrative kind of painting to one in which the figures appear as pure elements of form. It demonstrates the breaking up of recognizable figures (in this case, five women) into formalized shapes. The more literary elements of pity and pathos have given way to a strong dynamic quality. This has been considered by some critics as the painting which initiated the cubist movement. Perspective as well as most representational elements have disappeared from it. In the painting itself the three figures on the left are close to the mask-like figures painted in 1906, and the two figures on the right show a marked tendency toward distortion and even dislocation. Compactness and angularity increase in Picasso's painting until 1909, when his and Braque's paintings are difficult to distinguish.

The word *cubism* had been coined by Matisse when he had spoken a bit scornfully about some paintings of Braque in 1908. The cubist paintings of Picasso were to find even more favor with the surrealists than the paintings of his earlier periods. They developed the two surrealist aspects of the fantastic and the psychological, the two terms which Breton was to define later as *le merveilleaux* and *l'inconscient*. They were paintings in which recognizable char-

acteristics of the object gave way to pure forms. Cubism always considered a picture as an object creating lyricism. A painter may indulge in any liberty provided he generates the lyricism of forms. He owes nothing to nature because his goal is not imitation but the plasticity of forms and colors.

Picasso was never the artist of a landscape, or of a figure, for that matter. Inwardly he bore no image of a concrete object, but a kind of desert where any object might form and then be submitted to multiple transformations. This desert-characteristic of his mind, the need of constantly evicting images as they form in him, is stated in Rimbaud's *Saison en Enfer,* in the passage on the "Alchemy of Language": *J'aimai le désert, les vergers brûlés, les boutiques fanées, les boissons tiédies.* This list of the desert, dried orchards, faded shops, and tepid drinks, is inducement to ascetic behavior necessary for the creation of art such as cubist and surrealist art. By 1912, after passing through a few years when cubist art had been almost a collective work, it reached a remarkable point of loftiness and severity in Picasso and Braque (although Picasso's drawing was always more tormented than Braque's) when the intensity of the painting was austere and economical.

But Picasso never remained for long with any one mode of painting. His personal myth might well be that of Dionysos, the god whose rites alternate lamentation with rejoicing, whose celebration was both dramatic and magical. Picasso is not a changing or vacillating artist in his need for freedom and diversity; he is multiple. As the cult of Dionysos was enacted to insure the regeneration of plants and the multiplication of animals, so Picasso, who has come nearest in our day to the creation of a cult, has regenerated and multiplied his works of art. The cult of Dionysos, quite evenly divided between mystery and savagery, could be paralleled in the cubist paintings of Picasso and the studies of monsters which followed. Picasso's predilection

for the bull and tauromachy is also involved in the myth of Dionysos who was often represented in the shape of a bull or in some tauromachic practice, such as the slaughter of the bull in the vegetation rite.

Picasso was never closer to dadaists, like Tzara and Picabia, and to surrealists like Chirico, Survage, and Miró, than when he began modifying abstract architectural cubism by unusual proportions and by half-human, half-inhuman forms which are seen in dreams. Picasso became a prolific fabricator of monstrous forms, quite as terrifying as those created by Lautréamont in *Les Chants de Maldoror*. After the rose or the Médrano period and the few years of cubist painting, when his art had become more cerebralized and intellectualized than ever, he was painting exactly as he conceived, goaded on by an imperious need of knowing, which has always characterized his work. The monsters of Lautréamont and Picasso, far from being picturesque or ornamental decorations, testify to subconscious paroxysms and to a will to understand the most inaccessible of man's dreams. Picasso, like his great Spanish ancestor, Don Quixote, finds it difficult to distinguish between the phantom and the real worlds. He is the contemporary amateur of catastrophe, who, like Cervantes again, knows how to indulge, after moments of paroxysm, in passages of profound peacefulness, where the theme of a mandoline, of flowers and the female figure, proves that Dionysos has to recover from intoxication after ravaging the countryside and seeing with the derangement of his senses. The passage on the sleeping hermaphrodite in Lautréamont's second canto is a comparable passage of peacefulness and even tenderness inserted between scenes of violence.

Dionysos, god of vegetation rites, metamorphosed into a goat or a bull, and Don Quixote, who converted sheep into soldiers, are mythical and national phantoms in Picasso, whose method and principles of painting are always

investigations. Beauty, as Breton said in *Nadja,* must be convulsive, or not be at all. Most men live in a perpetual night, and the conventions of society carefully preserve the obscurity which is their climate. Those who are able to look at the monsters of Picasso (or read about the monsters of Lautréamont) are the men who remember their dreams and are not terrified by them. Nature is an appearance of things. The function of the greatest artists is to renew this appearance, to change it so that we may see more truthfully what we look at.

In speaking once to Christian Zervos, Picasso said: "I don't know in advance what I am going to put on the canvas. Every time I begin a picture, I feel as though I were throwing myself into the void." This statement is close to the surrealist doctrine whereby in the process of artistic creation, all links with the objective world are broken, and the artist is able to enter the realm of subjective fancy and dream. It is the method, brilliantly illustrated in Lautréamont, of preconscious imagery where observation is replaced by intuition, where reality is replaced by symbolism, but a special kind of symbolism where the symbols have the unpredictable dimensions of a submerged world.

III

During the authentic and controlled period of surrealism in Paris, 1925-39, Picasso influenced and was influenced by the exponents and artists of the new art. As the large painting of 1906-07, *Les Demoiselles d'Avignon,* was annunciatory of a new interest and way of composition, so the painting of 1925, *The Three Dancers,* marks another turning point, after which Picasso follows surrealist tendencies in revealing in his paintings psychological disturbances or torments. These years of both general and specific surrealist adherence culminated in the *Guernica* mural on which Picasso began work three days after the German planes bombed the Basque town on

April 27, 1937. In the light of the paintings done by
Picasso during the years of this decade, 1940-45, *Guernica*
is just a first culmination of vigor and historic protest. He
didn't literally paint the second World War, in his Paris
studio, but he has said himself that the war is in all the
canvases he painted during that time.

The meaning and the experience of the war are in
Picasso's works, in the very way in which he saw the figures
he painted. This illustrates his permanent method which
extends back to the already now distant "blue" kingdom
where the figures were related and bound to the world by
their suffering. Picasso has always been a romantic artist.
As the romantic art of his "blue" period became more
etherealized in the "rose" and "cubist" years, and as it
became more exultant in the "surrealist" and "war" pe-
riods, his temperament seems simply to have deepened its
sombre, revolutionary, and subjective traits. Like his tem-
perament, his problem as painter has remained the same
throughout half a century: that of seeing. To see, for
Picasso, is equivalent to transforming and to forgetting.
His goal remains steadfastly revolutionary, in that it always
means liberating his vision. One thinks instinctively of
Rimbaud's theory of *voyance,* whereby his soul will be con-
verted into something monstrous. Each of Rimbaud's
prose-poems, *Les Illuminàtions,* is quite independent of
the thing he saw, and in the same way, each picture of
Picasso ends, through his particular process of painting, by
becoming independent of the subject he imitates. He may
start with a woman, or a guitar, or a pot of flowers, but
then as the composition progresses, these objects take on
the function of a scaffolding, which when the picture is
completed, disappears because it is no longer needed. The
picture emerges indifferent to and independent from the
subject matter with which it started. The same process
occurred in *Les Illuminations* when Rimbaud knocked
out from under the construction the recognizable supports

and buttresses. Rimbaud debauched his themes and sub-
jects, and Picasso does likewise in the arabesques of his
lines, in the only partially human terrors he reveals, in his
long series of distorted figures.

Other painters were more literal-minded in their accept-
ance of surrealism: Max Ernst, André Masson, and Chi-
rico, the greatest perhaps, who during the few years of his
surrealist fidelity gave a rich documentation on the paint-
er's subconscious. But Picasso's art, in its abundance as
well as in the methods it illustrates, is the greatest testi-
monial to the energies and the forces which underly sur-
realism. All the various articles of surrealist faith may be
exemplified in Picasso: paranoiac-criticism, usually asso-
ciated with Dali; the art of dislocation wherein a supra-
human meaning may be found in the work; a psycholog-
ical intuition which involves both eroticism and violence.
But more than any other aspect of surrealism, Picasso uses
a sense or a vision which is magical and which relates him
to the function of the artist and the meaning of art elab-
orated on by Mallarmé.

By magic, I mean the extraordinary possession of reality
which Picasso makes when engaged in the act of painting.
He has told in this respect a humorous story about him-
self. During lunch at a friend's house, he had paid par-
ticular attention to a buffet in the dining-room. Some time
later, in his studio, he used this buffet, which he had car-
ried in his memory, in a painting. When he returned later
to the friend's house, and sat down again for lunch, he was
surprised to discover that the buffet had disappeared. "I
must have taken it away," he said, "when I painted it."
(*J'avais dû le prendre sans m'en apercevoir en le peignant.*)

Even in those paintings of Picasso which are the most
explosive, in which the dominant character is dynamism
of a psychic order, he opens up a dream world of magic
and the supernatural. Picasso maintains the primitive
meaning of magician as being the man who explores the

unknown. In this trait, he is close to the demiurge, whose rôle has been captured in the modern world by the artist. For the world at large today, the artist, more than the priest or the prophet or the magician, reveals the existence of an intangible psychic life which is constantly participating in our every day life. The artist today is the last exponent of the mysteries, the last believer in the duality of our world, the last teacher of the method whereby we may establish contact with the mysterious and convert the mysterious into the credible.

The large number of paintings and drawings done during the three years 1927-30 are perhaps the richest in terms of the pure inventiveness of magical and fabulous forms. This series of unusual studies which follow one another in a lyrical potency are the productions of Picasso the most calculated to affect and control the imagination of the spectator. One has literally to submit to them, to allow oneself to be moved by them. Otherwise they are impossible to look at. They are studies of figures which have been caught by the painter just at the moment when they are changing their form, at the precise moment when they are midway between the old form they are leaving and the new form they are assuming. There are almost no clues to their identity, and that is why it is so difficult to look at them. They are events by themselves, separate from the world of men and the world of objects.

This period in Picasso's career might well represent his attainment to greatest freedom in the creation of art, when he was able so to absorb everything within him, that what he actually painted was the abandonment of all he saw, the release from all he had experienced. By so completely absorbing the real world, he was able to go beyond it. He was able to annihilate it and to create in its absence visions and forms that man has hardly ever seen. Here Picasso showed himself more resolutely anti-conformist than ever before. Like Mallarmé's cult of the void and of

absence, where the symbol would so absorb the experience
that all recognizable narrative element would disappear
and only the shell of the symbol would remain as the
poem, only the vain useless beauty of Hérodiade as testi-
monial to an experience we may guess at, so Picasso's cult
of this exact moment of metamorphosis prevents any com-
fortable recognition on the part of the spectator either of
the form from which the study comes or the form toward
which it is moving. Picasso has depicted the literal act of
magic, the moment of suspension and suspense between
two worlds.

Thus, Picasso cannot be placed solely under the myth
of Dionysos, god of violence, intoxication, and taurom-
achy. Dionysos would at most explain only one half of
his art, as he explains only one aspect of surrealism. An-
other myth of magic and transformation would have to be
evoked, to accompany the myth of dynamic violence. I
suggest that the old legend of Mélusine might serve as
mythical explanation of this particular aspect of Picasso's
genius. Mélusine was the beautiful woman in the myth
associated especially with the province of Vendée, both
wife and mother, who was condemned to watch the lower
part of her body, on the night of each Saturday, turn into
a serpent's tail. Her husband had promised never to seek
to look at her on that particular night of the week, be-
cause if she were ever seen by him as the serpent-woman,
she would have to remain that. When Mélusine was half-
serpent, on Saturday nights, she was able miraculously to
fly out of the window and to build castles all over her
province of Vendée. Not only had she given ten sons to
her husband, but she was on Saturday nights the château-
constructing fairy. But one Saturday, her husband peeked
through the key-hole and saw her legs growing into a mon-
strous tail. And so Mélusine was condemned henceforth
to fly about in the air, to haunt all the places where she
had once been happy, and each year to detach one stone

from each castle she had built in many Vendée localities: Tiffauges, Mervent, Châteaumur, Vouvant.

Picasso, like Mélusine, is an excessive builder, and like her seems to inhabit the air as well as the earth. She might be called goddess of the fantastic (*le merveilleux*) presiding over artists like Picasso who have not ceased dreaming of a world truer than the real world. The marvellous is perhaps for us today the faculty of wonderment, the power of wonderment which is behind many paintings of Picasso and which places him in the distinguished line of artists who created such stories as *The Girl and the Unicorn, Beauty and the Beast* (converted recently by Cocteau into a surrealist film), *Alice in Wonderland*.

Picasso is both nihilist and wonder-maker, both Dionysos and Mélusine. But in both rôles he is the lover of freedom. He recently said, when he joined the Communist Party, "Through design and color I have tried to penetrate deeper to a knowledge of the world and of men, so that this knowledge might free us." During the last few years there have been demonstrations in Paris against Picasso, first on the occasion of the Salon exhibition in 1944 and then at Abbé Morel's lectures on Picasso in the Sorbonne in 1946. Different reasons have been offered to explain this hostility against the figure, who is perhaps the greatest of our age. It is true that the newest paintings are increasingly difficult to look at and to accept. The fantastic has given away again to the violent and the destructive. The cycle of changes in Picasso is delirious to follow. The same change took place in the career of Joyce, from the simple to the complex, from the real to the surreal. Both Picasso and Joyce, in their respective arts, observed the doctrine of primitivism. For Picasso, as the pictorial artist, there is equal value in things seen and not seen, a belief of primitive man, and this is perhaps the ultimate meaning of magic in art.

X · CONCLUSIONS

I

The new international surrealist exhibition, which opened in Paris, in the Galérie Meaght, in July, 1947, came as a very positive reaffirmation of continued life among the ranks of the surrealists, and as a denial of the charge that the cause of surrealism was entombed and extinct. The exhibition was directed by Marcel Duchamp and André Breton, and the actual installation and arrangement were in charge of the American architect, Frederick Kiesler. The avowed purpose of the undertaking was to testify to a persisting cohesion among surrealist artists and, more especially, to a program and development of their art. The initial announcement of the exhibit made much of the fact that the surrealist movement was the search for a new *myth* of man and that the present display was so arranged as to show the successive stages of an *initiation*. The ground floor of the galery was given over to a retrospective exhibit called "les surréalistes malgré eux," which included works of pre-surrealists, such as Bosch, Arcimbaldo, Blake, Carroll, and works of contemporaries who at some time in their career had been associated with surrealism: Chirico, Picasso, Masson, Dali,

Paalen, Magritte. Then on the second floor, the initiation to the various mysteries began.

Even from this preliminary sketch of the surrealist exhibition, it is obvious that the surrealists have maintained the strictness of their beliefs. The theoreticians have always been writers. (For impressionism, on the contrary, painters like Seurat and Cézanne defined the aesthetic.) And painters, particularly, have found surrealism a difficult creed to follow. André Masson, for example, has said: "I am more a sympathizer with surrealism, than a surrealist or a non-surrealist. The movement is essentially a literary movement."

The underlying forces of surrealism exist in most forms of great art. The creative process itself uses the conscious and the subconscious and might well be denominated as surrealist. The English sculptor, Henry Moore, has stated: "All good art has contained both abstract and surrealist elements, just as it has contained both classical and romantic elements—order and surprise, intellect and imagination, conscious and unconscious." There is a pedantic side to surrealism, an overemphasis on the exclusive use of the automatic method of producing a work of art, which has perhaps prevented its fullest development. So much time and energy have been given over to policing and judging, to manifesting and defining, that I often feel the greatest works of surrealism are ahead of us, and are yet to be produced.

The existentialists in Paris, since 1944, have taken over the first place in the French literary scene. Sartre has more or less proclaimed the demise of Breton. He has described the surrealists as being in exile among the French because they have nothing more to say. The veracity of this verdict may be strongly doubted.

The existentialist despair of the 1940's is sombre and sullen as contrasted with the surrealist pessimism of the 1920's and 1930's. Whereas existentialism is essentially

characterized by a mournfulness and a nauseating submissiveness of existence, of heavy Germanic origin, surrealism was born under the guidance of two or three extraordinary poets in revolt, adolescents who in their revolt demonstrated a fierce energy and demanding human spirit: Lautréamont, Rimbaud, Jarry. Whatever greatness and productiveness surrealism has achieved is largely due to its origins in the revolt of these exceptional adolescents. Thanks to them, the surrealist revolt has been mainly concerned with the two greatest subjects of revolt: love and poetry.

It is not perhaps too early to say that surrealism is essentially concerned with poetry, and existentialism with philosophy. The vision of poets is infinitely deeper and more fructifying than the vision of philosophers. Poetry has always something to do with the primitive and eternal mysteries of man, and philosophy, when all is said, if it remains philosophy and doesn't become poetry, is always related to mere history. Philosophy is about what men think concerning the universe at a given time in history. Poetry is about what men know concerning the universe, what men have always known consciously and subconsciously about the universe. Philosophy is timed, as history is; but poetry is man's one activity invulnerable to time, his one permanency. Poetry is the annihilation of the moment, or of any unity of time, and the surrealists made this doctrine into their ecstasy and glory. If it weren't for the fertility of the surrealist poets today, in the 1940's, for the poetry of Reverdy, Prévert, Michaux, Eluard, Aimé Césaire, French letters would be completely submerged in the existentialist nausea.

The time will come, if it has not already come, when the surrealist enterprise will be studied and evaluated, in the history of literature, as an adventure of hope. The passion for knowledge, expressed more poetically than philosophically, which means perhaps, more mythically than

metaphysically, underlies all the surrealist works. Human nature, which they studied, is limitless, as well as their curiosity about it. Everything can help in their study of human nature: dreams, subconscious states, eroticisms. But all these represent means by which to attain to that ultimate goal of man: his total liberation. Breton's celebrated phrase, *le seul mot de liberté* . . . , stands as the fundamental surrealist attitude.

In describing the form and the function of the image in poetry, I have already used the analogy with an object which is cut loose from the world, which is allowed to rise up by itself into the air, separated from the bonds and the reality with which it is usually joined. This process applies in a general way to surrealist art which possesses the genius of flight and lightness and airiness. It is a winging upwards. When it fails in its act of flight, when it has not loosened itself from all the bonds which hold it down to its original forms and models, it fails in achieving itself in its surrealist renovation. This process of flight upwards has its necessary counterpart, in the tradition of surrealism, in the flight downwards, the free uninhibited descent into sleep and dreams where modern man is able to engage in a primitive mode of activity, where, according to the theory of Freud, he is able to experience a decrease in his repressions, and where he ceases to resist authentic parts of his nature.

By these two flights, the surrealist realizes himself: first, by his winging upwards, by reenacting the myth of Dedalus and becoming the man-bird; and second, by his floating downwards, by reenacting the myth of Joseph and becoming the dreamer. Dedalus and Joseph opposed a total enslavement to the real, as the surrealists exercise their will in freeing themselves from the familiar objects which surround them. This fundamental act of the surrealist is the gesture of freedom, a deep-seated instinct in man to destroy what attaches him to the world: rules of the family,

of society, of the state, of sexuality. Surrealism began as an effort to destroy art itself: canvases and books; and to obliterate the usual appearances of nature. It continued in its revolutionary and liberating flights to such a degree and with such doggedness that the entire movement may be seen as an angelic temptation, as a great fear of falling down from the air to the earth.

The revolt of the early adolescents, of Lautréamont and Rimbaud, had in it a deep fascination for the spiritual absolute, for the total transcendency of the world. The need for a spiritual absolute is felt more deliriously in adolescence than at any other time. In a period of war, such as our own, the number of adolescents in the world, those who live by revolt, diminishes, with the result that the urgency of human enthusiasm, of revolt, of spiritual transcendency, is manifested only slightly. Surrealism represented for the young the fantastic (*le merveilleux*) and limitless possibilities of existence, a salvation by means of dream, love, desire, liberty. If existentialism treats the solitude of an individual man in an absurd world where every gesture of freedom is vain, surrealism starts from the emptiness and corruption of the world to mount on an impulse of implicit hope toward the limitless sky.

II

Throughout the history of surrealism there has been an evident tendency to consider it a cause or even a battle. Its superficial or exaggerated aspects affect, more than we realize, our daily life. Advertisements and posters, movies, ladies' dresses and especially hats, cartoons like *Barnaby,* have been influenced by surrealism. But as a cause, and even as a way of life, it has deeply affected and transformed only a small number of men. (The recent film of Noel Coward, *This Happy Breed,* depicts the same period of years as that of surrealism, 1919-39, and shows no trace of the movement.) It is perhaps

too early for surrealism to have created any great heroes and heroines. The novels and the epics, where individual characters will be celebrated, have not yet appeared, and of course may never appear.

In terms of heroes, surrealism may have to content itself with the legends of Lautréamont and Rimbaud, although in time it may well be that the literary artists will create works about such figures as the three men who committed suicide. Surrealism, like every other cause, has its martyrology. Jacques Vaché, the young friend of Breton in Nantes, whom I referred to in the first chapter, died in 1918. He bequeathed the initial hate for literature and scorn for traditional art. By the habits of his life he was the type of mystifying dandy who played on the absurdity of life. Then, on the 5th of November, 1929, the young secretary of Jacques-Emile Blanche, Jacques Rigaut, shot himself. His case is so complex to unravel that legend has already taken hold of it. The death of René Crevel, in 1935, is the third in this series. His case is tied up with the relationship between surrealism and communism. Crevel was a handsome, universally loved fellow, courted and imprisoned by the fair ladies of worldly society and by the mannequins of fashion. After his conversion to communism, he was expelled from the party, with Breton and Eluard, in 1933, but was absolved and reinstated soon after. His fidelity to Breton was exemplary. The day of his suicide was the opening of the "Congress of writers for the defense of culture" (*Congrès des écrivains pour la défense de la culture*), the congress at which the surrealists were refused permission to speak.

The meaning of these three deaths is limitless. Vaché represents the dandy, the game of life, the precious notion of accident. Rigaut marks the revolt against art and love, and a marriage with mystery. Crevel's legend seems to lie nearer to the attraction of fidelity and the fatalness of disappointment. In any case, beyond whatever interpretation

may be given to any one of these cases, the three suicides have taken on for the surrealists the expression of surrealism itself, which is always the extreme of liberation, or, if we use the politically-connotative word, of liberalism, "of freedom," as Kenneth Burke defines it, "projected into the aesthetic domain."

The heroes express a Maldororian defiance in constantly changing their form, in accentuating the principle of metamorphosis and diversity. The centaur, the man-horse, is an excellent symbol of the surrealist hero, because he is characterized by a will to efface any distinct resemblance with either a horse or a man, and to partake incongruously and triumphantly of two natures.

Likewise, the surrealist heroine, as in the painting of Pollaiuolo, which hangs in the National Gallery in London, on the subject of Apollo and Daphné, represents a dual nature. Daphné is caught by the artist just at the moment of her transformation, when, in flight, her arms are becoming branches. In André Breton's *Nadja*, the heroine is the type of the woman-child (*la femme-enfant*) who exists in a dream-world and a real-world at the same time, who has all the resources of feline independence and seductiveness. Nadja can be successively playful and nostalgic, gay and melancholy, and all these varied temperaments are put at the service of the man-genius. All these moods serve to induce in the genius a deeper awareness of himself and his art. The beauty of woman, in its multiple manifestations and artifices, serves to make the worry and agitation of man appear vain to himself.

Mélusine is an extreme example of the woman-child. She is the female counterpart of the centaur-image of man, because she is woman and serpent. The moment of the fatal Saturday nights when the lower part of her body changes into a serpent tail corresponds to the moment in the story of Daphné when her arms change into the branches of a tree and her legs into the roots of a tree. The surreal-

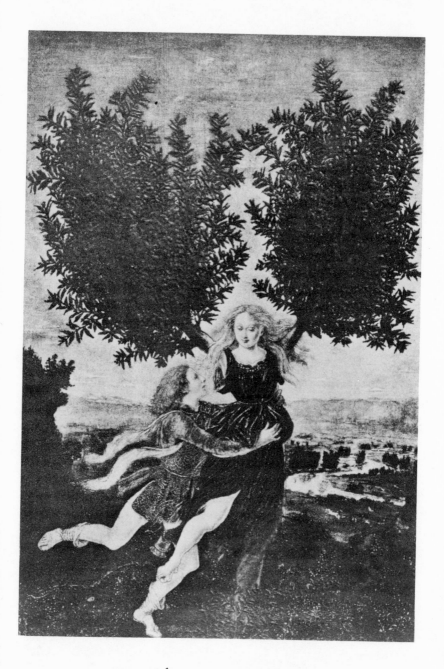

APOLLO AND DAPHNÉ *by Pollaiulo. National Gallery, London.*

ist emphasis on this moment of metamorphosis heightens the dual nature of man and woman, and their relationship with the material world. On the tragic Saturday night when Mélusine was seen by her husband to be the woman-serpent, there is, of course, a very evident parallel between Mélusine and Eve. Woman represents such a unique and overpowering knowledge of the world that it will have to be hidden from man. She is the source of the "fantastic" in the world, and he is mere spectator or poet, the one who contemplates the "marvellous" without understanding it.

In the legend, at the moment when Mélusine knows that she has been seen by her husband, she looks out of the window into the night which is now for her the night of enchantments through which she is going to fly. After being pure woman tempted by the serpent (Eve), she becomes the serpent-woman, fairy of the air who penetrates the night and casts a spell over it (Mélusine), until in the advent of day, she is transformed into the star of the morning, or star of the sea: *stella maris* (Mary).

After the examples of the poet's solitude, in Baudelaire, Rimbaud, Lautréamont; and after the examples of the three surrealists who risked their talents and their lives: Vaché, Rigaut, Crevel—the example of woman: in *Hérodiade,* who wills to become the sister of night, motionless and useless like the jewels and metals in the earth, in *Nadja,* who moves as in a spell between the extremes of dream and reality, in the legend of *Mélusine,* who is fated to haunt the night air and the castles she constructed miraculously—illustrates a oneness which is not a solitude, for it is without torment. Woman is so able to merge with the cosmos that she becomes it and loses her specific name and identity. Everything is really explained by the fact that the surrealist hero is Lautréamont or Vaché, a man characterized by his particular drama of solitude, and that the surrealist heroine is Daphné or Mélusine or even Cathy in *Wuthering Heights,* whose drama is not solitude but ex-

pansion, change, absorption, the magical combining of
lives and states of being.

III

 In Breton's first manifesto, in 1924, he
indicated considerable scorn for the form of the novel. He
seemed to consider it a banal game of information, a kind
of chess game where each move is calculated long in ad-
vance, where the author knows omnisciently each action
of his hero. The art form of the novel appeared false to
Breton because it was too willfully contrived, too tricky.
But twenty years later, in his lecture delivered at Yale Uni-
versity, he seems somewhat to have modified his views. He
expressed admiration for such a novel as Gracq's *Au Châ-
teau d'Argol,* and opened up the possibility of a surrealist
novel in which the characters would be endowed with ex-
ceptional powers of freedom, in which the hero would not
be fixed in a formula of a given sociological setting and
well-defined motivations, but in which he would illustrate
the equivocal, contradictory, and disturbing elements of
human nature. The surrealist novel would perhaps stress
the vacillation and change in human nature. It might even
create a new species of man or recreate the ancient species
of man-god. In the metamorphosis of man to archangel,
man would know the sacred, and in the demonic metamor-
phosis he would know the sacrilegious. The sacred and the
sacrilegious have affinities in the same way that reality and
surreality do. In the same way that the sacred myth of the
Grail was demonized in the 19th century by Wagner in
his opera *Parsifal,* so the realism of the novel, in the oppo-
site process, tends to become surrealism when a character
is dilated and expanded into a mythical character.

 In the last episode of Joyce's *Ulysses,* the long soliloquy
of Molly Bloom, composed of eight sentences of 5000
words each, the character has ceased being real in any

usual sense. She is lying down in bed and the words which pass through her in her half-dream, half-conscious state, convert her into the mythical figure of woman, into the figure of the earth itself. She becomes united with the movement of the earth and nature, as if she were a planet caught up in perpetual rotation in space. The figure of man, beside this mythical representation of woman, is diminished and almost comic. He appears like a puppet or a toy in the presence of the cosmic purposefulness of woman. And yet an important dignity is accorded to him in the final word of Molly's soliloquy. To the mythical representation of man, the symbol of departure, interruption, restlessness, search—woman, symbol of rotation, permanence, and nature, always says *yes*. If the symbol of woman for Joyce is the earth in *Ulysses,* or the river in *Finnegans Wake,* the symbol of man is Dedalus, the man-bird, that being who is a visionary, a *voyant,* endowed with miraculous powers of search. Man, in Joyce, reaches his fullest mythical conception as wanderer, either as son: Stephen-Hamlet, in search of a father; or as father: Bloom-Earwicker in search of a son. *Ulysses,* the story of twenty-four hours in Dublin, becomes *Finnegans Wake,* the story of all humanity, from Adam on.

Joyce as a technician is the opposite of Mallarmé, whose art is condensation and compression. Mallarmé's final surrealist poem, *Un coup de dés,* attempts perhaps to summarize and to resolve the story of man almost by means of typography, by the sparseness of his text and the whiteness of his page. But the art of Joyce moves in the other direction toward a concrete thickness and complexity. His art is the decomposing of syllables, sounds, and even letters and their reconstruction in prolonged new syntheses and meanings. The Anna Livia passage is the poem of the river Liffey whose Latin name was *Amnis Livia.* Anna Livia is river, nymph, woman, and the text of Joyce is as fast flow-

ing and elusive as that river which Heroclitus, surrealist dialectician, told us long ago we could never bathe in twice.

But Joyce was at all times too conscious a technician, too aware of pattern and ritual, to be associated in a literal sense with surrealism. The case of Henry Miller is far more applicable. His *Tropic of Capricorn*, the book which Miller himself prefers to all his others, is quite identifiable with surrealist art. The character Mona is as mysterious and enigmatical as Nadja. She is sought after in the same mythical terms by which Apollinaire's *Mal-Aimé* searches for his beloved as if she represented both woman and the secret of existence, the blind impulse which man follows in his longing for the Absolute.

Miller learned to write by writing. When he began writing, he encountered the usual problem of the young writer: that of having an overabundance of rich emotions and of having no focus for a literary expression of the emotions. The art of writing is the converting of an experience into the experience of writing. Henry Miller is as omnivorous a reader as he is a fertile writer. He reads, in an unacademic fashion, haphazardly, works which are often of a religious philosophical nature, or of a visionary prophetic kind, such as the writings of Blake, Rimbaud, D. H. Lawrence. This exercise of reading has provided him with both stimulation and focus for his own writings. In Paris, when he came upon the surrealists and especially the manifestoes of Breton, he was strongly attracted to surrealism, and although he never actively joined the movement, he has always manifested an interest and even a kinship with it.

Miller's method of writing at moments of enthusiasm and fervor, and in great jets of fertility as if he were hypnotized, and directed, and dictated to, is unquestionably very close to the surrealist method. He imposes no preconceived form on his narrative, which is more rhapsody

than narration. In his greatest passages, which are long sustained dithyrambs in lyric prose, charged with surrealist images in free association, propelled by listings and inventories forming a background on which the images grow and impinge, Henry Miller gives the impression of exercising his spirit, of revealing it as few writers ever have, and hence of indicating the endless possibilities of surrealism. His search and *inquiétude* are more religious, and even more mystical than those of the early surrealists; they are closer to the examples of Lautréamont and Rimbaud. In time, when the inane falsely moralistic controversies over Miller are exhausted in America and France, his books will be reconsidered as the great lyric expression of our twilight world.

It would be quite justifiable to read Miller's book *Black Spring* as an example of prose written in exceptional freedom, in surrealist freedom, where accident or hazard is juxtaposed with drama, and where dreams especially fill the fast moving canvas. Miller constantly relives the drama of childhood, the drama of the 14th ward in Brooklyn. "Each man," he tells us, is "his own civilized desert, the island of self on which he is shipwrecked." Each artistic work, he seems to consider a flight off from this island of self, and he alludes to the classic flights of Melville, Rimbaud, Gauguin, Henry James, D. H. Lawrence.

One of the chapters in *Black Spring,* a passage of about twenty pages entitled *The Angel Is My Water-Mark!,* is in one respect a treatise on the surrealist method of composition. In it Miller describes his painting a water-color. He feels like a water-color and then he does one. He begins by drawing a horse. (Miller has vaguely in mind the Etruscan horses he had seen in the Louvre.) At one moment the horse resembles a hammock and then when he adds stripes, it becomes a zebra. He adds a tree, a mountain, an angel, cemetery gates. These are the forms which occur almost unpredictably on his paper. He submits it to the various

processes: of smudging, of soaking it in the sink, of holding it upside down and letting the colors coagulate. Finally it is done: a masterpiece which has come about by accident. But he says that the 23rd psalm was another accident. He looks at the water-color and sees it to be the result of mistakes, erasures, hesitations, but "also the result of certitude." Every work of art has to be credited, in some mysterious way, to every artist. So Miller credits Dante, Spinoza, and Hieronymous Bosch for his little water-color.

I should like to quote the last page of this passage as an example both of surrealist art and surrealist theory. It is in two paragraphs, and, although it may well have been written without revision, it has its own structure and form. The first paragraph is composed of a series of questions, a list of possible things you might see, through the power of association, as you look at the picture. They are the private objects which an individual spectator will see and which come as much from him as from the painting. Then the second paragraph describes the one object in the painting which cannot be missed, the angel, formed by the water-mark. If you hold a beautiful piece of paper up to the light, you see its tracery, its real nature, its water-mark. In Miller's painting, the angel is the water-mark, the one element which cannot be scrubbed out, because if it were, the painting would cease to be a painting:

"My masterpiece! It's like a splinter under the nail. I ask you, now that you are looking at it, do you see in it the lakes beyond the Urals? do you see the mad Kotchei balancing himself with a paper parasol? do you see the arch of Trajan breaking through the smoke of Asia? do you see the penguins thawing in the Himalayas? do you see the Creeks and the Seminoles gliding through the cemetery gates? do you see the fresco from the Upper Nile, with its flying geese, its bats and aviaries? do you see the marvellous pommels of the Crusaders and the saliva that washed them down? do you see the wigwams belching fire?

do you see the alkali sinks and the mule bones and the gleaming borax? do you see the tomb of Belshazzar, or the ghoul who is rifling it? do you see the new mouths which the Colorado will open up? do you see the star-fish lying on their backs and the molecules supporting them? do you see the bursting eyes of Alexander, or the grief that inspired it? do you see the ink on which the squibs are feeding?

"No, I'm afraid you don't! You see only the bleak blue angel frozen by the glaciers. You do not even see the umbrella ribs, because you are not trained to look for umbrella ribs. But you see an angel, and you see a horse's ass. And you may keep them: *they are for you!* There are no pock-marks on the angel now—only a cold blue spot-light which throws into relief his fallen stomach and his broken arches. The angel is there to lead you to Heaven, where it is all plus and no minus. The angel is there like a water-mark, a guarantee of your faultless vision. The angel has no goitre; it is the artist who has the goitre. The angel is there to drop sprigs of parsley in your omelette, to put a shamrock in your buttonhole. I could scrub the mythology out of the horse's mane; I could scrub the yellow out of the Yangtsze-Kiang; I could scrub the date out of the man in the gondola; I could scrub out the clouds and the tissue paper in which were wrapped the bouquets with forked lightning. . . . *But the angel I can't scrub out. The angel is my water-mark.*"

IV

The most deeply spiritual aspect of surrealism, at times clearly acknowledged as in Breton's first *Manifeste,* but at all times actively pervasive, is the will to stress the continuities and similarities in men. Whenever the mind is able to penetrate into the dark degree of knowledge where opposites cease conflicting with one another, it has reached a surrealistic state. In *Eureka,* Poe describes the moment when the heart of man is confused

with the heart of divinity. The surrealist experiment is the most recent way (and the most ancient as well) of reconciling man with the universe. In the *Purgatorio,* canto 18, where Dante has seen the spirits of the slothful, he becomes conscious of a new thought set within him and describes how many other thoughts spring from it, so that finally he closes his eyes through drowsiness and says surrealistically at the very end of the canto:

> *e il pensamento in sogno transmutai*
> ("and I transmuted thought into a dream")

Surrealism, in stressing the relationship between and even the identity of spirit and matter, differs from supernaturalism which in its Greek, Hebraic, and Christian forms emphasizes the dualism of spirit and matter.

The movement itself, especially at its beginnings, and to some degree through its brief history, is best characterized by its rejection, its violent and revolutionary rejection, of the human condition of man. The idea of warfare against the purely human condition of man occupies the dark center and focus of surrealism. Revolution is always associated with sacrifice, with the idea of a personal disposition for sacrifice. The history of French letters from Baudelaire to Vaché and Crevel, from Lautréamont to *Nadja* of André Breton and *Au Château d'Argol* of Julien Gracq, might be described as an extraordinary disposition toward holocaust, wherein the hero is damned and sacrificed. Georges Bataille, who was influenced by surrealism, wrote in his book *L'Expérience Intérieure: Nous sommes conduits à faire la part du feu.* ("We are led to participate in the fire.")

In countless passages of Baudelaire's *Mon coeur mis à nu,* we can read an apocalyptic resonance, a terrifying vision of man as sacrificial victim. Baudelaire saw in Poe a victim of conscience, an example of premeditated immolation. In

the art of Daumier, the sacrifice of man is derisive and sardonically bitter, but in Baudelaire, it takes on the form of a mission, of an altar celebration and sacrifice. In his three categories of great men, the poet, the priest, and the soldier, we have the singer, the sacrificer, and the sacrificed. They are all united in a single ritual. (*Mon coeur mis à nu:* 48). From this aspect of revolutionary martyrdom, from Baudelaire's notations on the supernatural voluptuousness which man feels in seeing his own blood flow, the surrealists derived a tendency to depict sanguinary marvels. What represents their efforts of liberation, interpretation, and sincerity, often turn out to be a black desperate kind of caricature. This is not their fault, however, but the world's and the great distance the modern world has moved away from a belief in the free will of man and the ultimate chance of his victory. The patrimony of romanticism, on which we are all living, in the center of which men like Baudelaire, Lautréamont, and Jacques Vaché opened up the darkest regions, has to be used up first and completely exhausted before the sense of caricature will disappear from modern man's enterprises, such as surrealism.

Jean-Paul Sartre, in a recently published introduction to the *Ecrits Intimes* of Baudelaire, has passed a cruel verdict on the poet, but one that is quite in keeping with existentialist philosophy. Sartre refuses to believe in the Greek myth of the fates or the Christian myth of God's mercy and intervention in affairs of the world. Baudelaire made his own destiny and was completely responsible for his own suffering according to Sartre. Because he willed to make himself into the passive type, the boy who submitted himself to his parents, and then the man who submitted himself to the will of his mistress and usurers, he became the type of the *fouetté*, the man whipped.

What Sartre seems to have forgotten, or what he deliberately refuses to include in his analysis of Baudelaire,

is the deliverance and liberation which the poem itself brought to Baudelaire. The act of writing for the poet was always the act of discovering the unity of the world, and there the surrealists have fervently perpetuated the lesson of Baudelaire. For Baudelaire and the surrealists, the imagination is not simply that faculty of the poet which creates and combines images. It is the faculty which goes much more deeply, in the discovery of the ancient belief in the world's unity. It is the faculty able to call upon the subconscious forces which relate this belief. The doctrine of Baudelaire's *Correspondances* may be traced back to ancient Greece and ahead to the surrealist experiments with poetry where the human spirit is seen to be a single spark in the midst of a cosmic flame. The region described in Baudelaire's *Invitation au Voyage—Là tout n'est qu'ordre et beauté*—is that point where the human spirit participates in everything, where the one is apprehended in the multiple. Examine the final stanza of the poem as an example of a surreal picture of the world, as a communion with a peacefulness where opposites are united.

In his *Confiteor de l'Artiste,* Baudelaire speaks of the solitude and the silence of the poet where all things think through him or where he thinks through them. (*Solitude, silence, incomparable chasteté de l'azur! . . . toutes ces choses pensent par moi, ou je pense par elles.*) His mysticism, like that of surrealism, is more heterodox than orthodox, more a communion with himself and the universe, than with divinity. He has called his worship of images, in one of his most important sentences of *Mon coeur mis à nu,* his unique primitive passion. (*glorifier le culte des images, ma grande, mon unique, ma primitive passion.*) In his two sets of images, those of *spleen* and those of the *ideal,* Baudelaire described the schizoid nature of our civilization, as dramatically as the Netherlands painter, Jerome Bosch, 450 years before surrealism, described the same nature, in the infernal vision of mysteries, such as his *Temp-*

tation of St. Anthony in Lisbon. Baudelaire and Bosch would agree with the surrealists that much of man's inner life is composed of caverns, fearful, guiltful nightmares which must be explored, and whose projection in art is a liberation of the human spirit.

Baudelaire was among the first to see in modern life, in modernism as we call it now, the epic possibilities which the surrealists especially have exploited. He was one of the first to see the sublime motifs and the particular kind of heroism in modern life. One hundred years ago, in his *Salon* notes of 1846, he wrote a page on "heroism in modern life" in which he describes Paris as beset by occult and contradictory forces. This is the passage in which he defines beauty as composed of an eternal element and a transitory element and in which he states that the moderns have their own kind of beauty. Cleopatra's suicide differs from the modern suicide. The everlasting black suit which the modern bourgeois feels he must wear in his evening functions, Baudelaire elaborates on as the expression of the public soul, the parade of modern politicians, lovers, and bourgeois who are all celebrating, without realizing it, their own funeral.

But Baudelaire would agree with the surrealists that even in this modern age when men dress in black suits, the marvellous *(le merveilleux)* surrounds us and feeds us as the atmosphere does. During most of its life, the human spirit lives in exile. In the creation of poetry, it leaves its exile and returns into its natural climate, into the region where it acquires its full powers of enchantment and witchcraft and transformation. Realism is always just below poetry as mythology is always just above. Surrealism is an exceptional way by which a correspondence is established between realism and mythology.

Poetry is a definitive language. It may come from a variety of experiences. Love, for example, in itself a transitory and changing experience, when it is transformed into

a sonnet or an elegy, becomes a miraculously fixed and surreal experience. Keats says about the lovers depicted on the Grecian Urn:

> For ever warm and still to be enjoy'd,
> For ever panting, and for ever young;
> All breathing human passion far above.

Surrealism is the most recent effort to establish a communion between the poet and the world, between the poet and the masses of men or the coolness of a forest or a church or a prairie. The poet is the man most able to project and prolong his civilization into the future, because he transmits a divinized or surrealistic picture of everything in his own world, war and peace, joy and tears, to the man of the future. Poetry is at once a practice and a deliverance of the spirit.

EPILOGUE: *Surrealism in 1960—a backward glance*

At the time of their greatest activity, during the years between the two wars, the surrealists claimed that no national barriers existed and that the movement they represented was international. Now, after a lapse of twenty years, the direct influence of surrealism in most countries appears slight. In England, for example, it has been almost negligible. In America, there are more traces of its effects. But all in all, when the accounting is made, surrealism is essentially French. A fairly large number of French writers today were at one time surrealists. The last vestiges of a movement or a school have disappeared, but a surrealist attitude still survives in France. There are no members because there is no membership, but there are French painters and writers—and I dare say, a considerable number of them—who would easily enroll in such a membership if it existed. One remembers the persisten claim of some of the theorists for the ubiquity of surrealism: in every man who writes there is a deep-seated surrealist vocation.

Destructiveness was one of the principal tenets of Dada,

the brief movement which immediately preceded surrealism, in 1916 and 1917. The term itself, "destructiveness," and to some extent its literal Dada meaning, were absorbed into surrealism. This took many forms: serious, half-serious, childish, and playful. But today, as one looks back at surrealism, it seems to be far more affirmative than negative and destructive. The seeming lack of seriousness in the behavior of surrealists in the streets, in the cafés, at their exhibitions and meetings, was in reality dead serious.

Automatic writing, which was once looked upon as the central discovery of surrealism, is now considered an experiment that failed. But what it signified once has now reached a larger meaning. Today we understand more fully to what degree automatic writing was an attack on man's ordinary reflection and ordinary language. It was an effort to move beyond the usual antinomies and contradictions which vitiate our thinking and our articulated thought. The surrealists fully believed that it was a means of reaching the absolute. They were bent upon revealing the emptiness and the falseness of logical discourse. They strove to emancipate words from the bondage of rhetorical speech. It was hoped that in the exercises of automatic writing words would appear free. The language they hoped to capture is that which lies just beneath the silence of man's immediate thought.

If the goal of automatic writing was not achieved, the definition of the goal is significant because of its relationship to the linguistic experiments of Lautréamont, of Mallarmé's *Coup de Dés* and of Apollinaire's *Calligrammes*. By renouncing all activity of control over speech, it was hoped that man would emerge as he is in his real self, in his unconscious self. From time to time these exercises would produce astonishing plays on words and images of fresh startling beauty. Unless literature was able to become an activity which would involve and interest all of man, his conscious and subconscious selves, his emotional and intellectual selves, surrealism was very willing to reject literature. On

the whole, the surrealists were dissatisfied with most of what literature had produced, but they believed that human speech, if it found another way of expression, would be revelatory and profound. At least, it would be one means of revealing to man what is obscure and profound in himself.

If poetry is called by some the highest form of discourse, it remained for the surrealists only one way of knowing, only one manifestation of man's fate in its totality. In surrealist doctrine art always disappears as an end in itself. Only life itself will be that, because in the final analysis, language is confused with or becomes identical with the pure movement of consciousness.

Marinetti's *Manifeste du Futurisme,* published in *Le Figaro,* February 20, 1909, and the brief movement of dadaism beginning in Zurich in 1916, were preludes to the far more ambitious and affirmative program of surrealism, which today, long after the silencing of the obstreperous quarrels, appears as an effort to express those matters, those realities which civilization, in the prudent course of its various routines, disguises or denies. That which comes about in the life of man as the result of chance, and that which in the mind of man is unknowable, are derided by the forces of civilization, but these are precisely matters of important surrealist investigation.

In the latter days of the surrealist movement, André Breton himself acknowledged more and more gratitude and respect for the work of Apollinaire. The meaning of this debt is clearer to us today as the influence of Apollinaire deepens, as his understanding of reality becomes more and more lucid in the light of surrealist doctrine. His key text, *L'Esprit nouveau* (1917), has taken its place now beside theoretical passages of Baudelaire, Rimbaud, and Mallarmé concerning imagination as that bond joining the inner world of psychological man with the outside world of reality. Much of the best French poetry of the past twenty years bears the mark and the influence of surrealism. Language

conceived of as a new instrument in such writers as Jean
Paulhan, Maurice Blanchot, and Raymond Queneau is es-
sentially a surrealist belief. These writers are distrustful of
the usual forms of rhetoric, as surrealists were, and their
predilection for bold, spontaneous notations and images can
easily be named surrealist. The remarkable poet René Char
is only one of several who are continuing the surrealist ad-
venture of language as discovery, of language as the means
of carrying out some kind of cosmic communion. One of
the most fervent points in the surrealist program was to re-
place the study of man's psychology by an hallucinatory ob-
session lyric in nature. To a large degree, this has been real-
ized in the work of those writers who have heeded Apolli-
naire's lesson in purified, simplified sentimentality.

In the case of such poets as Henri Michaux and Francis
Ponge, as well as in Char and Queneau, poetry is the sub-
stitute for spirituality. They count among the heirs of sur-
realism in their constantly expressed need for freedom, in
their will to move beyond literary and psychological limita-
tions. The regions where they live are not psychological.
They are regions of violence, absurdity, grace, and irony,
and there they encounter the risk of conquerors, the danger
of adventurers, the exhilaration of inventors. They repre-
sent surrealism with greater detachment and greater free-
dom than Eluard, Artaud, and Desnos represented it twenty
years ago.

One city was able to absorb the movement. Paris was the
literal site of most of the activities and the meetings, and it
was sung of, especially in the work of Aragon and Breton,
as it had never been sung of previously in French literature.
The obscure streets, the cafés, the Tour Saint Jacques, the
movie houses, the boulevards—all figure in the daring sur-
realists' way of looking at nature and the exterior world.
They made Paris into one of the greatest junk collections of
all time as well as the site of one of the purest revolutions.

In the surrealist treatment of Paris, it is fairly obvious

that the movement was not concerned with a problem of aesthetics as much as the problem of freedom—freedom of speech and thought. By breaking with the false stability of speech and logic, the surrealists hoped to prepare and create a future different from the past. As surrealism now enters the domain of history and legend, it appears to have marked its age, as cubism marked the second decade of the century and as existentialism marked the forties.

Yet even clearer today than the historical literal movement of surrealism is its continuity. With the passage of time, the revolutionary aspect of surrealism fades and we are better able to see its relationship with romanticism. In its acceptance of the mysteriousness of life, and of the secret "correspondences" which exist between matter and spirit, between the conscious and the subconscious, surrealism is clearly one manifestation of romanticism. In acknowledging Arthur Rimbaud as one of their forerunners, the surrealists were in fact attaching themselves to that aspect of romanticism which is a revolt against the human condition. The seemingly incoherent existence of Rimbaud was surrealist before the law was defined. Lautréamont, the other ancestor, guided the writers of the twentieth century into that world of violence and terror where they believed they would be free of all constriction. In the writings of Bergson, they applauded the limitations which the philosopher set on man's intelligence. In Dostoievsky, whom they helped to make into one of the fashionable novelists of today, they heeded in particular the contradictory tendencies visible in each conscience.

After the cubists' practice of dislocating and distorting reality, the surrealists undertook the search for unity behind the world's multiplicity. In this search they followed not only their more distant ancestors, Rimbaud and Lautréamont, but also their immediate forebears: Apollinaire, in his poetry of the unexpected and the unusual, in his belief in that other life of man subjacent to conscience; and Jarry,

the antagonist to conventions. Jarry's character Ubu was the representative of surrealist humor, and humor was one of the strong forces able to destroy society, able to shake the yoke of hypocrisy. If laughter is the mask of despair, it is also the refusal to bow to prejudice. Raymond Queneau today is still expressing in a recognizably surrealist way this doctrine of humor. When Artaud, in the heyday of surrealism, praised *Animal Crackers,* the first film of the Marx Brothers, he testified to the surrealist belief concerning humor, the power to displace objects, to wrench beings and things from their usual occupations and settings. Such a film is also a document on automatism, on the descent within oneself toward the domain of pure instinct where one's repressed desires reside. The surrealists looked upon *Animal Crackers* as the explosion of those desires, as the epic release of instincts.

Those surrealists who flagrantly attacked the social norms and conventions were those men who had been profoundly marked by the war. Their disgust with humanity had been nurtured by the horror and the uselessness of the war's spectacle. Rimbaud and Lautréamont, a generation earlier, had been marked in a similar way by the defeatism of the War of 1870. From the beginning to the end of the active period of surrealism the partisans demanded a total reorganization of society. At first they were guided by Marxist theories, but these failed to satisfy them for long. The two meetings of André Breton and Jacques Vaché, the first at Nantes at the beginning of 1916, and the second at the première of Apollinaire's *Mamelles de Tirésias,* in June 1917, were significant in the sense that they emphasized the individual's hostility to society as now constituted. Arthur Cravan, the boxer and "deserter of seventeen nations," was one further case history lauded by the surrealists in their search for what they called the emotions of the masses.

The literary ancestors of the surrealists are closely associated with the theme of violence. Occultism and the depic-

tion of vice in the Gothic novels of Horace Walpole, Ann Radcliffe, Maturin, and Lewis were presented as flagrant revisions of moral and social standards. André Breton always insisted upon the contribution of Sade to the study of man's consciousness of self. Lautréamont was looked upon as another Sade whose work was inspired by the power of cruelty and the attractiveness of crime. Lautréamont's star was never in eclipse in the surrealist heaven. He might well be called the real founder of the movement. Mallarmé was held in high esteem at the beginning, but his prestige diminished at the end. Even Rimbaud, who helped open almost all the doors of surrealism, was somewhat neglected in the final phases.

The Marquis de Sade sought for the absolute in the domain of pleasure. He became and remained the central figure for the surrealists in their discussions concerning the power of man's desire and the legitimacy of its realization. One of the principles of the surrealist program was to recognize desire in its submerged repressed state within man, to bring it to the surface and release it in the world. This principle involved the notion of ambivalence characteristic of human reality, which admits violent contradictions cohabiting within a single human being. Heraclitus, the philosopher of contradictions, was always admired by the surrealists, and has continued to play a part in the recent poetry of René Char.

But even more than the power of desire and the theme of violence, love occupied first place in the preoccupations of the surrealists. The philosophy of love inspired many of the most admirable texts of Breton and Eluard. The surrealists followed closely the myth, expounded by Plato in *The Symposium,* of the original divisioning of one being into two parts and the subsequent search for reunion. Love is the synthesis of the subjective and the objective, the love of something other than self. Love always tends toward that of which it is deprived, and woman, the goal of man's search,

easily takes the place of God. Woman is sung of by the sur-
realists as the key to man's search, as the great secret of
nature, as the incarnation of man's subconscious destiny. In
the most fully realized texts on this theme, the surrealists
seem to have made a permanent contribution to the poetry
of love. They are perhaps the most ardent and most con-
vincing arguments for the basic surrealist belief in man's
need to remain faithful to his destiny. In the love poems it is
easy to understand what this destiny is and to accept Breton's
insistence on the passivity of man's mind and the insistence
that the artistic creation of man is far less important than the
revelations that come to him from precisely such an experi-
ence as love.

With time, with the passage of these few years separating
the active movement of surrealism and the present, when
the movement appears historical, the psychoanalytical as-
pect has grown clearer. The effort to integrate the irrational
with the rational was helped by psychoanalysis. The legiti-
mate domain of surreality was often named the unconscious.
In Artaud's attempt to rejuvenate the theatre, the meaning
he gave to the word *cruelty* was an appetite for life. Actions
in such works as *Nadja* and *L'Amour fou* are explained by
dreams and by past acts. Psychoanalysis is the method by
which one can learn more about one's destiny, in which
chance is abolished, and in which reality and surreality are
constantly combining and interfering with one another.

The surrealists eagerly found in Novalis, for example,
confirmation for what they believed to be the common work
of primitives, mystics, and poets. These precisely are the
men who demonstrate the unity of the two worlds of reality
and surreality by converting thoughts into material objects
and converting material objects into thoughts. Surrealism
began by advocating the giving over of oneself to imagina-
tion with the avowed purpose of discovering new perspec-
tives for the human mind, for the sensibility and the emo-
tions of man. Artaud claimed that when he submitted to

the madness of dreams, it was for the express purpose of discovering new laws. *"Je me livre à la fièvre des rêves, mais c'est pour en tirer de nouvelles lois."*

Of all the activities of man, the one which appears to the surrealists the most endowed with prestige is poetry. It is the one untouchable permanent force. Poetry is the power to create, to confer a new meaning on an object. The activity conveys for the surrealists the meaning of both exploration and revelation. Under the practice of poetry the dreams of man and his subconscious life recover their rights, and thus he penetrates the secrets of the world.

The surrealist contribution to the theory of poetics ranks high today among the movement's major contributions. The poet, they say, borrows nothing that is foreign or unfamiliar to himself. He takes back what was his to begin with—those things, precisely, in which he recognizes himself. This is why the surrealists claim that the poet feels in himself all of universal life. They speak constantly of the state of poetry (*état poétique*) as something that is lived and thought of as an interrogation, as a quasi-discovery. The poet changes life and the world, and he transforms man.

Vigorously André Breton attacked the concept of a propagandistic art or of a circumstantial art. And with equal vigor he defended an autonomous art, by which he seems to mean an art which bears in itself its own revolutionary strength. When Breton uses the word *le merveilleux,* he seems to be using it as a synonym of surrealism, as describing the poet's submission to the laws of the subconscious. When he speaks of the poetry of posters and signs and newspaper clippings, he has in mind that inexhaustible source of poetry to be found in the subconscious of a city: in the scissors grinder in the street, in the cafés, in idiotic films, in circus parades, and in the flea market.

The passage of time has helped to justify the belief that surrealism did formulate and bequeath a body of doctrine on love, on imagination, on the relationship between man

and the world. In 1956, a professor at the Sorbonne, Ferdi-
nand Alquié, who had established a personal contact with
the movement, published a *Philosophie du Surréalisme.*

An historical study of surrealism makes it out to be anti-
literary and anti-poetical. Yet today it seems to us the
founder of a new literature and a new poetry. Born in Paris
and nurtured by approximately ten men, it spread in all
directions and has influenced men everywhere directly or
indirectly. In his novel *Paysan de Paris,* of 1924, Aragon
movingly announced the birth by calling it the newest ver-
tigo given to man, and the offspring of frenzy and darkness:
*un vertige de plus est donné à l'homme: le surréalisme, fils
de la frénésie et de l'ombre.*

The word "freedom" has an extraordinary resonance in
so many of the important surrealist writings, that one often
feels inclined to give it first place in the new world of men
which this movement hoped to establish. To free man from
the constrictions of an excessively utilitarian world is fore-
most in all programs of surrealist intention. The hope was
that thereby man would be upset and would find the vital
forces of his life elsewhere than in his intellect. Whenever
in the history of man an exceptional individual had at-
tempted to free himself from his limitations, this would be
called a surrealist action. Surrealist behavior is eternal even
if the surrealist movement of the years 1919 to 1939 led to
an ideological impasse.

Wisely surrealism was never defined by the surrealists
themselves as a new artistic school. Rather it was defined as
a way of knowledge. Breton has persistently condemned a
pragmatic view of life which would emphasize a calculated
search for the kind of happiness that could only be limited
and prudent. In proposing to man the hope for existence,
surrealism advocated as means for achieving a better ex-
istence the disinterested play of thought, the power of
dreams, the will to interpret the data of experience and to
surpass ordinary experience. Even within what the world

calls states of madness, an inner enduring force can be discovered. By accepting the demands of human desire, man can experience what has more reality than a logical and objective universe. One of the most original traits of surrealism, when one considers its contribution to poetry and painting, is the conviction that art is not an end in itself, that man must never stop with aesthetics and speculative philosophy.

SELECTED BIBLIOGRAPHY

General Works on Surrealism

Balakian, Anna, *Literary Origins of Surrealism,* King's Crown Press, New York, 1947.

Lemaitre, Georges E., *From Cubism to Surrealism in French Literature,* Harvard University Press, Cambridge, 1941.

Nadeau, Maurice, *Histoire du Surréalisme,* Editions du Seuil, Paris, 1946..

Nadeau, Maurice, *Documents Surréalistes,* Editions du Seuil, Paris, 1948.

Raymond, Marcel, *De Baudelaire au Surréalisme,* Corréa, Paris, 1933.

Reed, Herbert, *Surrealism,* Faber, London, 1936.

Articles on Surrealism

Bataille, Georges, *Le Surréalisme et sa différence avec l'existentialisme, Critique,* No. 2, juillet 1946.

Blanchot, Maurice, *A propos du surréalisme, L'Arche,* août 1945.

La Rochelle, Drieu, *La véritable erreur des surréalistes,* N.R.F. août 1925.

Peyre, Henri, *The Significance of Surrealism,* Yale French Studies, Fall-Winter, 1948.

Renéville, Rolland de, *Dernier état de la poésie surréaliste,* N.R.F. février 1932.

Ribemont-Dessaignes, *Histoire de Dada,* N.R.F. juin-août 1931.

Rivière, Jacques, *Reconnaissance à Dada,* N.R.F. août 1920.

OTHER WORKS TO CONSULT

Aragon, Louis, *Le Paysan de Paris,* Gallimard, 1926.

Aragon, Louis, *Traité du Style,* Gallimard, 1928.

Baruzi, Joseph, *La Volonté de Métamorphose,* Grasset, 1911.

Cassou, Jean, *Pour la Poésie,* Corréa, 1935.

Maritain, Jacques, *Les Frontières de la Poésie,* Plon, 1927.

Monnerot, Jules, *La poésie moderne et le sacré,* Gallimard, 1945.

Renéville, Rolland de, *L'Expérience Poétique,* Gallimard, 1938.

Renéville, Rolland de, *Univers de la Parole,* Gallimard, 1944.

Vaché, Jacques, *Lettres de Guerre,* Au Sans Pareil, 1919.

LAUTRÉAMONT

Lautréamont, *Oeuvres complètes,* Corti, 1938.

Bachelard, Gaston, *Lautréamont,* Corti, 1939.

Blanchot, Maurice, *Lautréamont et le mirage des sources,* Critique, No. 25, juin 1948.

Pierre-Quint, Léon, *Le comte de Lautréamont et Dieu,* Cahiers du Sud, 1930.

Soupault, Philippe, *Lautréamont,* Cahiers Libres, 1927.

RIMBAUD

Rimbaud, Arthur, *Oeuvres Complètes,* Edition de la Pléiade, 1946.

Blanchot, Maurice, *Le Sommeil de Rimbaud, Critique,* No. 10, 1947.

Etiemble et Gauclère, *Rimbaud,* Gallimard, 1936.

Fowlie, Wallace, *Rimbaud,* New Directions, 1946.

Fowlie, Wallace, *Rimbaud in 1949, Poetry,* December 1949.

Hackett, C. A. *Rimbaud l'enfant,* Corti, 1948.

Renéville, Rolland de, *Rimbaud le Voyant,* Au Sans Pareil, 1929.

Starkie, Enid, *Arthur Rimbaud,* Hamish Hamilton, 1947.

MALLARMÉ

Mallarmé, Stéphane, *Oeuvres Complètes,* Edition de la Pléiade, 1945.

Beausire, Pierre, *Essai sur la Poésie et la Poétique de Mallarmé,* Roth, 1942.

Cohn, Robert Greer, *Mallarmé's Un Coup de Dés,* Yale French Studies, New Haven, 1949.

Fowlie, Wallace, *Mallarmé,* University of Chicago Press (to be published in 1951).

Mondor, Henri, *Vie de Mallarmé,* Gallimard, 1942.

APOLLINAIRE

Apollinaire, Guillaume, *Alcools,* Gallimard, 1927.

Apollinaire, *Calligrammes,* Gallimard, 1936.

Apollinaire, *Les Mamelles de Tirésias,* Editions Sic, 1918.

Billy, André, *Apollinaire vivant,* La Sirène, 1923.

Shattuck, Roger, *Apollinaire* (translations), New Directions, 1950.

Soupault, Philippe, *Apollinaire ou les reflets de l'incendie,* Cahiers du Sud, 1927.

BRETON

Breton, André, *Manifeste du Surréalisme,* Kra, 1924.

Breton, André, *Nadja,* Gallimard, 1928.

Breton, André, *Second Manifeste du Surréalisme,* Kra, 1930.

Breton, André, *Le Surréalisme et la Peinture,* Brentano's, 1945.

Breton, André, *The Situation of Surrealism between the Two Wars,* Yale French Studies, Fall-Winter, 1948.

Gracq, Julien, *André Breton ou l'Ame d'un Mouvement,* Fontaine 58.

Pfeiffer, Jean, *Situation de Breton, L'Arche,* juillet, 1946.

COCTEAU

Cocteau, Jean, *Le Rappel à l'Ordre,* Stock, 1926.

Cocteau, Jean, *Orphée,* Stock, 1930.

Cocteau, Jean, *Essai de Critique Indirecte,* Grasset, 1932.

Mauriac, Claude, *Jean Cocteau,* Odette Lieutier, 1945.

ELUARD

Eluard, Paul, *Capitale de la Douleur,* Gallimard, 1926.

Eluard, Paul, *Donner à voir,* Gallimard, 1939.

Eluard, Paul, *Chanson Complète,* Gallimard, 1939.

Balakian, Anna, *The Post-Surrealism of Aragon and Eluard,* Yale French Studies, Fall-Winter 1948.

Carrouges, Michel, *Eluard et Claudel,* Du Seuil, 1945.

Delattre, André, *Personal Notes on Paul Eluard,* Yale French Studies, Winter 1948.

Seeley, Carol, *The Poetry of Paul Eluard,* Western Review, Fall 1949.

Parrot, Louis, *Paul Eluard,* Seghers, 1944.

PICASSO

Apollinaire, Guillaume, *Les Peintres Cubistes,* 1912.

Barr, Alfred H., *Picasso: fifty years of his art,* N. Y. Museum of Modern Art, 1946.

Cocteau, Jean, *Carte Blanche,* 1920.

Eluard, Paul, *A Pablo Picasso,* Trois Collines, Genève, 1945.

Laporte, Paul, Space-time concept in Picasso, *Magazine of Art,* January 1948.

Raynal, Maurice, *Picasso, L'Art d'aujourd'hui,* Paris, 1924.

Uhde, Wilhelm, *Picasso et la tradition française,* Editions des quatre-chemins, 1928.

INDEX

See page 215 for index to Epilogue.

211

A selected list of MIDLAND BOOKS